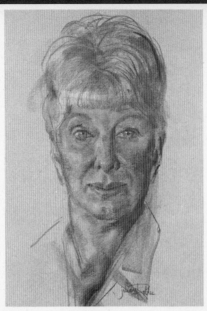

Portrait of Dorothy Harmsen by Julian Robles

DOROTHY B. HARMSEN's great interest in Western history and early American art and antiques began many years ago and is shared by all members of her family. She already had a fine collection of early American primitives when her husband William purchased their first Western painting in the 1960s. Western art rapidly became his most engrossing interest, and in a few short years, the collection grew to be one of the most extensive private collections in America.

Born in Minneapolis, Dorothy Harmsen attended schools there and was a fashion model for a time prior to her marriage. In 1941 the Harmsens moved to Denver, and in 1949, founded the Jolly Rancher Candy Company and later, Sweetners, Inc. She now serves as vice-president of both firms and is editor of *Sugar 'n Spice*, a commercial trade publication.

A woman of many talents and diverse interests, Mrs. Harmsen is also active in several Denver charities and a number of museums. She is listed in the 1971 edition of *Who's Who in American Women*.

HARMSEN'S WESTERN AMERICANA

HARMSEN'S

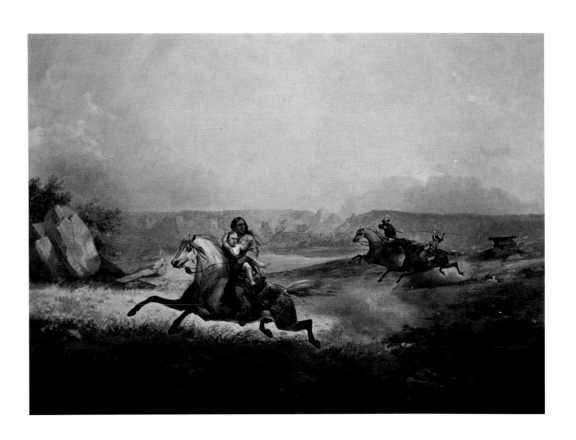

WESTERN AMERICANA

A collection of

one hundred western paintings

with biographical profiles

of the artists

By Dorothy Harmsen

FOREWORD BY ROBERT ROCKWELL

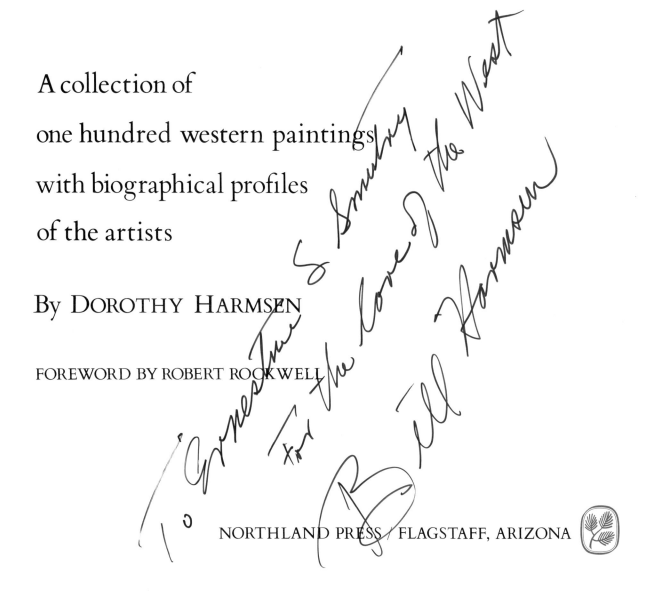

To Ernestine, Something for the love of the West, Bill Harmsen

NORTHLAND PRESS / FLAGSTAFF, ARIZONA

Doris Monthan, *Editor*

F. C. Hilker, *Photographer*

Copyright 1971

by

Harmsen's Western Americana

ISBN 0–87358–061–3

Library of Congress Number 79-134925

*To my husband Bill
and our sons William, Jr., Robert, and Michael*

Contents

Foreword

THE LAST DECADE has been an explosive period in the recognition as well as the appreciation of Western Americana and its related art. The recognition is significant in that we have finally acknowledged the pictorial records of the early West not only as historical documents, but as a unique and legitimate art form.

The romantic period of the settling of the American West covered a comparatively short span of time following the Civil War, only some thirty-five years. Yet, it was the most interesting era ever experienced by any country in such a short period, and its influence on all the people of America, from the Atlantic to the Pacific coasts, is tremendous.

Until recent years much of the work done by the early artist-explorers who recorded the drama of this period was neglected — hidden away in grandmothers' attics, in the basements of museums, or in regional archives. But suddenly, these great paintings have emerged from their hiding places, as we have realized that they are an expression unique to our country and a concrete part of our American heritage. The so-called discovery of this art now plays a major part in art sales in the United States, to museums as well as to private collectors.

Harmsen's Western Americana collection adds another great dimension to this heritage, and this book expands the knowledge and depth. Bill and Dorothy Harmsen started collecting because of their love and dedication to things American. In just a few short years they have assembled one of the most extensive collections in America, representing over 300 different Western artists. It not only includes the better known artists of the past, but the well-deserving contemporary artists who are actively adding their contribution to recording the West.

The collection has brought to light many artists who had slipped into obscurity, such as John Marchand, Raphael Lillywhite, Charles Craig,

Henry Raschen, William Cary, H. W. Hansen, John Hauser, and many others. The Harmsens continually search for new works and documentary data in all parts of the country. In addition, they have been generous in sharing their collection with museums, galleries, and schools so that more Americans have been able to share a new appreciation of the West.

Dorothy Harmsen is to be commended for the painstaking research and many hours of writing devoted toward making this comprehensive gathering available in book form.

ROBERT ROCKWELL

Introduction

THE COLLECTING OF WESTERN PAINTINGS was a natural outgrowth of a long and ardent interest in the history of the American West. The adventurous and talented men who were the creators of those paintings give us a colorful and comprehensive look at an exciting part of our heritage. This book originated from the desire to share our collection with a wider segment of Americans, and to present the artists and their involvement in the history of the West.

When my husband and I first began collecting Western art in the late sixties, we had no idea that our collection would grow to its present proportions. We began with the purchase of a painting by John Howland, an Ohio born artist who made his first trip west in 1856. With each addition, our enthusiasm for the art of the West mounted, and within several years our collection grew to more than 600 works by 350 artists. An increasing curiosity about the backgrounds of these Western artists began to take hold. Where had they come from? What made them want to paint the West, what inner compulsion or outward impetus made them leave home to record it on canvas? Were there unknown others who saw the same vision?

Curiosity about the artists took us to libraries, museums, and galleries in every part of the United States. Among the contemporary artists our task was simple. We met them, heard much of their history from their own lips, visited their studios and gallery shows, where we could view firsthand extensive collections of their works. In addition, there were many published sources of information. Among the earlier and lesser known artists, however, the task was much more difficult, and we found ourselves delving in obscure archives, searching newspaper morgues, and writing dozens of queries to known descendants, private collectors, and art authorities.

I

Despite the many miles traveled and the frustrations encountered along the way, our research expeditions proved to be very rewarding — not only for the information they produced on our particular artists, but on the entire span of Western art in America.

We discovered that the early artists of the West had little influence on succeeding generations until 1830 and the advent of George Catlin, John Mix Stanley, Alfred Jacob Miller, and Karl Bodmer. Before these painters there were few pictures of aboriginal life on the frontier; artists, never having seen any Indians, based their paintings on travelers' descriptions aided by their own colorful imaginations. George Catlin's fresh and vital Indian portraits and depiction of ceremonies, dances, and hunts preserve for us the spirit and traditional culture of the Plains Indian before it disappeared forever. Catlin dedicated his life to becoming their historian. Alfred Jacob Miller spent only one summer in the West, but he managed to capture its spirit and color, and painted from the memories of his one visit for the rest of his life. Charles Bird King never came west at all. Yet, in his Washington, D.C. studio he painted from life over 100 portraits of Indians who had come east as members of delegations to the nation's capital. John Mix Stanley made his first trip to the West in 1842, and arriving in Santa Fe in 1846, may well have been the first American artist to visit New Mexico. He traveled throughout northern California and the Pacific Northwest and was one of the earliest and by far the most prolific of the artists on the northern survey route.

The Rocky Mountain School, the first important Western school, was founded by a German-American, Albert Bierstadt, who made his first trip to the Rockies in 1859 with a government expedition which traced much of the route traveled by Alfred Jacob Miller twenty-two years before. Bierstadt wrote that he found the figures of the Indians "so enticing," and there was no doubt that he was impressed by the immensity and grandeur of the country. His monumental and theatrical canvases presented the Rocky Mountains as rivals to the Swiss Alps. By the 1870s his canvases were represented in major collections throughout the world and he was America's most widely known painter. Thomas Moran, another leading artist of the Rocky Mountain School, made his first trip west in 1871. His idealized paintings of the rugged and breathtaking Tetons, the Yellowstone region, Yosemite Valley, and Grand Canyon influenced the United States Congress to develop our National Parks System, which was unique in the world at that time.

2

Charles M. Russell and Frederic Remington, considered by many to be the giants among Western artists, worked frantically to preserve an image of the wild and action-packed West. They vividly recreated the world of the open-range cowboy, the Indian Wars, the trappers, traders, and scouts in hundreds of paintings, sketches, and sculptures. The coming of the settlers and the railroads, the fencing of the land, the extermination of the buffalo, and the confinement of the Indian to reservations signified to them the end of a romantic and picturesque American life. In 1902 when Remington spent some time sketching in Taos, he expressed his feelings in an unpublished manuscript: "The Americans have gashed this country up so horribly with their axes, hammers, scrapers and plows that I always like to see a place which they have overlooked; some place before they arrive with their heavy-handed God of Progress."

Taos, a sleepy little Indian Pueblo in New Mexico, was indeed one of those "overlooked" places, but it became the first American art colony in the West. Joseph Henry Sharp visited there for the first time in 1883, and found that the Indians still maintained their ancient way of life. The magic of the Taos landscape — its desert, dramatic mountains, and unique lighting combined with its handsome Indians, their colorful costumes and dwelling places — made an ideal setting for an artist to work. Sharp's enthusiastic accounts persuaded Bert Greer Phillips and Ernest L. Blumenschein to visit Taos in 1898. They were joined during the next three or four decades by artists from all over the world and every school of painting. The Taos colony was motivated by a new nationalism, a vigorous exploration and re-discovery of America and it continued to thrive as such until the advent of World War II. I sincerely believe that the Taos School has made a major contribution to American art and will someday be as well known as the Ashcan School which revolutionized the American art scene in the beginning of the 20th century.

Springing up almost simultaneously with the Taos group, and only some sixty miles away, was the Santa Fe art colony. Carlos Vierra settled in Santa Fe in 1904, and in 1906 Warren E. Rollins was the first artist to have a formal exhibition there. Randall Davey, Gerald Cassidy, Sheldon Parsons, Julius Rolshoven were just a few of the artists who were to find inspiration in this picturesque town with its ancient heritage of Indian, Spanish, and Mexican cultures.

Our research was indeed rich in its rewards. But, as this volume reached completion, how many of our earlier questions were answered

3

about these men who chose to paint the West — did a composite picture emerge? Among the 100 artists we selected we discovered we had covered over 150 years of painting, from our earliest painter, Charles Bird King, born in 1785, to our youngest, Ramon Kelley, born in 1939. We found that while some had been born and reared in the West, most had come from the Midwest and eastern United States, some from Europe and Scandinavia and, as in the case of Leon Gaspard and Nicolai Fechin, from as far away as Russia. Many had extensive academic training in the major art centers of America and Europe, others were largely self-taught. Some came from comfortable or affluent homes, others from impoverished homes. We found that several achieved fame and wealth in their lifetime while others died in poverty and obscurity. Their personalities were diverse: hearty, robust men, others shy and introverted, and several were plagued by frail health all of their lives. Their styles ranged from romantic and impressionistic to almost photographic realism to semi-abstract. What then was the unifying factor in their lives?

The one quality applicable to all of them was that they found their niche in the West, whether permanently or temporarily. They were inspired and excited by its plains and deserts, majestic mountains, rugged canyons, by its Indians, cowboys, and horses, by its pioneers and new frontiers, and they were determined to record what they saw. They were adventurous men, infected by the spirit of the Old West and, among the contemporary artists, by those remnants of the Old West which still prevail — the working ranches, rodeos, and the still untamed wilderness areas and unmarred grandeurs of much of its landscape. These present-day artists who are recording the historical and contemporary West are men of great foresight and dedication. They are giving us a record of what soon may be gone.

It is fortunate, too, that our early Western artists had the desire to preserve the Indian's culture in its primordial state at a time when few Americans were interested, for it was the European visitor in our country who first appreciated and collected the ancient artifacts of the American Indian. But, perhaps, this is understandable, for Europeans are trained and immersed in the veneration of the old, surrounded as they are by centuries-old cathedrals and ancient art forms. Young America was too busy growing and going forward to look back. Now, caught in the rapid changes of the past few decades, when we have seen historic old urban areas torn down to be replaced by the new; virgin landscapes filled with

new towns and housing developments; our national parks depressingly overcrowded, we are taking an apprehensive look over our shoulders.

What is very significant is that the nationwide concern with ecology — the preservation of our streams, lakes, wildlife and wilderness areas — has come almost simultaneously with the boom in the Western art market. Today the demand for Western art is far greater than the supply. America has reached the point in its development where it wants to treasure and preserve the visual record of its last frontier. It is our hope that this book will contribute in some way toward that preservation.

DOROTHY HARMSEN

EDITOR'S NOTE: The initials NA following an artist's name indicate National Academician. ANA refers to an associate of the academy. Members of the Cowboy Artists of America are identified by CA.

THE COLLECTION

Manuel Acosta

b. 1921

THROUGH THE SCULPTOR, Urbici Soler, Manuel Acosta became friends of Peter Hurd and his wife Henriette Wyeth. They were influential in making him realize that as a Mexican American he has a wealth of material to portray about his people on the Rio Grande.

When he was a baby, Manuel Gregorio Acosta was brought to El Paso, Texas, from his birthplace in Villa Aldama, Chihuahua, Mexico. Born in El Paso were five brothers and one sister. After completing his high school education he served in the U. S. Air Force during World War II. Upon his discharge Acosta studied at the University of Texas at El Paso, and later at the University of California, and the Chouinard Art Institute in Los Angeles. He now has his home and studio in El Paso.

Working principally in oil, watercolor, or charcoal, Acosta depicts such colorful Latin subjects as mariachi bands, weathered old Mexican women making paper flowers, the romantic bullfighter, and street urchins catching pennies thrown to them from the International Bridge. In addition to his easel painting, Acosta was commissioned by the Bank of Texas at Houston to execute a series of murals depicting the history of Texas. Other murals may be seen in the First National Bank of Dona Ana County in Las Cruces, New Mexico and the Casa Blanca Restaurant in Logan, New Mexico; these latter show the history of the Mesilla Valley.

Recently Acosta has evolved a new technique and subdued his palette. Now, in an effort to capture the subtleties of light and shadow and to fuse his subject into a more harmonious whole, he blends his subject into the background, emphasizing the surrounding areas. In spite of these soft-edged spaces, and light leading softly into darkness, he always includes a detail that is done with an accurate feeling for pure realism. This new style is a conscious attempt to cause the eye of the viewer to travel in rhythmic progression throughout the painting. His work has been reviewed by prominent critic John Canaday as romantic but *"muy dulce."*

Manuel Acosta's work is in many important collections and has been exhibited throughout the country. He has paintings on one-year tours with the American Watercolor Society's exhibit. His work has also been exhibited in the Texas Watercolor Show; Dallas Museum; El Paso Museum; Art U.S.A.; HemisFair, San Antonio; and the Chihuahua Art Museum in Mexico.

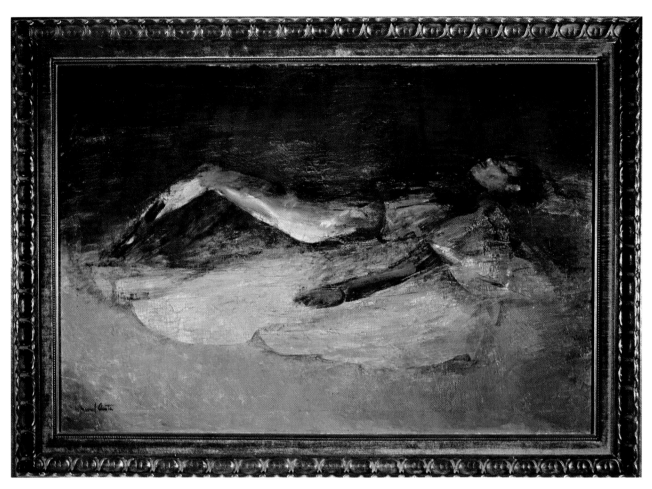

WOUNDED BULLFIGHTER *Oil* 24 x 36 inches

Charles Partridge Adams

1858-1942

ALTHOUGH A NATIVE OF NEW ENGLAND, Charles Partridge Adams was to become one of the finest delineators of the West's majestic Rocky Mountains and one of Colorado's most popular painters.

He was born on January 12, 1858 in Franklin, Massachusetts. After studying painting under the famous early American artist, George Inness, Adams and his wife moved to Denver in 1876 and fell in love with Colorado. Within a short time, helped by business cards which stated "Landscapes and Crayon Portraits," Adams attained success among the fashionable people of the day who bought his oils to give as Christmas and wedding presents, and to decorate their own homes.

In the summer he moved his studio, called "The Sketch Box," to Estes Park, where he studied, sketched, and taught. From this studio he had a magnificent view of Longs Peak, whose many moods were a constant source of inspiration to him. Not all of his paintings were restricted to Estes Park, however, as he traveled about the Rockies — south into the Spanish Peaks, north to the Tetons and Yellowstone Park, and west to the San Juans and the San Miguels.

His love of the mountains is apparent in all the masterful detail, the authority with which he captures an atmosphere — a flaming sunset back-lighting jagged peaks, a snow-swept storm in the uppermost reaches of the alpine heights; the viewer can almost feel a cool summer breeze scented with pine. The same subject is played upon in an endless variety of ways.

A prolific artist, it is estimated that he completed almost 800 paintings. The largest and most definitive collection of his work is in the possession of a Denver collector who has almost two hundred of Adams' sketches and paintings. Fine examples of his work may also be seen at the State University, Boulder, Colorado; Teachers' College, Greeley, Colorado; and the Denver Art Association.

In the 1920s Charles Partridge Adams moved to Laguna Beach, California, where he began to paint marine subjects reminiscent of Winslow Homer, bringing to them the same power and variety that he displayed in his beloved mountain subjects.

He died in Pasadena in October, 1942.

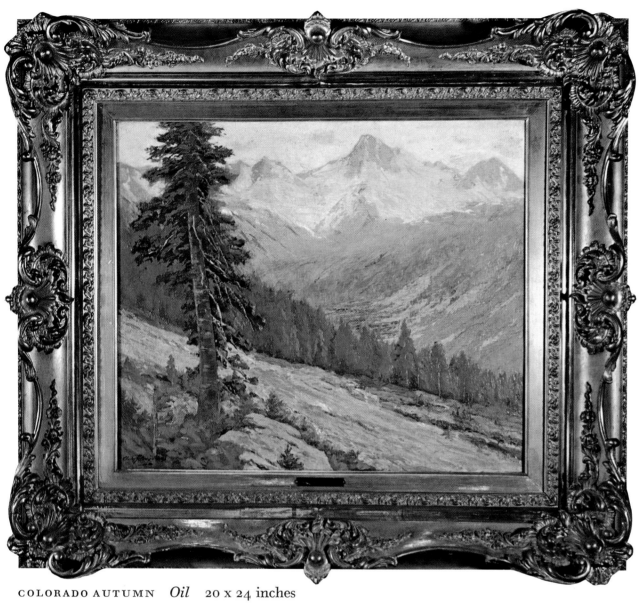

COLORADO AUTUMN *Oil* 20 x 24 inches

Kenneth M. Adams NA
1897–1966

FOR MORE THAN FORTY YEARS, Kenneth Adams played an important role in the artistic life of New Mexico. As the youngest and last member to be elected to the Taos Society of Artists, he was closely associated with both the "old guard" and the later arrivals to the New Mexican art scene.

He was born in Topeka, Kansas, and at the age of sixteen, began his study of art with George M. Stone. After attending the Art Institute of Chicago, he served briefly as a private in the Army. In 1919 he resumed his study at the Art Students League in New York under Kenneth Hayes Miller, George Bridgeman, Maurice Sterne, and Eugene Speicher. At the League's summer school in Woodstock he studied with Andrew Dasburg.

It was Dasburg who first told him of the favorable artistic climate of Taos and in 1924, after two years of study in France and Italy, Adams settled in Taos. Three years later he was elected to the Taos Society of Artists, just shortly before it was dissolved in 1927.

Albuquerque became his home in 1938 when he was awarded a Carnegie Corporation grant as the first artist-in-residence at the University of New Mexico. Later, he became Professor of Art, a post he held until his retirement in 1963.

Adams' awards and honors are numerous. At the 1939 New York World's Fair, his painting, "Benerisa Tafoya," was awarded both the first prize by jury and first prize by popular selection. In 1938 he was elected Associate to the National Academy of Design, and in 1961, a full Academician. He executed murals for the post offices at Goodland, Kansas and Deming, New Mexico; the Colorado Springs Fine Arts Center; and the University of New Mexico Library. His work is represented in major museums and collections throughout the country, including the Los Angeles County Museum, Dallas Museum of Fine Arts, the Whitney Museum of American Art, Corcoran Gallery, Carnegie Institute, Princeton University, and the National Academy of Design.

The work of Kenneth Adams reflects a desire to clarify, rather than to distort or obscure. While a student of Dasburg, he experimented with cubism and found that some of its basic tenets complemented the realism he was trying to achieve. His realism, however, was very different from that of the older Taos artists. In its simplicity and directness it was closer to the art of Orozco and Rivera.

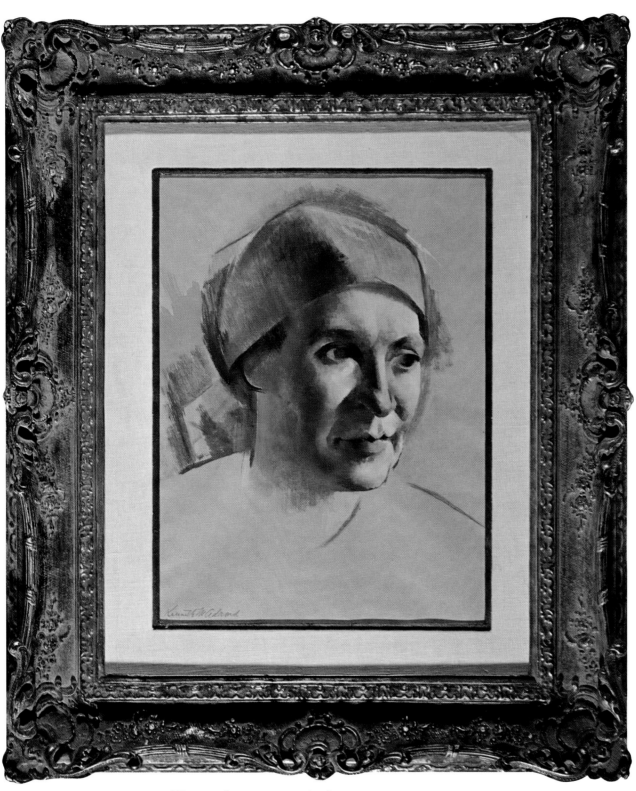

NEW MEXICO WOMAN *Watercolor* 17 x 13 inches

H. Ray Baker
b. 1911

THE HARD TIMES of the Depression years forced H. Ray Baker to try his hand at a variety of occupations — sign painter, artist, boxer, writer, reporter, and even bootlegger on the side. But it was fine arts painting which finally claimed his full attention. From his birthplace in Thomas, Oklahoma, where his father was unsuccessful at growing cotton, Baker moved with his family to Reading, Kansas. There his father tried cattle ranching, which gave the young Baker an introduction to the world of the cowboy.

While in high school Baker supported himself by doing theater posters and sign painting. After graduation in 1929 he continued with the sign painting as his main source of income, but also tried his hand at reporting for a newspaper in Oklahoma. Later, giving in to an urge to see more of the country and have a taste of adventure, he traveled throughout the West as an itinerant sign painter and boxer.

After settling in Steamboat Springs, Colorado, he began to seriously apply himself to easel painting and was successful enough so that, along with sign painting and the nefarious bootlegging, he was able to eke out a living.

Toward the end of the Depression period he moved to Denver, where he worked as a commercial artist and art director for printing firms. In his free time he polished his painting technique and wrote articles which appeared in men's adventure and automotive magazines. He had several one-man art exhibits, including a major one at the Colorado Springs Fine Arts Center.

In 1949 Baker accepted a position as editor and art director of the *Denver Post's Sunday Empire Magazine*, and he remained at this job for the next twenty years. As usual, however, his vast energies and interests could not be contained in one career, and so during this period he also found time to buy and run a cattle ranch, serve as planning chairman for Littleton, Colorado, and to write a book, *Mountin' Man*. His various articles and book manuscripts, along with many of his Western illustrations, are in the H. Ray Baker Collection at the University of Wyoming.

Recently, Baker retired from the *Denver Post* and moved to Taos, New Mexico, where he devotes his full time to writing and painting.

UTAH COUNTRY *Oil* 17 x 21½ inches

Joe Beeler CA
b. 1931

BEFORE HE WAS FORTY YEARS OLD, Joe Beeler already had an impressive list of achievements in his chosen field of art. He was one of the four founders of the Cowboy Artists of America; the first artist to have a one-man show at the National Cowboy Hall of Fame in Oklahoma City; one of few artists to have a one-man show at the Gilcrease Institute in Tulsa; he has written and illustrated a book, *Cowboys and Indians*; and has illustrated several others — among them *The Last Trail Drive Through Downtown Dallas*, by Ben K. Green.

In addition to these accomplishments he has won three different awards for his bronzes at the National Cowboy Hall of Fame; been awarded a Meritorious Achievement Award by the Kansas State University; and in 1970 he had a show at the renowned C. M. Russell Gallery in Great Falls, Montana.

Part Cherokee Indian, Beeler was born in Joplin, Missouri. From his earliest childhood he heard stirring tales of the West told by his grandparents who had experienced life on the frontier during the Gold Rush. His father taught him the ways of an outdoorsman and a respect for animals.

His childhood in northeastern Oklahoma brought him into close association with Indians and cowboys; he went to rodeos, took part in the Indian powwows, and formed lasting friendships among the Indian peoples, all of which provided an excellent basis for later subject matter.

Formal art training for Beeler began at Tulsa University where he studied under Alexander Hogue. The Korean War interrupted his education for two years, but upon his return he earned a degree from Kansas State and married Sharon McPherson. He had further training at the Art Center School in Los Angeles, a school which he credits with advancing his career greatly.

A growing family seemed to necessitate more financial remuneration, but always at the crucial moment when Beeler was ready to turn to commercial art as a means of livelihood a stroke of luck intervened, and he was eventually able to make his way in the field of fine art.

At present, Beeler lives with his wife and family in the redrock country of Sedona, Arizona, where he still loves to participate in roundups and brandings — events which give him firsthand knowledge of his subjects.

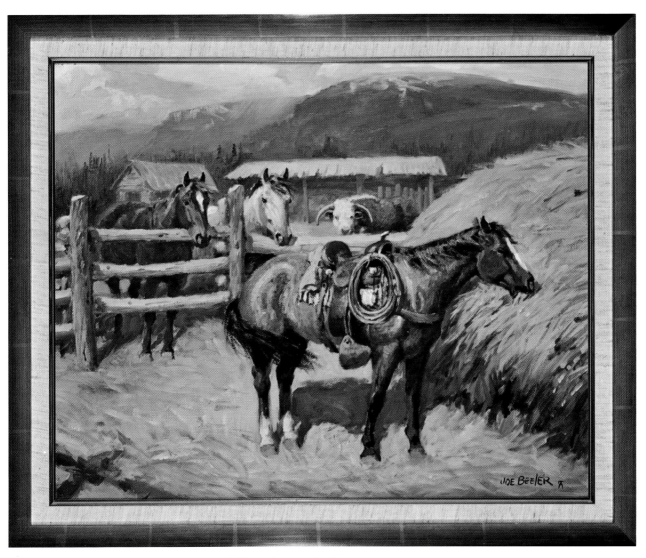

THE PRIVILEGED CHARACTER *Oil* 16 x 20 inches

J. Charles Berninghaus
b. 1905

J. CHARLES BERNINGHAUS was born in St. Louis, Missouri. As the son of painter Oscar E. Berninghaus, he received much encouragement in his pursuit of an artistic career and studied at the St. Louis School of Fine Arts, the Chicago Art Institute, and the Art Students League in New York. When he was seventeen years old the family moved to Taos, New Mexico. As early as 1899 his father had become interested in the region while on a trip from Santa Fe to Colorado. The conductor of the narrow gauge railroad train on which he was traveling happened to remark, as they approached the Taos junction, that there were a couple of artists living there. This aroused the older Berninghaus' interest to such an extent that he disembarked to explore the area and to meet the artists, who were Bert Phillips and Ernest Blumenschein.

From this nucleus, and under the guidance of Joseph Sharp, the art colony eventually grew to include E. Irving Couse, the Berninghauses, Herbert Dunton, Walter Ufer, Victor Higgens, E. Martin Hennings, and Kenneth Adams. Oscar Berninghaus was a charter member of the Taos Society of Artists. The older painters were very kind to young Berninghaus and often included him on their field trips during which they helped him with his painting. In return, he frequently served as a model for them.

Walter Ufer became a special friend of his, and on later trips to Chicago and New York Ufer introduced him to a wide circle of artists prominent at the time.

Known principally as a landscape painter, Berninghaus also assisted his father in doing murals for the State Capitol of Missouri. He again worked with his father in executing commissions for the Anheuser-Busch Company. The beauty of the flowers, trees, and countryside of New Mexico is exquisitely captured on his colorful and decorative canvases. His work has been exhibited in many museums, and is in the permanent collections of numerous libraries, clubs, and schools, as well as in distinguished private collections. The painting shown here appears as Plate #4 in the book *Taos and Its Artists* by Mabel Dodge Luhan.

Twice married, Berninghaus now lives alone in the place of which he has said, "The nicest thing that has ever happened to me was coming to live in Taos."

TAOS PUEBLO RIVER *Oil* 35 x 40 inches

Oscar E. Berninghaus ANA

1874–1952

UNLIKE MOST INDIAN PAINTERS, Oscar Edmund Berninghaus kept an objective eye on the times. His Indians are frequently shown with blue overalls instead of the colorful, traditional costumes, and their horses may be shown alongside a Model-T Ford pickup. He depicted the West in a simple, direct style supported by splendid draftsmanship.

Berninghaus was born in St. Louis, Missouri, and, like so many other artists of the period, began his art training as an apprentice lithographer. Following that, he worked for a large St. Louis printing firm, attending night art classes at Washington University. He took further study at the St. Louis School of Fine Arts and later taught at Washington University.

In 1899, at the age of twenty-five, Berninghaus made his first visit to Taos, New Mexico. His reputation as a skilled illustrator was already established in St. Louis, but the visit to Taos was the beginning of his national reputation. He returned each year for longer and longer visits until he was spending half the year there and half in St. Louis. He was active civically and artistically in both communities. For many years he designed the floats and costumes for St. Louis' famous Veiled Prophet parade. In 1912, when the Taos Society of Artists was formed, he was one of the six charter members. In 1919 he bought a beautiful old adobe house on the Loma and, by 1925, the Berninghaus family had established year-round residence in Taos. Berninghaus' son Charles, who is also a noted artist, continues to live and work there.

In the mid-twenties, Berninghaus abruptly changed his style, resulting in richer pigmentation, more intricate composition, and lending an abstract quality, though his work continued to be representational. In both periods, however, his paintings reflect a true psychological insight into the life of the twentieth century Indian. They are among the most popular produced in the Southwest and are represented in many major museums and private collections.

The Anheuser-Busch Company of St. Louis, for whom he did advertising art over a period of many years, commissioned him to do a series of historical paintings which they published in 1914. The originals are on display in the company's office.

20

Berninghaus died in Taos at the age of seventy-eight.

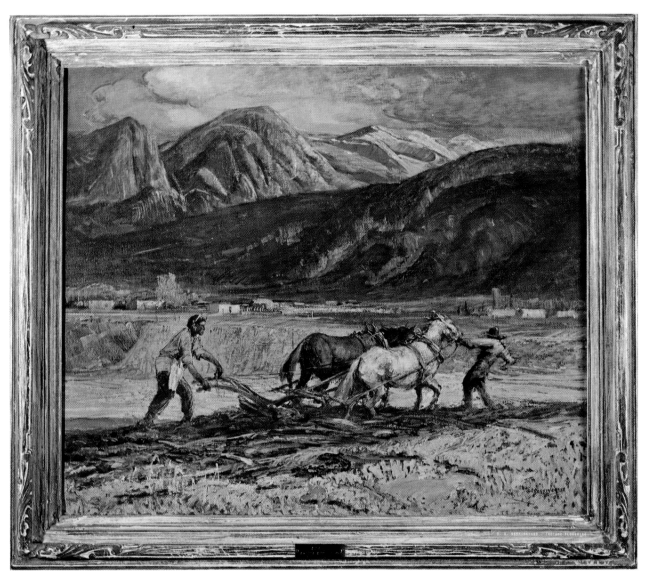

TAOS FIELD WORKERS *Oil* 25 x 30 inches

Albert Bierstadt NA

1830–1902

KNOWN AS THE LEADER of the Rocky Mountain School, which included such artists as Thomas Hill, William Keith, and Thomas Moran, Albert Bierstadt became one of the most successful and highest paid painters in the United States while still in his thirties. His work also introduced Easterners to the splendors of the Western frontier scenery.

Bierstadt was brought to New Bedford, Massachusetts from his birth-place in Solingen, Germany, when he was two, and had his first drawing lessons in the New Bedford public school. In spite of discouragement by his family due to lack of finances, he persisted in his struggle to become an artist. After exhibiting at the New England Art Union in Boston, when he was twenty-one, Bierstadt returned to Germany to study at the Düsseldorf Academy, where his teachers included Leutze, Achenbach, and Lessing. Traveling about Europe with Worthington Whittredge and Sanford Gifford, he sketched mountain scenery and later developed the sketches into finished oil paintings which he regularly sent home to be sold. He received much publicity in New England newspapers and began to acquire a fast-growing reputation.

His first trip to the Rockies occurred in 1859 when he joined a government expedition as a civilian artist. The expedition traveled through the Laramie Mountains and the south pass of the Rockies up into Oregon. After the exhibition of the paintings resulting from this trip, he was elected full academician at the National Academy of Design. On another more extended trip to the West he became fascinated with the herds of buffalo and began painting them into his landscapes.

Bierstadt continued to have spectacular success which enabled him to have a huge studio-home on the Hudson River, to entertain royalty, and travel widely in this country and abroad. Eventually, however, American tastes in art underwent a change and his massive canvases fell from public favor. Then his fortunes seemed to take a downward trend: fire destroyed his home, his wife died, and his health began to fail. A second marriage helped him financially, and he continued to paint the mountain scenes he loved until his death in New York City. Recently the early descriptive style in which Bierstadt painted has regained popularity, and his work is once again in wide demand.

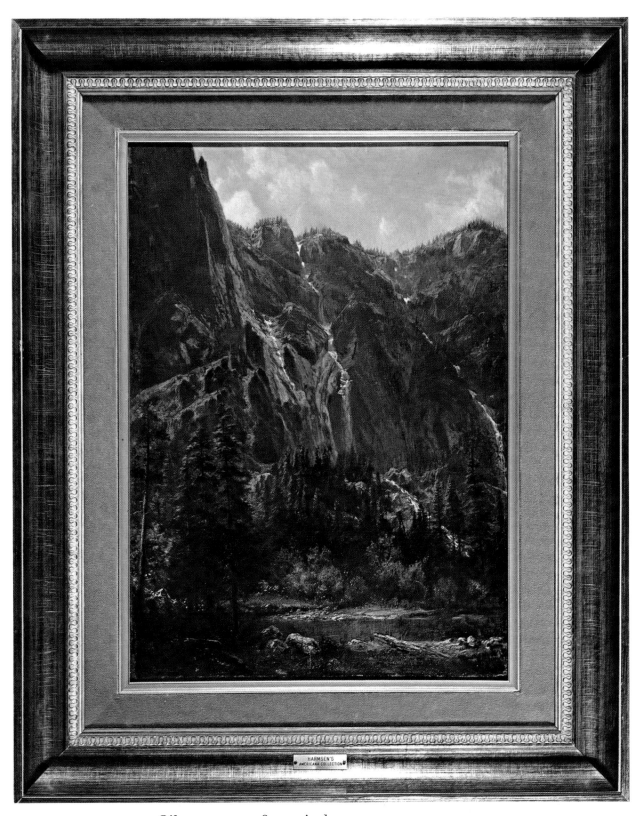

WHITE MOUNTAIN *Oil on paper* 28 x 20 inches

LaVerne Nelson Black

1887–1938

IT WAS NOT UNTIL THE LATE 1930s that LaVerne Nelson Black received the recognition he deserved. This was due in part to an unusually reticent personality and also to an impressionistic style which was not popular during the preceding years.

He was born at Viola, Wisconsin, in the Kickapoo Valley, an area rich in Indian lore. As a boy, already interested in drawing horses and Indians, he used vegetable juices, earths, and a soft stone called the red keel as his first painting supplies. In 1906 Black's family sold their hotel and restaurant business and moved to Chicago where he enrolled at the Chicago Academy of Fine Arts. During his second year at the academy his work was of such outstanding quality that he was awarded a scholarship.

After completing his training, Black did artwork for newspapers in Chicago and, for a time, in New York City. He continued to work at his easel painting, and received a few commissions from galleries, but during this period he was better known for his bronzes. They were the first to be shown at Tiffany's since Remington's, an indication of their high quality.

Ill health forced Black to leave the East and he settled with his wife and two children in Taos, New Mexico. It was here, in a region rich in Western atmosphere and Indian heritage, that he did some of his best work, using as his subjects the pueblo architecture, Indians in their colorful garb, and the snow-covered peaks of the Sangre de Cristo Mountains.

Failing health once again demanded a warmer climate, and this time he chose Phoenix, Arizona. Here he was commissioned by the Public Works Administration to paint four murals for the United States Post Office. His friends believe that he contracted a form of paint poisoning while executing the murals, for shortly after their completion he received medical attention at the Mayo Clinic and later died in a Chicago hospital at the age of fifty-one.

Black's paintings were characterized by broad brush strokes and frequent use of the palette knife. Blocks of bold color, usually warm hues, without the distraction of much detail are used to convey the essence of the Southwest, which he painted from life whenever possible, rather than working from sketches.

24

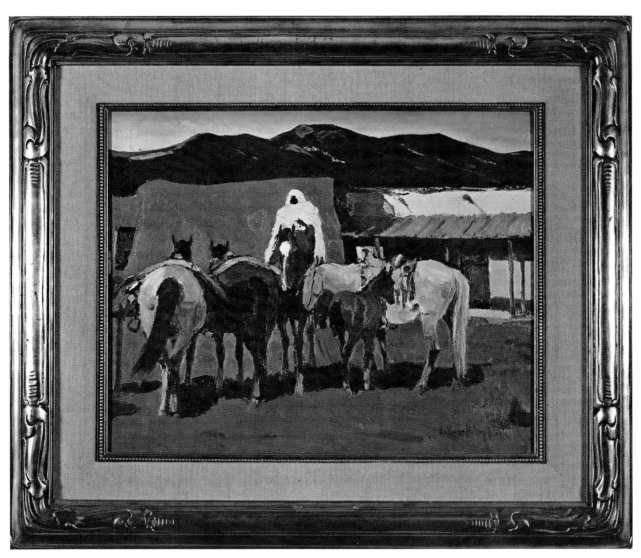

NIGHT OUT IN TAOS *Oil* 16 x 20 inches

Ralph A. Blakelock NA
1847–1919

IN ADDITION TO A TRAGIC LIFETIME filled with disappointed hopes, grinding poverty, and finally insanity, Ralph Albert Blakelock's work was also denied the acceptance and popularity which it is now accorded.

The son of a physician, Blakelock was born in Greenwich Village, New York City. He received his education in the New York public schools and at the Free Academy, where he showed an affinity for foreign languages, but preferred studying art and music. In college he studied medicine for a time, but his love of art caused him to abandon this endeavor in favor of painting landscapes of the White Mountains, the Adirondacks, and scenes in New Jersey.

In 1869 he took an extended trip through the West — Colorado, Utah, Wyoming, and on to the Pacific Coast; from there he traveled through Mexico to Panama, and the West Indies.

When he painted in a realistic style his work gained some measure of success, and he was represented in the National Academy for several consecutive years. But upon adopting an impressionistic style of painting, thus becoming the first portrayer of the Western scene to do so, he fell from favor with the academy and the public. In spite of the struggle for existence he pursued his dream and continued to paint as he felt he must.

Throughout his marriage to Corra Rebecca Bailey there was a constant battle for survival, for themselves and their many children. His paintings, so radically different from those of his contemporaries, sold not at all or by the stack at prices so low that they scarcely covered the cost of materials. In 1899, on the night his ninth child was born, Blakelock was committed to an institution for the mentally ill.

Three years before his death his paintings had achieved recognition and he was elected to the National Academy of Design. His work which had been selling for one or two dollars a canvas now commanded prices up to twenty thousand dollars; so popular had his paintings become that forgers were busily duplicating his style.

A final tragic footnote to Blakelock's life was that one of his daughters, unaware of the intent, was used by forgers in copying her father's work, and also became the victim of insanity.

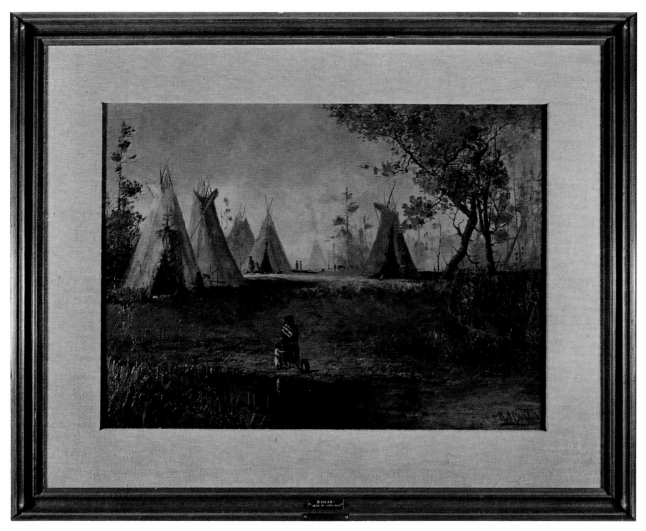

ENCAMPMENT ON THE UPPER MISSOURI *Oil* 26 x 36 inches

Ernest L. Blumenschein NA
1874–1960

ONE OF THE SIX CHARTER MEMBERS of the Taos Society of Artists, Ernest Leonard Blumenschein was a man of incredible vitality and versatility. Destined to become the best known of the pioneer New Mexico painters, he was also a tennis champion, accomplished violinist, master bridge player, and award-winning illustrator.

Blumenschein, the son of a distinguished organist, composer, and conductor, was directed toward music in his early training. He was born in Pittsburgh, Pennsylvania, but from the age of four lived in Dayton, Ohio, and graduated from high school there. At seventeen, he received a scholarship in violin at the Cincinnati College of Music, but a year later decided on painting as a career. Soon after, he went to New York to study at the Arts Students League, helping to support himself by playing first violin in Anton Dvořák's newly organized symphony orchestra. After winning a prize for an illustration, he went to Paris to study. At the *Académie Julien*, he heard of Taos from another student, Joseph Sharp.

On his return to America, the illustrating field became a substantial source of funds, and in the winter of 1898 an assignment for *McClure's* magazine sent him on his first trip west. The following summer he and Bert Phillips bought a team and surrey in Denver and headed for Mexico on a sketching trip. When the surrey broke a wheel near Questa, New Mexico, Blumenschein went into Taos for repairs. Returning, he announced that if Phillips agreed, the Taos Valley would be the end of their trip. Blumenschein then began dividing his time between Taos, New York, and Paris, doing more and more easel painting, but still continuing the lucrative illustrating assignments — leading magazines, and books by Jack London, Stephen Crane, Booth Tarkington, and Willa Cather.

While in Paris in 1905, he married artist Mary Shepard Greene. In 1919 they bought a house and studio in Taos large enough to accommodate three working artists, as their daughter, Helen, had become an artist too.

In 1910 a New York art critic praised a Blumenschein painting for its "unhackneyed presentation . . . originality . . . force . . . sound craftsmanship." The same words could be applied to his later work, but after 1920 it reflected less of his European training. His colors took on the depth and strength of the Southwest and a strong, underlying design began to emerge, which was both distinctive and innovative.

28

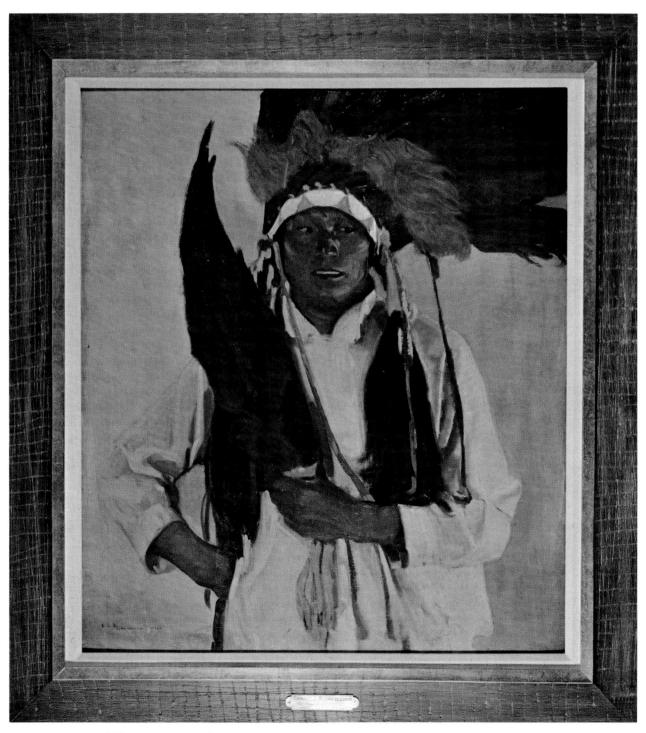

EAGLE FAN *Oil* 34 x 30 inches

Edward Borein
1873–1945

AS AN ARTIST AND A MAN, Edward Borein was one of the most popular figures on the Western scene. The fact that he became the intimate friend of such men as Charles Russell, Will Rogers, President Theodore Roosevelt, Leo Carillo, and others of equal prominence testifies to his attractive personality as well as to his talent. Completely lacking in sham and social artifice, he was typically a man of the West.

Born in San Leandro, California, young Borein used the inside cover of a dull geography textbook as his first sketch pad. This early effort — horses, a cowboy, and a steer — gave a good indication of his future choice of subject matter. By the time he was seventeen he achieved the main ambition of his youthful life and became a working cowboy, drifting through most areas of the West, from Mexico to Montana. During this period Borein practiced his art on almost any available surface, including bunkhouse walls, and scraps of paper which he freely gave to his fellow workers.

Charles F. Lummis, then editor of *The Land of Sunshine* magazine in Los Angeles, was the first purchaser of Borein's work. A lifelong friendship was formed and in 1921, some twenty-five years later, Borein and Lucille Maxwell were married in Lummis' home.

In 1907 Borein went to New York to learn etching techniques. He opened a studio so typical of the West in its atmosphere that he soon attracted the companionship of other homesick Western artists working in the East at that time. Charles Russell came to regard him as a brother.

Feeling ill at ease in New York City, and electing not to return to his more familiar Oakland surroundings, Borein took his new bride to Santa Barbara in 1921 and established a studio there. His old cronies and new friends found this studio a delightful place to gather.

Watercolor, especially in his later life, was a favorite medium of Edward Borein. He was equally adept at pen-and-ink drawing, and his etchings were of such vigorous, realistic quality that no Western artist has surpassed him in this field. In spite of his financial success in the highly competitive field of Western art, Borein remained to the end a down-to-earth man whose pictorial renditions of the Western scene were the result of lifelong personal observation and experience.

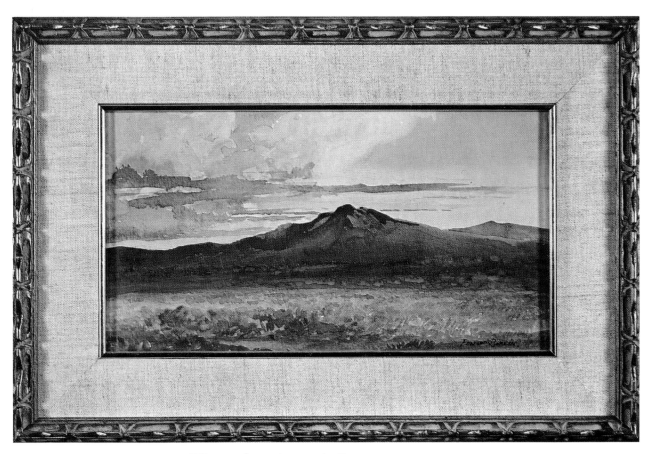

MOUNTAIN LANDSCAPE *Watercolor* 8 x 15 inches

James Boren CA
b. 1921

MICHELANGELO, FREDERIC REMINGTON, Charles Russell, and Nicolai Fechin — these are the four who fired James Boren's imagination, and whose inspiration made him decide to be an artist.

Even as a boy in his hometown of Waxahachie, Texas, Boren enjoyed drawing and painting more than anything else. And through his school years and the time spent in military service during World War II, he kept his dream alive. After his discharge he enrolled at the Kansas City Art Institute, and from this school, augmented by studies at Kansas City University, he graduated with an A.B. and later an M.A. in Fine Arts.

He taught art for two years at St. Mary College, Leavenworth, Kansas, followed by three years of traveling in the western part of the United States, Alaska, and Canada. Something in Boren strongly responded to the rugged beauty of this part of the country. When asked why he chooses to paint western subjects, he says, "While subject matter may not be the all important ingredient in a painting, it can be inspirational to an artist to paint the subject matter he likes best. I have always been captivated by the West, its incomparably beautiful landscape, its exciting history, and the interesting profile of its present character — a blend of the old and the new."

For eight years Boren, his wife Mary Ellen, and their children lived in Denver. Colorado's spectacular scenery provided him with a wealth of subject matter and was also a convenient point of departure for painting trips to other parts of the West. In February 1965 Dean Krakel, managing director of the National Cowboy Hall of Fame in Oklahoma City, offered Boren the post of art director of the famous museum. Boren has said that the two nicest things that ever happened to him were this job and the book written by Krakel, *James Boren: A Study in Discipline*, published by Northland Press in 1968.

He won the Gold Medal Awards for best watercolor paintings in the Cowboy Artists of America Exhibits of 1968, 1969, and 1970 — the only artist ever to win three of these prizes in a row. Due to the great demand for his work, he has resigned his position at the Cowboy Hall of Fame and now devotes all of his time to painting in his Oklahoma City studio.

32

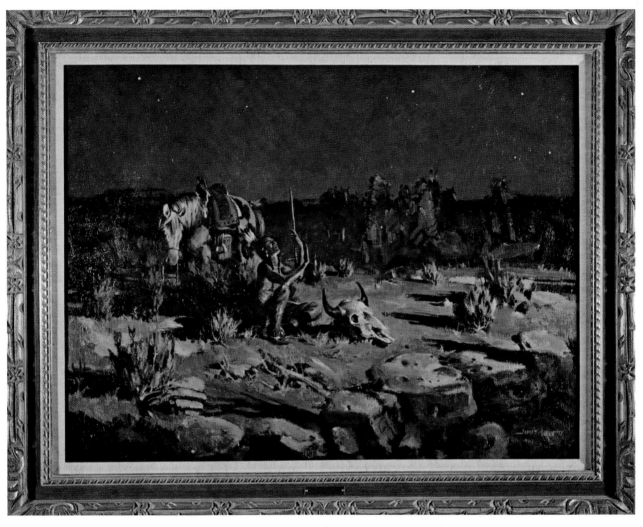

BEFORE THE BUFFALO HUNT *Oil* 27 x 36 inches

Carl Oscar Borg ANA
1879-1947

WHEN HE WAS A VERY YOUNG MAN, Carl Oscar Borg came to this country from Sweden, where he was born in 1879. He had received his art training in Europe, and upon his arrival in the United States was employed by a portrait studio in California.

His first exhibit in 1905 much impressed art critic Anthony Anderson and dealer William Cole, both of whom helped further his career and became life-long friends.

Through Cole, Borg met Charles Lummis, founder of the Southwest Museum and an authority on Indian culture, whose articles on the Indians for the *Los Angeles Times* gained international recognition. He helped develop Borg's interest in Indian life and taught him much about the Red Man's ways and artifacts.

During the next several years Borg traveled extensively throughout the West, working in oil, watercolor, tempera, and block prints. Eventually his paintings came to the attention of Phoebe Apperson Hearst who exerted a strong force on his future artistic career. She sent him abroad, where he held exhibitions in Paris, Rome, Venice, Amsterdam, and his native Sweden. Later, after Borg had returned to this country, she commissioned him to paint a number of primitive ceremonies of various Indian tribes of the Southwest. This collection was presented to the University of California.

In 1917 Borg had a very successful exhibit at the Palace of Fine Arts in San Francisco. Some years later he exhibited in the National Gallery and the Smithsonian Institution in Washington, D.C.

Not limiting himself to painting alone, Borg taught art in the California Art Institute and in Santa Barbara. He worked in the movie industry as an art director and set designer. During this period of his life he did a series of Western paintings depicting areas in the Coachella Valley.

Borg died in Santa Barbara in 1947. A full-length book on his life and work has been published in Sweden.

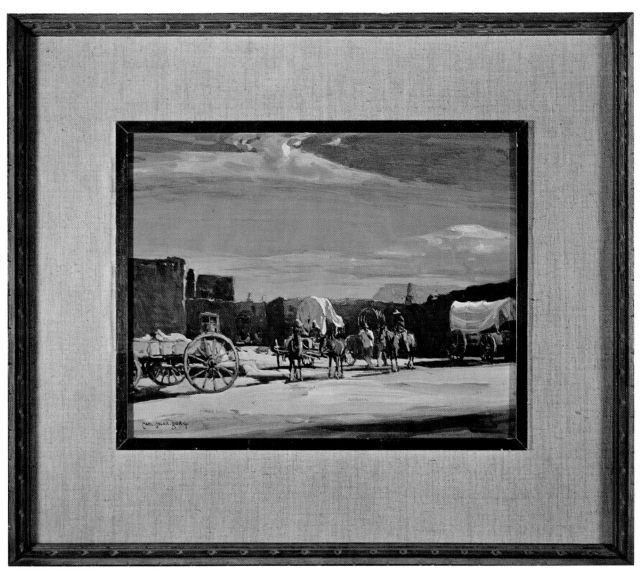

PUEBLO SCENE *Watercolor* 14 x 18 inches

George de Forest Brush NA

1855–1941

HERE WAS AN ARTIST who portrayed the American Indian in a completely different way than his predecessors. Rather than emphasize the warlike and ceremonial aspects of Indian life, George de Forest Brush accented the quiet stoical philosophy of the Indian. His pictures evoke a gentle loveliness and an idealized spiritual quality which he himself tried to achieve in living. These characteristics, combined with his fine draftsmanship, a result of continual practice, mark all of his work. He was the poet-philosopher of American Indian painters.

Born in Shelbyville, Tennessee, Brush spent his early life in Connecticut. His mother, a woman of refined tastes and an amateur portrait painter herself, spent much time and effort in furthering her son's artistic ability. She arranged for him to study at the Academy of Design in New York when he was sixteen. At nineteen he was sent to Paris where he spent six years studying with the renowned Jean Leon Gérôme.

Upon his return to the United States, Brush spent four years traveling and drawing the Crow Indians in Wyoming and Montana. So friendly was his association with them that they allowed him to learn many of their skills and crafts, and witness their religious ceremonials.

In spite of the fame and critical approval that came to him shortly after, he realized few sales from his Indian paintings. To support his family he went back to Europe for a brief time in search of more saleable themes and further study. He developed a contemporary version of the madonna and child motif, and with this he gained further acclaim and financial success. Today, however, his Indian paintings are more highly valued and in greater demand than his madonnas.

He returned to his studio in Dublin, New Hampshire, and spent almost fifty years painting there. He died in Hanover, New Hampshire at the age of eighty-five.

Among the many honors and awards bestowed upon George de Forest Brush were an honorary degree from Yale and membership in the Society of American Artists, the National Institute of Arts and Letters, and the National Academy, which awarded him the first Hallgarten Prize in 1888. He also won several Gold Medals at international expositions.

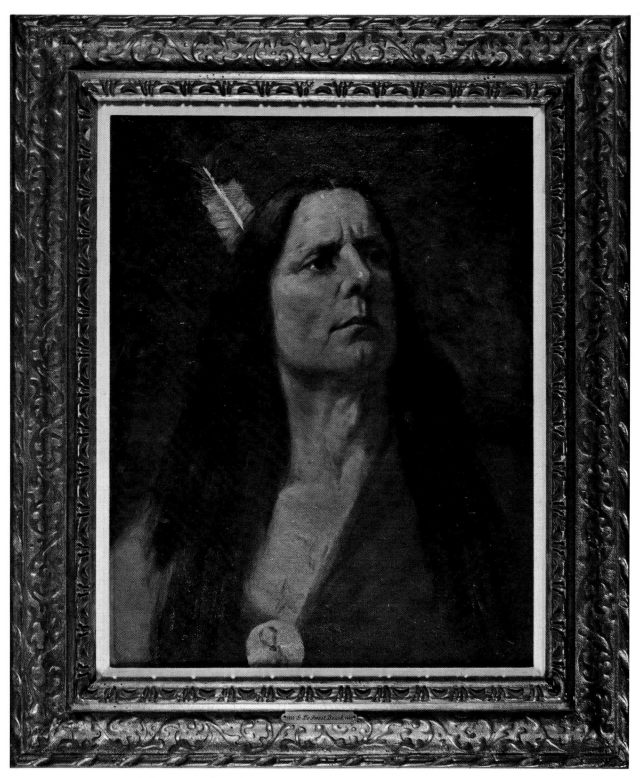

INDIAN CLASSIC *Oil* 22 x 18 inches

Elbridge Ayer Burbank

1858–1949

IT IS FORTUNATE THAT Elbridge Ayer Burbank painted the famous old chiefs when he did, for not long after, many of them were dead or had adopted the white man's way of dressing. As it is, Burbank left a rich and important historical legacy.

Burbank was born in Harvard, Illinois. As a student at the Art Institute of Chicago he won many honors, and upon graduation he accepted a job with the *Northwest Magazine*. One of his assignments was to do Western scenes to promote land sales for the Northern Pacific Railway. Gathering material for this job he traveled the Rocky Mountains, Idaho, Montana, and Washington.

After several years Burbank resigned and went to Munich, Germany for further art training. Among his fellow students were Joseph H. Sharp, William R. Leigh, and Toby Rosenthal, who became a close friend.

Upon his return from Europe he specialized for a time in painting the Negro children of Chicago. Then came a great turning point in his career. Burbank's uncle was Edward E. Ayer, the first president of the Field Columbian Museum, a trustee of the Newberry Library, and the owner of one of the finest private libraries of books on Indian culture in the United States. Ayer commissioned his nephew to do a series of portraits of Indian chiefs prominent at the time. Burbank traveled throughout the West, visiting 128 tribes, and painting the leading figures of each. From Oklahoma he traveled to New Mexico and Arizona painting the Navajo, Hopi and Zuñi. He painted numerous California tribes and later visited the Sioux, Crow, Nez Percé, and Ute tribes. Among those who sat for him were such illustrious personalities as Geronimo, Sitting Bull, Red Cloud, and Rain-in-the-Face.

This trip resulted in approximately 1,200 works, done in oil, watercolor, and crayon. Burbank was unique in that he was one of the few Western artists to employ crayon as a medium for portraiture; his use of it was highly successful, however, for he achieved a freshness and power often lacking in the more conventional oil portraits. This collection, put together after his travels, is now in the Newberry Library in Chicago. Another large group of his paintings is in the Smithsonian Institution.

Burbank died in San Francisco on March 21, 1949.

38

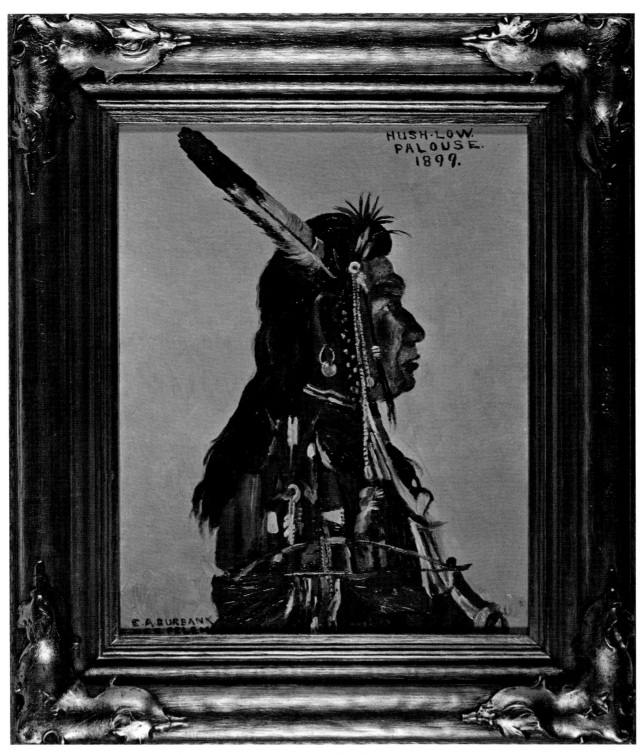

HUSH-LOW PALOUSE *Oil* 12 x 10 inches Dated 1899

George Elbert Burr

1859–1939

DURING A CAREER which spanned almost three-quarters of a century, George Elbert Burr produced some 1,000 watercolors and more than 25,000 etchings, all pulled from his own presses, in addition to oils, lithographs, pencil, wash, and silver-point drawings. In 1906 the *Denver Post* proclaimed him "one of America's leading watercolor workers." He later became famous as an etcher of the Western landscape, and in the field of color etching, he was not only a virtuoso but an American pioneer.

Born in Munroe Falls, Ohio, he began having daily art instruction from his mother before he was six. When he was ten, the family moved to Cameron, Missouri where his father owned a hardware store. In 1870 Burr studied for three months at the Chicago Academy of Design, his only formal art training. In 1884 he married a Cameron girl, Elizabeth Rogers, and by 1890 was doing illustrations for *Harper's, Scribner's, Cosmopolitan* and *Frank Leslie's Illustrated Newspaper*. In the early 1890s he was commissioned to do 1,000 pen-and-ink drawings for the catalog of Heber R. Bishop's jade collection. The earnings from this and other Bishop commissions enabled the Burrs to travel Europe for the next four years, where he did hundreds of sketches, many of which were later translated into watercolors and etchings.

By 1906, when Burr moved to Denver in search of a more healthful climate, his watercolors had been shown in several major cities. The Burrs spent summers in Denver and winters in the deserts of Arizona, New Mexico, and Southern California from which emerged his most famous series of etchings, the "Desert Set." He pulled forty sets, each of which included thirty-five studies. Prior to this he had completed another series, "Mountain Moods," containing sixteen etchings with matching watercolors of Colorado's Estes Park. In 1924 the Burrs moved to Phoenix, where he continued to work until his death at age eighty.

Burr was a member of at least a dozen arts and graphics societies. He was the first president of the Denver Art Association and one of the founders and a president of the Phoenix Fine Arts Association. Some of the major collections of his etchings are in the Metropolitan Museum of Art, Fogg Art Museum, Boston Museum of Fine Arts, New York Public Library, Phoenix Art Museum, Arizona State University at Tempe, Denver Public Library, and the British Museum in London.

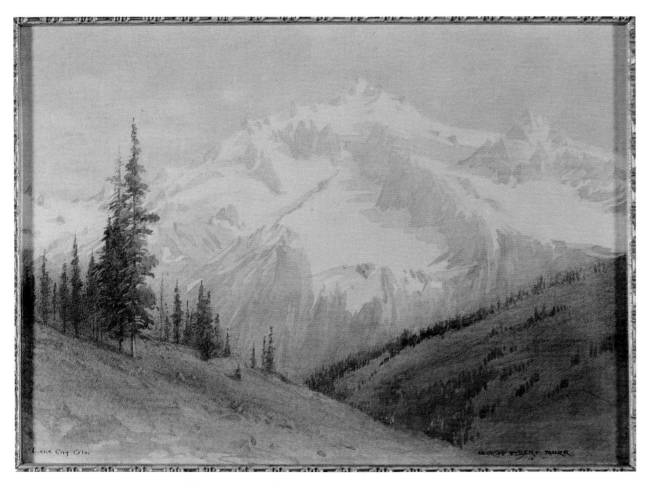

LAKE CITY, COLORADO *Watercolor* 8 x 11 inches

William de la Montagne Cary

1840–1922

BORN IN TAPPAN, NEW YORK, most of William de la Montagne Cary's early life was spent in Greenwich Village. As a teenager he was contributing illustrations to such magazines as *Harper's Weekly*, *Leslie's*, and *Appleton's*. He worked in oil, watercolor, pen-and-ink, black and white wash, and in later years did some seventy wood-engraved illustrations for five of the popular books of the day, in addition to etchings on copper plates for Currier and Ives and other publishers.

In 1861 when he was twenty-one years old, Cary made his first trip to the West accompanied by two friends, W. H. Schiefflin and E. N. Lawrence. Traveling by ox-wagon, steamboat, and stagecoach he went to St. Louis, Fort Union, Fort Benton, across the Rockies to Walla Walla, south to San Francisco, and eventually returned to New York by way of Panama. This journey was an important turning point in his life, for the adventure and excitement he encountered inspired him to spend the next fifty years painting scenes of Indian and pioneer life. Over thirty years later, Schiefflin gave an account of this trip in a four-part serial in *Recreation* magazine, accompanied by Cary's illustrations.

Cary made another trip to the West in 1874 and this, too, resulted in innumerable sketches and paintings. Even though his home remained in New York, life on the frontier was the subject he chose to depict. His son, Clinton Cary, recalled that in later years at their New York home, a young neighbor, Teddy Roosevelt, would frequently come over to listen to Cary's stories about Western life.

On his travels he often drew famous leaders of the Plains from life, among them Buffalo Bill, Custer, Sitting Bull, and Rain-in-the-Face. Having a sharp eye for the unusual, he nevertheless executed his canvases with such careful attention to realistic detail that they came to be regarded as important historical documents. Perhaps his most important contribution was his portrayal of Plains Indian customs and ceremonials, such as the funeral procession shown here. His friend Schiefflin wrote: "He painted as he saw things, and not as he imagined them to be. . . . He depicted the Indian true to life, on the spot and in all the local color and atmosphere of his wild state." One of the major collections of his Western paintings is in the Gilcrease Institute in Tulsa, Oklahoma.

Cary died at the age of eighty-one in Brookline, Massachusetts.

42

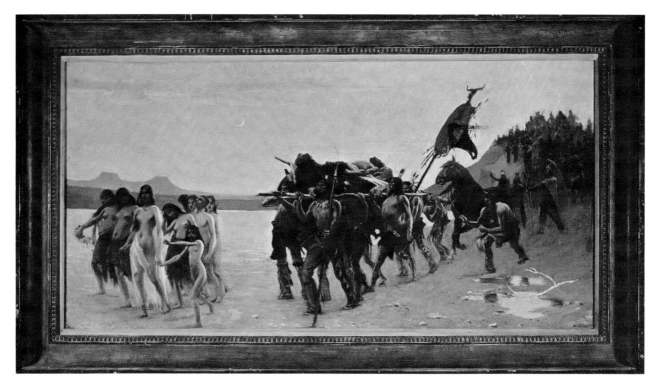

INDIAN BURIAL PROCESSION *Oil* 20 x 40 inches

Gerald Cassidy

1879–1934

TWO CAREERS RAN PARALLEL in the life of Gerald Cassidy and he excelled in both of them. He was considered one of the three best lithographers in America and his paintings gained world-wide acclaim. Raised in Cincinnati, he studied under Frank Duveneck at the old Mechanic's Institute, where he won his first prize in drawing at the age of twelve.

In 1899, faced with a life expectancy of six months because of tuberculosis, he was sent to New Mexico. Later he moved to Denver where he concentrated on the lithographic field, executing many theatrical and circus posters, stage sets, magazine illustrations, and advertisements. He then turned to the fine arts and studied briefly in New York at the Art Students League and the National Academy of Design.

Returning to New Mexico for his health, he settled for a time in Albuquerque, doing illustrations in the style adapted by Howard Pyle and Will H. Bradley from the then popular Lautrec-Steinlen method. Drawings of Indians for reproduction on postcards provided his first source of income in New Mexico. Though the medium was humble, the pictures had a distinctive flair and a sophistication of line and composition which were far different from the pictures of Indians then being done in the Southwest. It was during this second period in New Mexico that he changed his signature from Ira Diamond Cassidy to Gerald Cassidy, placing a sun symbol of the Tewa Indians between his first and last name or between his initials.

Early in 1912 he married sculptress Ina Sizer Davis, and in December of that year moved to Santa Fe, becoming the third artist to establish permanent residency there. He and his wife made numerous trips into the Indian country and the spontaneous sketches and small, personal paintings which he made on these excursions are among his best.

In 1915 the Panama-California International Exposition in San Diego awarded him the Grand Prize and Gold Medal for his murals in the Indian Arts Building. From this date on, he was established as a serious painter; his paintings won numerous prizes and were purchased by major museums throughout the world. In 1945 the Gerald Cassidy Memorial Art Library was created at the University of New Mexico and in 1963, the Cassidy Collection was established in the Bancroft Library of the University of California. He maintained his home in Santa Fe until his death.

44

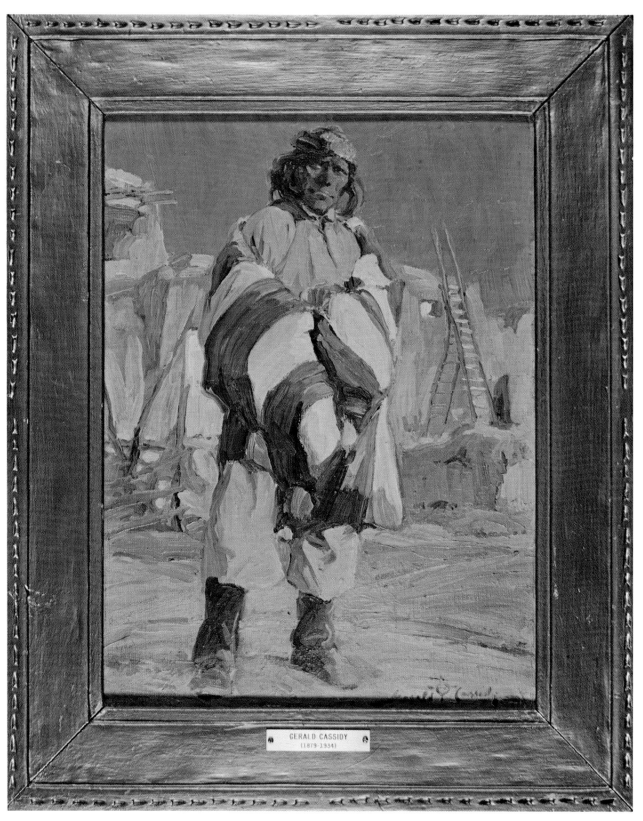

HEMEZ INDIAN *Oil* 16 x 12 inches

Benton Clark

1895–1964

"ROBUST, COLORFUL, ACTION-FILLED" are the adjectives which best describe Benton Clark's paintings. In his approach he owed much to Frederic Remington and the Pyle school of artists whom he particularly admired. Scorning the sweet and photographic, he strove for dramatic effects; this and his love of painting horses made the Western scene especially appealing to him.

His birthplace, Coshocton, Ohio, provided an ideal setting for a budding artist — a beautiful countryside of woods and valleys, three rivers, and the old Ohio Canal with its picturesque warehouses, locks, bridges, and mills. In Clark's youth a few canal boats were still around, and he spent many hours painting them. Another advantage was the fact that a group of artists were employed there by the H. D. Beach Company and the American Art Works. One of these artists, Arthur Woelfle, conducted an art class and gave young Clark his first lessons in painting, later encouraging him to seek further training in New York. Years later, Woelfle, then a noted portrait painter and teacher, said that of all his many students over the years Benton Clark had the greatest natural talent.

In the fall of 1913, Clark went to New York and entered the art school of the National Academy of Design. After several years there, he attended the Art Institute of Chicago. While still a student he made his first sale, a cover for *Baseball* magazine. After that he did paintings for calendar houses, worked for the Stevens Sundblom and the Kling advertising art studios in Chicago, and in 1925 began illustrating for *Liberty* and *Outers' Recreation* magazines.

In 1932, when he returned to New York he was made a member of the Society of Illustrators, and illustrated for most of the leading magazines: *Saturday Evening Post, McCall's, Cosmopolitan,* and *Good Housekeeping.* For many years he and his brother, Matt Clark, also a noted illustrator, shared a studio. Clark remained in New York for the rest of his career with the exception of a few months in Chicago, a short time in California when he worked in the art department of the M.G.M. Studios, and brief trips to the South and West for background material.

Benton Clark died in Coshocton a month before his sixty-ninth birthday. At the time he was preparing to do a mural for his old high school, depicting a historic event that took place near Coshocton in 1764.

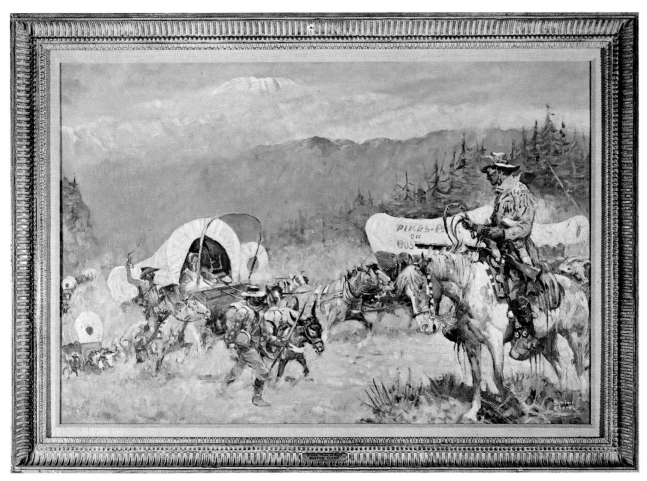

PIKE'S PEAK OR BUST *Oil* 24 x 36 inches

Howard Cook NA

b. 1901

AT TWENTY-FIVE Howard Norton Cook made his first trip west when he was sent to New Mexico on an assignment for *Forum* magazine. There he fell in love not only with the artist, Barbara Latham, whom he married the following year, but with the Santa Fe-Taos area, which eventually became his permanent home.

A native of Springfield, Massachusetts, Cook went to New York in 1919 where he received his formal art training at the Art Students League. He then traveled extensively in Europe, North Africa, Turkey, Central America, Japan, and China, and utilized his proficiency in the graphic arts by contributing drawings and woodcuts to the *Atlantic Monthly*, *Scribner's*, *Harper's*, *Survey*, and *Forum*.

Twice the recipient of Guggenheim fellowships in the early 1930s, Cook spent a year and a half painting in Taxco, Mexico. His second fellowship took him to the Deep South. He depicted its folkways and Negro life in drawings, prints, and paintings which are now in the Georgia Museum of Art and the J. Frank Dobie Collection, University of Texas.

Cook also excels in murals and his work in this medium may be seen in the post offices of San Antonio and Corpus Christi, Texas; the Law Library in Springfield, Massachusetts; the Federal Building of Pittsburgh, Pennsylvania; the Mayo Clinic in Rochester, Minnesota. Others were in the old Hotel Tasqueño, Taxco, Mexico. In 1937 he was awarded the Gold Medal for mural painting by the Architectural League of New York.

During World War II Cook served in the South Pacific as an artist-war correspondent. His paintings of the area were exhibited by the War Department at the National Gallery of Art in Washington, D.C. and later shown throughout the United States in a traveling exhibition.

Rounding out his comprehensive career in art, Cook has often served as a guest professor in various universities and art schools. Included among his numerous awards are purchase awards from the Metropolitan Museum of Art in New York, the Philadelphia Art Museum, the Dallas Museum of Fine Arts, and the National Academy of Design. In 1967 he was appointed the first artist-in-residence at the Roswell Museum, Roswell, New Mexico. The frame on this painting was brought to Cook by Ernest Blumenschein when he returned from one of his Paris trips.

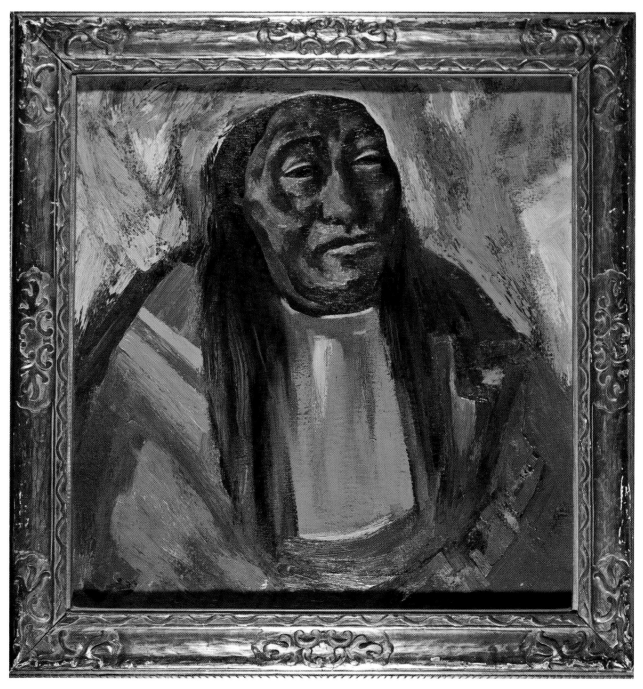

WAR CHIEF *Oil* 31 x 30 inches

A. D. M. Cooper

1856–1924

RELATED AS HE WAS TO SOME of the most distinguished men in the history of the West, it is not surprising that Astley D. M. Cooper became a painter and historian of the Western scene. His maternal grandfather was Major Benjamin O'Fallon, Indian Agent for the Missouri River tribes, and a friend of George Catlin. Cooper's great-uncles were the famous frontier soldier George Rogers Clark and the explorer William Clark. O'Fallon had commissioned Catlin to do portraits of prominent Indian chiefs, and these so impressed young Cooper that he decided he, too, would become an artist.

As a boy in St. Louis, Missouri, where he was born, he was interested in studying about life on the Western frontier. Throughout the years he continued his pursuit and in time became an authority on this aspect of American history. After completing his early schooling, he attended Washington University in St. Louis, then spent two years in Colorado.

Before he was twenty-one years old Cooper had painted a number of Indian chiefs' portraits which attracted favorable attention in the art world. Though maintaining his connections with art dealers in Chicago, Philadelphia, and New York, he moved to San Jose, California, in 1883. There he established a studio noted for its Egyptian style architecture; it became a visiting place for art lovers from all over the world, who were graciously received by Cooper and his wife Charlotte.

Long hours at his sketch table and easel followed, and Cooper finally achieved fame through being frequently published in Frank Leslie's periodicals. Frank Leslie was one of the most astute publishers of the day, having an uncanny feel for what the public wanted. He often said, "Never shoot over the heads of the people." Apparently Cooper's work was the kind the people understood and appreciated, for it soon commanded wide sales both in this country and in important galleries of Europe.

Wildlife of the West was the subject of his most interesting and popular work, though he also did fine portraits, as in the studies of the Indian chiefs and several done of General Grant who visited Cooper's studio in California.

Cooper belonged to the Salmagundi Club of St. Louis, and was an early member of the San Francisco Art Association. He resided in San Jose for forty-one years and died there in September, 1924.

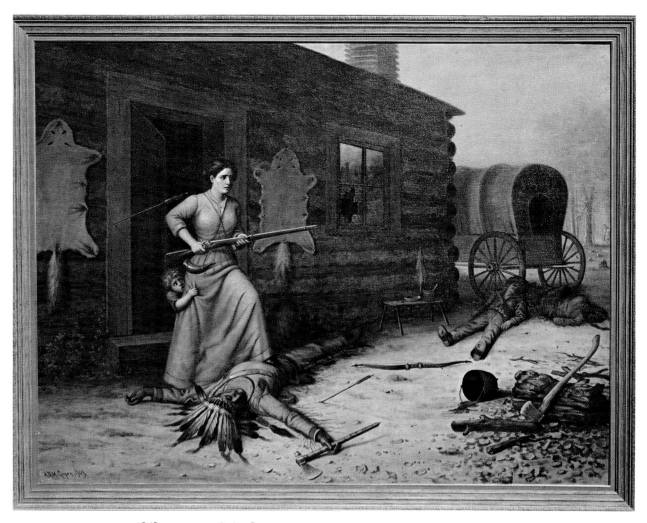

THE OLD GUARD *Oil* 72 x 108 inches

E. Irving Couse NA
1866–1936

PROPHETICALLY, THE FIRST SUBJECTS that Eanger Irving Couse chose to sketch were the Chippewa Indians who lived around his hometown of Saginaw, Michigan. Indians remained his favorite subject matter throughout his long and successful career. The son of a poor hardware merchant, he painted houses and barns to earn enough money for art school. At the age of eighteen he attended the Chicago Art Institute and later, the National Academy of Design in New York, where he won two major awards in two years.

In 1887 he went to Paris to study at the *Académie Julien* under Robert Fleury and Adolphe Bouguereau. It was Bouguereau who was largely responsible for his superb draftsmanship and classical technique. Couse returned to Paris many times in subsequent years and on one of these visits married Virginia Walker, a fellow student at the *Académie*. Returning to America, they went to the Walker ranch in northeastern Oregon where Couse painted the Klikitat, Yakima, and Umatilla Indians. Since there was little market for Indian portraits at that time, they returned to France and settled in the province of *Pas de Calais* on the English Channel. There Couse devoted his talents to the more marketable pastoral scenes. His son, Kibbey, who was born in France, recalled that the family referred to this as his father's "sheep period."

Couse visited Taos for the first time in 1902, having heard of its artistic potential from Joseph Sharp while in Paris. It proved to be a most propitious event. In Taos he found the perfect subject matter; his paintings began to take on more color and new authority. In 1912, when the Taos Society of Artists was formed, he was elected president, and in 1927 the family established a year-round home there. His wife died two years later, and though he continued to paint, he never fully recovered. He died in Taos, April 24, 1936; in June the Santa Fe Museum held a retrospective show of his works in memoriam.

Couse won award after award and was a member of innumerable art and social societies. His poetic interpretation of the Taos Indian with clay pottery in the firelight, or the tall white trunk of the aspen tree as a background for the glowing flesh of the Indian became familiar to thousands. Two of his favorite models were Ben Luhan and Geronimo Gomez. In this painting, the center Indian was modeled by Gomez.

52

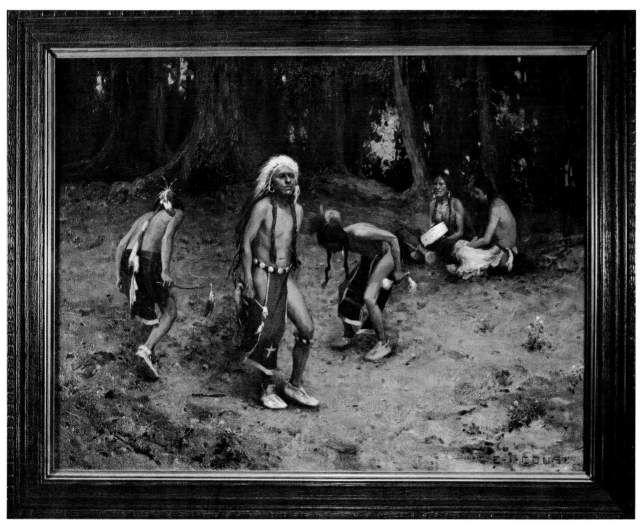

WAR DANCE AT GLORIETTA *Oil* 35 x 46 inches

Charles Craig

1846–1931

THE INDIAN PAINTINGS OF Charles Craig are characterized by ethnological accuracy and authentic detail, for he spent a great deal of time actually living among the Indians.

Western exploration and Indian life captured his imagination as a boy in Morgan County, Ohio, where he was born. He was inspired to paint when he saw an illustrated book and made his first colors from a lump of indigo, macerated cornstalks, ground pebbles, and gaboge from a doctor's medicine bag. For his canvas he used an old bedsheet covered with flour-paste and linseed oil, which, when dried, made the sheet taut; a coat of white oil paint completed the canvas. In his late teens he went to northern Illinois, where he spent four years living among various tribes, learning their way of life and attempting to record it.

Realizing that he lacked the technical ability to achieve a high standard of work, he returned to Zanesville, Ohio, where he maintained a studio until he had saved enough money to attend the Philadelphia Academy of Fine Arts. After completing his training there, he studied with Thomas Moran's younger brother, Peter, who was also a painter of Indian life.

In 1881, Craig moved to Colorado Springs, Colorado, where he established a permanent studio and lived for the rest of his life. He and Harvey O. Young were the first resident artists of the town, and as it was already popular as a health resort they had a ready-made clientele. As a good friend of the manager of the Antlers Hotel, Craig displayed his paintings there for many years and made a daily habit of mingling with the guests, who were the greatest prospects for his oils. When the old hotel was destroyed by fire in 1898, eleven of his canvases were lost.

Taking an active part in the art circles of Colorado, Craig was not only a practicing artist, but directed exhibits and activities in Pueblo and Denver as well as in Colorado Springs. He also gave art lessons and still managed to spend time with the Indians on the reservation, increasing his knowledge of their culture and improving his technique.

Craig's paintings are now scattered throughout private collections all over the United States and Europe. One of his best known paintings is "Custer's Last Charge," which he executed from a description of the fight, and Indian artifacts recovered from the battlefield. Some of his work may be seen as illustrations for the book *Lo-To-Kah*, by Verner Z. Reed.

54

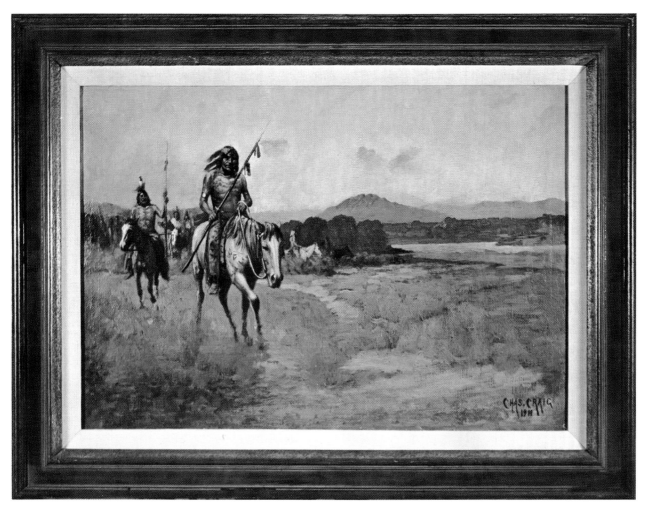

HUNTING PARTY *Oil* 18 x 26 inches

Henry H. Cross

1837-1918

THERE IS A PARALLEL in the lives of R. Farrington Elwell, Robert Lindneux, and Henry H. Cross — all three had their first glimpse of Indians, cowboys, and horses under a circus tent, and were stimulated to travel the Western frontiers to see the real thing for themselves. And like Lindneux, Cross was befriended and encouraged by Rosa Bonheur. For a time he studied animal painting under her expert guidance.

A native of New York, Cross had the look of a conservative businessman; he was plump, wore rimless glasses, a walrus moustache, and usually the traditional chesterfield. But his appearance did not express his true nature, which was an adventurous one. Twice in his youth he succumbed to the lure and glamour of traveling circus shows and ran away with them. When only sixteen he made his way to Paris, and it was there that he received training from Bonheur.

Upon his return to the United States his fascination with the circus once again led him to join a show which was traveling westward. On this trip he saw real-life Indians, but they were tame and civilized spectators who came to see the performance — not the wild and savage creatures of his imagination. After working for a time painting wild animals on P. T. Barnum's circus wagons, his desire to see the raw, untamed life of the frontier became so strong that he quit his job and headed west.

During the years that followed, Cross roamed the Western territory, undaunted by Indian uprisings. Constantly painting wherever he went, he left a rich legacy in his portrayals of white scouts, cavalrymen, and especially of Indian life and Indian chiefs prominent at the time. He became particularly involved with the Sioux tribe and learned their language. His portrait of the famous Sioux chief, Red Cloud, who caused the U.S. Army so much discomfort, is considered one of his best.

The Gilcrease Institute of Tulsa, Oklahoma has one of the most comprehensive collections of his Indian chief portraits. Other examples of his work are to be found in the Chicago Historical Society and in the State Historical Society of Wisconsin.

In style his portraits were rather formal with much attention paid to detail and accuracy of dress. "Buffalo Bill" Cody, who knew prominent artists of the era, said of Cross' work, ". . . Striking likenesses . . . sketched from life by the greatest painter of Indian portraiture of all times."

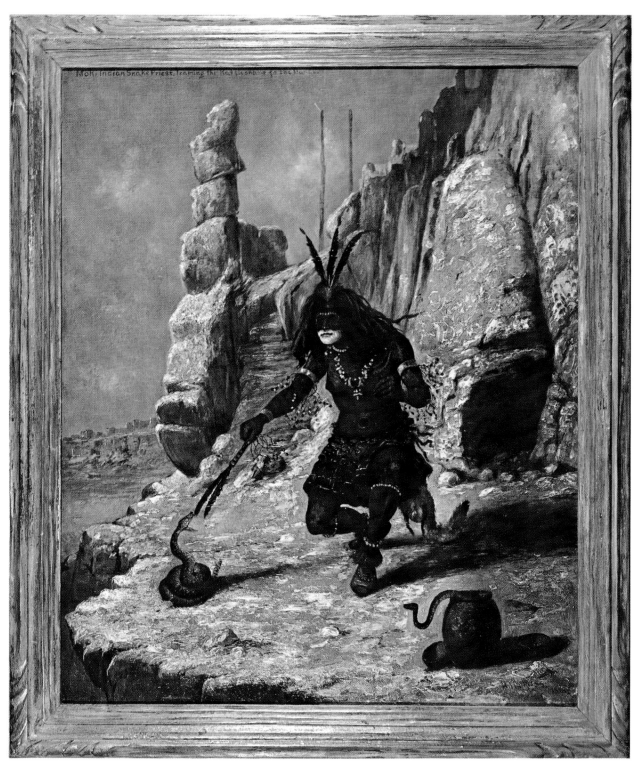

MOKI INDIAN SNAKE PRIEST TRAINING THE RATTLESNAKE TO THE DANCE

Oil 30 x 25 inches Dated 1898

Andrew Dasburg

b. 1887

MORE THAN ANY OTHER PAINTER in the Taos or Santa Fe group, Andrew Michel Dasburg influenced and shaped the work of his fellow painters. Among those who felt the impact of his teachings and style were Kenneth Adams, Victor Higgins, Ward Lockwood, and Cady Wells.

Born in France, Dasburg came to America when he was five years old, receiving his elementary education in the public schools of New York. He took his art training at the Art Students League under Kenyon Cox and Frank DuMond, and at the New York School of Arts under Robert Henri, who later painted in Santa Fe. In 1907 at the Art Students League, he was awarded a scholarship to study landscape painting with Birge Harrison at the League's summer school in Woodstock, New York. Later Dasburg taught at the League, both in New York City and Woodstock.

It was during a stay in Paris in the first decade of the twentieth century that Dasburg realized the significance of Cézanne and Cubism. This made a tremendous impression on his own work and, subsequently, on that of his students and admirers. In 1910 when he returned from Paris, he met Henry Lee McFee in Woodstock. McFee was the first person Dasburg had met in the United States who talked about the work of Cézanne and the two men became close friends. Soon Dasburg became one of the leading exponents of abstraction, and in 1913 his work was represented in the historic New York Armory show which was to change the course of American art.

In 1917, at the urging of Mabel Dodge Luhan, Dasburg went to Taos. From that time on, he spent several months of each year in Taos or Santa Fe and in 1930, became a permanent resident of New Mexico.

From the very beginning, he was excited and stimulated by the New Mexico landscape, particularly by the dramatic effects left by the age-long batterings of wind and rain. He began to apply cubist techniques to its mountains and valleys with a strong emphasis on rhythm and form. This re-casting of nature, peeling away the recognizable superstructure to achieve a pure aesthetic emotion, introduced a new and sophisticated approach to the New Mexico painters.

Andrew Dasburg is represented in almost every major anthology of modern American art, and his works are in museum collections throughout the country. He continues to live and work in Taos.

58

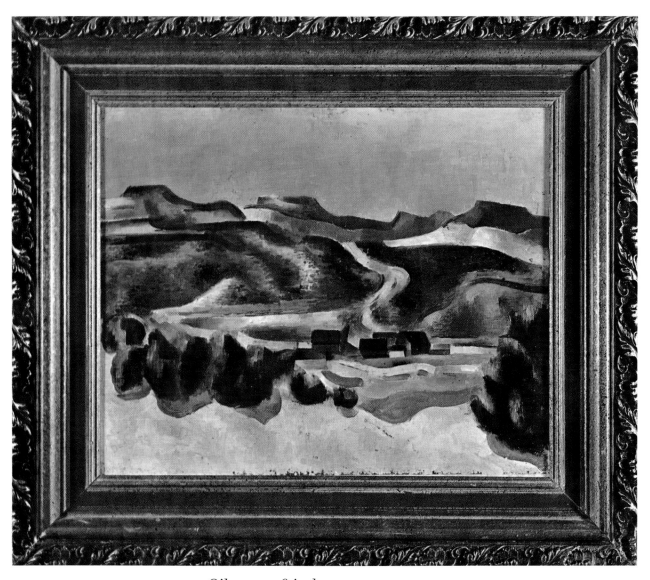

EAGLE NEST, NEW MEXICO *Oil* 13 x 16 inches

Randall Davey NA

1887–1964

ALTHOUGH HE STUDIED ARCHITECTURE at Cornell University, with the intention of a career in that field, Randall Davey switched to fine art — a fortunate decision for the countless admirers of his work.

The birthplace of Davey was East Orange, New Jersey. After leaving Cornell, he studied at Robert Henri's School of Painting and at the Art Students League in New York. In later years he taught at the Chicago Art Institute; the Broadmoor Art Academy in Colorado Springs, Colorado; the Kansas City Art Institute; and at the University of New Mexico.

His first contact with New Mexico occurred in 1919 when Davey, John Sloan, who was another of Henri's disciples, and their wives took an extended trip to the West in a Simplex open touring car. Arriving in Santa Fe, they were delighted with the clear lucid air, the Spanish architecture, and the surrounding countryside. The Daveys decided to settle there, and converted an old mill not far from town into a studio.

In Santa Fe, Davey found artistic fulfillment in the Western rural atmosphere, the inspiring scenery, and the stimulating company of other artists in residence there. Because of his strong and favorable influence on his colleagues, and perhaps also due to his close association with Henri and Sloan, he was held in high esteem by the Santa Feans. A sophisticated and extroverted man of much charm, Davey brought an aura of internationalism to the social and artistic scene of this New Mexican town. Surprisingly, he seldom painted Indians; he found that the nude, which he did in a post-impressionistic style aglow with bright and gay colors, was a subject which strongly appealed to him. His second wife, Belle, was the model for many of his nudes.

Not only an easel painter, Davey received numerous commissions for murals, some of which may be seen in the Will Rogers Memorial Shrine in Colorado Springs, Colorado, and in the post offices of Claremore and Nimita, Oklahoma. He is represented in museums in New York, Washington, D.C., and Cleveland, as well as in the Delaware Art Center in Wilmington. A dining room of the Broadmoor Hotel in Colorado Springs is named "The Randall Davey Room," in his honor.

He was killed in an automobile accident near Bakersfield, California, and is buried with his wife on their estate in Santa Fe.

60

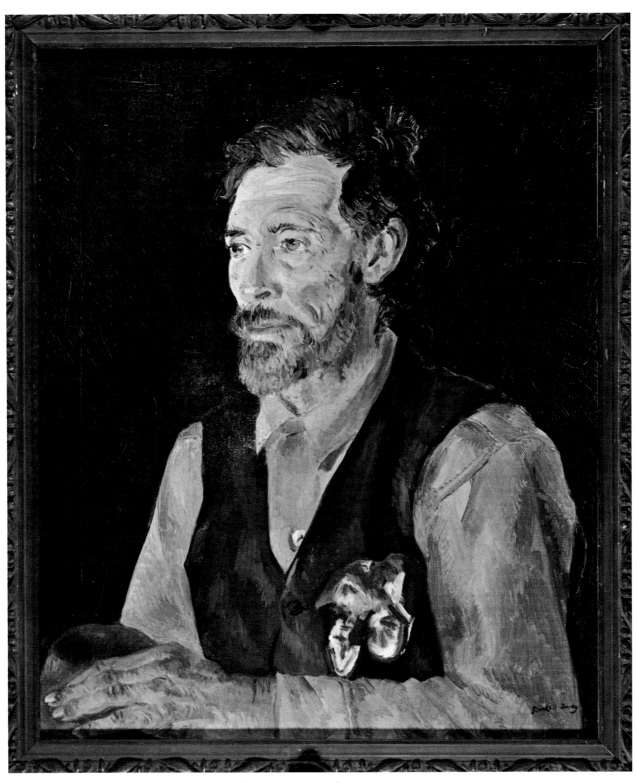

PORTRAIT OF A WESTERN MAN *Oil* 24 x 20 inches

Gerard Curtis Delano

b. 1890

BORN IN MARION, MASSACHUSETTS, only twenty miles from Plymouth Rock, Gerard Curtis Delano has succeeded in bridging the gap between his New England heritage and the Western way of life which he has adopted. The son of a sea captain, Delano was named for Gerard Curtis, the owner of the ship his father commanded.

The sale of a pen-and-ink drawing to *Life* magazine encouraged Delano, who had been drawing Indians and horses since he was four, to take up art as a career. He began training at the Swaine Free School of Design, near his home. In 1910 he moved to New York, worked as a textile designer, and attended evening classes at the Art Students League. There his teachers were Frank Vincent DuMond, Edward Dufner, and George Bridgeman. At the Grand Central School of Art he worked under such noted artists as N. C. Wyeth, Dean Cornwell, and Harvey Dunn.

After completing his education, Delano maintained a studio in New York and worked as an illustrator. His first trip to the West was in 1919. In 1921 he homesteaded in the mountains of Summit County, Colorado. On land beside Cataract Creek he built himself a log cabin studio with a dirt roof. A trip to the Navajo country was a decisive factor in Delano's becoming a Western artist, for there he found his favorite subjects — the gentle and dignified Navajo people in their colorful costumes against the spectacular towering walls of the canyons of Arizona. He paints scenes of the Indians tending their flocks of sheep and goats with a deep understanding of their way of life. He describes his work as "designed realism." Emphasizing subtle coloring and simple, dramatic compositions, he sets a poetic and almost mystical mood which is strictly "Delano."

Researching authentic details for a Western magazine illustration, Delano realized that he needed to be nearer to library materials and wider resources and so he left the homestead and moved to Colorado Springs. Later he established a home and studio in Denver, where he now lives in the winter. During the summer months he and his wife, Blanche, reside at their home in Opdike, Illinois, Mrs. Delano's home town. But even when he is back there Delano continues to paint scenes from sketches made on trips in the West. His work has been featured in *Arizona Highways*, *True West* magazine, *American Artist*, a Walter Foster book, and is represented in numerous important collections.

FRIEND OR FOE *Oil* 22 x 38 inches

Maynard Dixon

1875–1946

SURROUNDED BY THE VAST FLATLANDS of his birthplace in Fresno, California, Maynard Dixon began sketching at the age of ten. Frail health restricted his childhood amusements to sketching trips with his pony, reading, and listening to the local old-timers' tales of the early West.

By the time he was sixteen, he had sufficient confidence in his work to send his sketch book to Frederic Remington, his illustrator hero, who replied with two encouraging letters. At eighteen, spurred on by the encouragement and advice of Remington, he enrolled in the San Francisco School of Design. Before he was twenty he was working as a newspaper and magazine illustrator in San Francisco.

One of his strongest convictions as an artist was: "If doubtful of your work, return to nature and renew your vision." It was advice which he, himself, followed diligently all of his life. When he was not working on a commission in his San Francisco studio, and later at his Tucson, Arizona studio, his time was spent on painting and sketching trips, which eventually encompassed every state in the West. From these extensive field trips and the insights they produced, he evolved a mastery of his material and a highly distinctive style — the architectural structuring of bold masses combined with dynamic composition and vibrant coloring.

During the 1930s, deeply moved by the many dislocated and tragic victims of the Depression, he did a series of powerful paintings which are a departure from his usual subject matter. Some of the most memorable are "Scab," "Destination Unknown," and "Keep Moving."

Dixon's style, with its strong, dramatic forms and clear, vivid colors, was perfectly suited to murals and he painted many of them. Two of his outstanding works in this medium were painted in 1939 for the Department of Indian Affairs in Washington, D.C. In 1946 he prepared sketches for a large mural of the Grand Canyon for the city ticket office of the Santa Fe Railroad in Los Angeles. Already extremely ill, he nevertheless managed to supervise the execution of this last work at his Tucson studio. Within a month after its completion, he died.

Maynard Dixon's many works: sketches, drawings, paintings, illustrations, and murals, attest to the deep understanding he had of his subjects — primarily the desert and its inhabitants, the Indians, early settlers, and cowboys.

PLAINS INDIAN IN WARBONNET

Watercolor 24 x 12 inches

Harvey Dunn NA

1884–1952

HARVEY DUNN WAS BORN IN A SODHOUSE just off the main buffalo trace, south of Manchester in Dakota Territory. In later life he was to say of his work: "I find that I prefer painting pictures of early South Dakota to life of any other kind, which would seem to point to the fact that my search of other horizons has led me around to my first."

He worked on his father's farm until the age of seventeen, when he decided that he wanted to paint the beautiful and moving scenes around him. Studying art at Brookings, South Dakota, he received encouragement from a young art teacher named Ada B. Caldwell, who taught him "to put his eyes on the horizon and his feet on the ground." After two years of study at the Art Institute of Chicago, he was invited by Howard Pyle, then America's foremost illustrator, to work at his school in Wilmington, Delaware, and at his summer school in Chadds Ford, Pennsylvania. Of Pyle's teaching, Dunn said, "His main purpose was to quicken our souls that we might render service to the majesty of simple things."

Dunn married Tulla Krebs in 1908 and they had two children, Robert and Louise. His career flourished; he became an illustrator of leading magazines and books, as well as a painter of portraits and murals. During World War I he served as an official war artist depicting the American Expeditionary Force in France. Twenty-four of these paintings are now in the Smithsonian Institution.

After the war he and Charles S. Chapman conducted the Dunn School of Illustration in Leonia, New Jersey. Among their pupils were Dean Cornwell, Mario Cooper, Arthur Mitchell, and Harold Von Schmidt. Even before his death at his home in Tenafly, New Jersey, Dunn's helpfulness to his students and other aspiring artists was legendary.

Among his best known paintings are "The Prairie is My Garden" and "Something for Supper," both of which are in the Dunn collection at South Dakota State College in Brookings. In the book, *Harvey Dunn: Painter of Pioneers*, Edgar M. Howell accurately assesses Dunn's approach: ". . . he did not focus on the lusty life of the frontier, its far-ranging hunters and explorers, its bad men and marauding Indians. He looked beneath this thundering drama to paint a no less heroic, God-fearing people who brought the Bible and the plow to the Middle Border — that area which includes the Dakotas and Nebraska."

THE CHUCK WAGON *Oil* 16 x 36 inches

W. Herbert Dunton

1878–1936

THE SIXTH CHARTER MEMBER of the Taos Society of Artists, William Herbert Dunton, known as "Buck" to his friends, was among those fortunate people who make a livelihood out of their greatest pleasures. This happy combination began in his birthplace, Augusta, Maine, where he spent his childhood roaming the woods and fields with gun, sketchbook, and pencil. As his mother said, "He was using a pencil before he had mastered successfully the use of a teaspoon." By the time he quit school, at the age of sixteen, he had already been selling drawings and stories to the local newspapers and magazines.

From 1896, when he was eighteen, to 1911, he went west every summer, traveling from Oregon to Old Mexico, working on cattle ranches, hunting, and sketching the life of the cowboy for his thriving illustrating career in New York, where he spent his winters. He produced illustrations for sporting magazines, wrote and illustrated stories of his own, and did countless covers for *Harper's Weekly*, *Woman's Home Companion*, *Saturday Evening Post*, *Cosmopolitan*, and many other major magazines. In addition, he illustrated forty-nine books, mainly about the West. Among them were such classics as Zane Grey's *Riders of the Purple Sage* and *Under Western Stars*.

Returning to school spasmodically, he studied at the Cowles Art School in Boston and at the Art Students League in New York where he worked under Fred Yohn, Frank DuMond, and Ernest Blumenschein. By the age of thirty-four, having built up an enviable reputation and accumulated a fortune, Dunton was tired of the confining city life. Following Blumenschein's advice, he and his wife moved to Taos in 1912.

There he studied further with Blumenschein and also Leon Gaspard and spent over twenty productive years — hunting, camping out, studying wildlife, doing lithographs of animals, portraits of old-timers and cowboys, paintings of the Western landscape, and continuing his own creative writing. Though his paintings were literal, reflecting his long training as an illustrator, they had a carefully researched authenticity and a tremendous appeal.

Dunton died in Taos at the age of fifty-seven, leaving behind an unfinished autobiography which he had titled, "The Story of a Happy Life."

READY FOR THE KILL *Oil* 20 x 28 inches

Charlie Dye CA

b. 1906

BROUGHT UP NEAR Cannon City, Colorado, where he was born, Charlie Dye had sketched all of his early life, but it was not until a big black bronc fell on him that he seriously considered art as a career. While in the hospital recuperating from his injuries, he discovered the paintings of Charles Russell reproduced in a magazine and was inspired to become a professional artist. He wanted to portray the life of the cattleman, which he remembered from his days of riding with the old-time cow outfits.

After studying at the Chicago Art Institute and the American Academy, he went to New York where he was strongly influenced and helped by Harvey Dunn, a great illustrator, and Felix G. Schmidt, an instructor who later became a close friend and business partner in a commercial studio.

Dye's work improved to such an extent that he became an illustrator for such magazines as the *Saturday Evening Post*, *Argosy*, *Outdoor Life*, and *The American Weekly*. On a trip to California he was impressed by the lack of significant Western art and decided that he could do better. He soon began selling enough to pay for vacations in the West and established a studio in his home state of Colorado. Not long afterward, Dye left New York and moved to Colorado where he became a partner in the Colorado Institute of Art in Denver.

The demand for his paintings precluded his giving enough time and attention to his teaching, however, and in 1960 he and his wife Mary moved to Sedona, Arizona, where he now lives, devoting all of his time to painting. His work is as robust and colorful as his own personality; his canvases are truthful, rich in detail, and exciting representations of ranch life.

The Cowboy Artists of America was formed in Sedona in 1965, and is a group of outstanding contemporary painters and sculptors of the Western scene. Charlie Dye, one of the original five founders, became the second president of the association, which has grown in membership. Its members exhibit annually at the Cowboy Hall of Fame in Oklahoma City where Dye won first prize at the Cowboy Artists Show in 1967.

ARIZONA TERRITORY *Oil* 24 x 36 inches

Nick Eggenhofer CA

b. 1897

SINCE WESTERN STORY MAGAZINE gave him his first illustrating commission in 1920, Nick Eggenhofer has turned out an estimated 30,000 paintings and drawings, establishing him as one of the most prolific artists of the Western scene. His work is noted for its historical accuracy, the product of careful research, and in the field of early Western transportation, he is recognized as one of the country's leading authorities.

Though born in faraway Gauting, Bavaria, Eggenhofer was exposed to the romance of the American West at an early age, for Europeans were still talking about Colonel "Buffalo Bill" Cody's tour of Europe with his Wild West Show. As a child he displayed an interest in drawing and in cowboys and Indians. With the arrival in Europe of the first American Western movies, his interest was heightened still more. The Eggenhofer family came to the United States in 1913, and three years later he enrolled in night art classes at the Cooper Union in New York. During the day he studied lithography at the American Lithographing Company, which provided a training ground for many other prominent artists.

After completing his studies, he turned to magazine and book illustration for his livelihood. Commissions were abundant, and over the years he illustrated hundreds of stories and articles by the foremost Western writers of the period. His skillful and faithful representations of the Western scene enhance some thirty-five books, among them Ramon F. Adam's *The Old Time Cowhand* and *Come and Get It*. In addition Eggenhofer has written and illustrated a book of his own, *Wagons, Mules, and Men: How the Frontier Moved West*, one of the most comprehensive and detailed volumes on the various pack animals, wagons, carts, and stagecoaches used for transport in the Western movement. He has made numerous models of these early vehicles, and a series of ten scale models of Conestoga Wagons, which he had done as a research project, are now on display at the Whitney Gallery of Western Art in Cody, Wyoming.

In time, Eggenhofer was able to turn his talents exclusively to easel painting and now his paintings are in greater demand than he is able to supply. In the 1960s he moved from his home in West Milford, New Jersey and settled in Cody, the town named after the man who first inspired his interest in the West.

'A PELOUSE' HORSE *Watercolor* 16½ x 12½ inches

R. Farrington Elwell

1874–1962

AS A CHILD IN MELROSE, MASSACHUSETTS, Robert Farrington Elwell sketched, and molded figures in clay and snow, but it was a chance meeting with Colonel "Buffalo Bill" Cody that altered and gave direction to the course of his life. On an assignment for the *Boston Globe*, young Elwell went to Cody's Wild West Show in Boston to sketch the cowboys, Indians, and horses. He became so fascinated that he attended all the performances to make drawings of these colorful figures. Cody, impressed with his ability and interest, invited him to spend his summers at his Wyoming ranch where he would have more than enough in Western subject matter to fill his sketchpads. Thus was formed a friendship which lasted until Cody's death.

Elwell sold his first sketches at the age of eighteen to the D. Lathrop Company of Boston. By the time he was twenty-two, he had not only vastly improved his talent, but had become so knowledgeable in the ways of ranch life that Cody made him manager of his TE Ranch, a job he held for many years. During this period he also did paintings for magazine illustrations and calendars. It was at the ranch that he became friends with many great personalities of the day — Frederic Remington, Diamond Jim Brady, Theodore Roosevelt, Annie Oakley, and Chief Iron Tail, who made him a member of the Sioux tribe.

Later, Elwell took over the management of Cody's business enterprises — other ranches, hotels, and irrigation projects. But always in his spare time he was sketching and painting, and on his frequent trips back East, seeking contacts with publishers and editors as outlets for his art work. By the time he was twenty-five, his illustrations were appearing in many of the leading magazines and books; several books on life in the West he himself wrote. He received innumerable Western scene and calendar commissions from such companies as U.S. Cartridge Co., Winchester Arms Co., and Brown & Bigelow; his work was also in great demand by lithographers. Throughout his career, Elwell worked towards authentic and realistic presentation of the Old West he recalled so vividly. He employed lively colors and strong action as integral elements of his art.

Elwell made his final studio and home in Phoenix, Arizona, and until shortly before his death at eighty-eight, he exhibited a vigor and youthfulness of spirit which was characteristic of his life as well as his work.

74

JACK-KNIFING THE LEAD TEAM *Oil* 26 x 20 inches

Nicolai Fechin

1881–1955

ALTHOUGH A MAN OF DELICATE HEALTH and a quiet introspective personality, Nicolai Fechin's paintings are bold and dramatic, lavish in their use of brilliant color, and technically so well executed that they remind one of a Renaissance master.

His great ability was the result of natural talent and extensive training over a long period of years. He was the son of a poor wood-carver in Kazan, Russia. After a miraculous recovery from meningitis he spent his boyhood in his father's shop where he learned to draw and carve. Before the age of ten some of his designs of religious icons were so outstanding that his father used them as models in his work. Fechin studied for a time at the Kazan Art School and won a scholarship to the Imperial Academy of Art in St. Petersburg when he was only thirteen. For the next thirteen years he worked diligently at the academy and finally graduated with another scholarship which enabled him to travel about Europe studying the works of the masters.

In 1923, after having endured years of deprivation caused by World War I and the Bolshevik Revolution, Fechin fled to New York with his wife and baby daughter. His fame had preceded him and a show of his work in the Grand Central Galleries brought him into contact with John Burnham and Clyde Forsythe who later helped pave the way to contacts in the West.

After doing portraits and landscapes in New York for several years Fechin visited Southern California and delighted in painting its desert country. Then he settled in Taos where he rented a studio from Mabel Dodge Luhan until his own home was built. In Taos he excelled in painting the colorful Mexicans, Indians, burros, and early cowboys. One of his great passions was drawing hands and he did many sketches of them which are now greatly prized. He also gained fame through his portraits of famous personalities of the day.

Fechin won innumerable awards and honors, but at the height of his career in 1936 he suddenly divorced his wife and left Taos to travel and paint in Mexico, Japan, Bali, and Java. Eventually he moved to Santa Monica, California, where he painted until his death. Delwin Brugger, whose firm in Los Angeles shipped paintings for hundreds of artists, said of Fechin, "He was the only painter I ever called 'Maestro'."

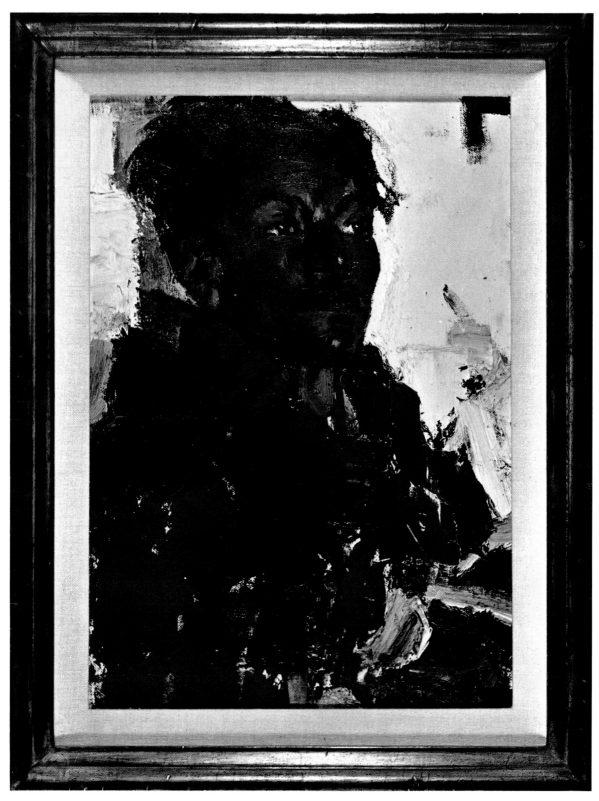

MEXICAN COWBOY *Oil* 17 x 12 inches Dated 1935

Nicholas S. Firfires CA

b. 1917

HAVING WORKED AS A COWBOY riding the range, breaking and training horses since the age of ten, Nicholas S. Firfires is particularly well equipped to portray the Western scenes he does so well.

Born in Santa Barbara, California, Firfires spent his time, when not in school, working on his family's ranch near Santa Margarita and on neighboring ranches in northern Santa Barbara county. As a child he was interested in drawing the animals around him, and after he finished high school in Santa Maria he attended the Art Center School and the Otis Art Institute in Los Angeles.

When the United States entered the war in 1941 Firfires enlisted in the Army and served in Europe with the Combat Engineers. During this time he did many sketches and paintings for Army publications and historical records. He also received commissions to do portraits of military leaders and paintings of combat scenes.

Upon his discharge from the service in 1945 Firfires opened a studio in Santa Barbara, and for a time concentrated on illustrations for Western magazines, though he also worked diligently at perfecting his easel painting technique. In 1960, after his first show in Los Angeles, his paintings received such wide acceptance and acclaim that he has since been able to devote his full time to the field of fine art.

A versatile artist, Firfires depicts both the contemporary Western scene and the historic past. He is especially interested in that period of California history when the Spaniards exerted such a strong influence on Western culture. In either era he chooses to portray, his work is stamped with a sureness of draftsmanship and a vibrant masculine use of color.

In 1969 Firfires won the Silver Medal Award for a watercolor in the Fourth Annual Exhibit of the Cowboy Artists of America at the National Cowboy Hall of Fame in Oklahoma City.

He and his wife, Maxine, live in Montecito, California, near Santa Barbara, and Firfires continues to put in an eight hour day at his studio in Santa Barbara. For the past twenty-four years he has been an active participant in the famous *Rancheros Visitadores*, a group of 500 men who gather in the mountains near Santa Barbara each May to recreate the mission days of the early California *rancheros*.

RIDING HIGH *Oil* 24 x 18 inches Dated 1962

Clyde Forsythe

1885–1962

VICTOR CLYDE FORSYTHE is often referred to as one of the first "Pioneer Painters of the Desert," a distinction he shares with two other native Californians, Maynard Dixon and James Swinnerton. Shortly before Forsythe was born, his family moved from Tombstone, Arizona to Orange, California, and consequently he became heir to the folklore of both areas.

At the age of nineteen he enrolled at the Art Students League in New York and in 1905 obtained a job with the *New York World* as a cartoonist. He spent five years illustrating the articles of Arthur Brisbane, covering fights and other sporting events, and doing comic strips, the most famous of which was "Way Out West." His friends and co-workers were among the most colorful men of the era: Irvin S. Cobb, Leo Carrillo, Grantland Rice, Dean Cornwell, Charles Dana Gibson, Damon Runyon, and Bat Masterson. He also befriended an unknown young artist named Norman Rockwell, encouraged him, and introduced him to the *Saturday Evening Post*, beginning a collaboration which lasted more than fifty years. During World War I he painted many war posters including the unforgettable American doughboy in the flush of victory, entitled "And They Thought We Wouldn't Fight!"

Despite the money and success he achieved in New York, Clyde Forsythe had never lost his boyhood memories of the desert and his desire to paint it. In 1920 he and his wife returned to California to live permanently. There he immersed himself in the culture of the West, living in ghost towns, camping with prospectors, and associating with such "real Westerners" as Charles Russell, Ed Borein, and Will Rogers. The painting he did of Will Rogers on his horse, "Old Soap Suds," was chosen to illustrate Rogers' life story in the *Saturday Evening Post*. He shared a studio in Alhambra with Frank Tenney Johnson and became a joint founder with him of the Biltmore Art Gallery in the then new Biltmore Hotel.

His paintings were so successful in communicating his own vision that people soon began referring to the "Forsythe sky," the "Forsythe clouds," or the "Forsythe prospector."

FLYING HIGH *Oil* 30 x 24 inches Dated 1920

Leon Gaspard

1882–1964

ONE OF THE MOST COMPLEX and exotic styles to be applied to the New Mexican scene was that of Leon Gaspard. The son of a retired Army officer and a brilliant pianist, he was born in Vitebsk, a town west of Moscow. His father had become a rug and fur trader, and early travels with him into the snowy wastes of the Siberian steppes greatly influenced Gaspard's future art. Brilliant Asiatic color tones mingled with snow or snow-like white areas became the signature for much of his work.

He studied art in Vitebsk under Julius Penn along with another young Vitebsk artist, Marc Chagall, and took further study at a government preparatory school in Odessa. While still in his teens he went to Paris where he received a thorough classical grounding in draftsmanship from Adolphe Bouguereau at the *Académie Julien*. During this period he met Modigliani, Pascin, Matisse, and Utrillo who led him toward impressionism, but despite their influence and Bouguereau's training, he went his own way to develop his own highly individual style. When George D. Pratt, founder of the Pratt Institute of Art in New York and a director of Standard Oil, purchased thirty-five of Gaspard's Paris sketches, the young artist achieved a trans-Atlantic reputation.

His career was interrupted by World War I and enlistment in the French Aviation Corps. Serving as an observer, he was seriously wounded when his plane was shot down. In 1916 he and his wife sailed for New York where he exhibited his war sketches, but ill health required him to move to the West and in 1918 they settled in Taos, New Mexico. There Gaspard traveled the desert painting the various Indian tribes and delighting in the outdoor life the region offered. At one point, fellow Taos artist, Herbert Dunton, took painting instruction from him and, in exchange, showed Gaspard the best hunting and fishing spots in the area.

Two years after Gaspard's wife died in 1956, he married artist Dora Kaminsky. After an extensive trip abroad, they returned to Taos where Gaspard settled down to a rigorous daily schedule of painting to meet the increased demand for his canvases. He withdrew his paintings from the commercial galleries and hung them in his two-story adobe home which provided a perfect setting; visitors found it charming and sales were greater than ever. In his late seventies he experienced a new and productive period in his art. He died of a heart attack in Taos.

82

TWINING CANYON NEAR TAOS *Oil* 23 x 15 inches

E. William Gollings

1878–1932

DEATH TOOK ELLING WILLIAM GOLLINGS after a short illness in Sheridan, Wyoming, at the age of fifty-four. His demise at such an early age was a tragic loss to the world of Western art, for his skill in various media and the faithfulness of his representation mark his work as a major contribution.

"Bill" Gollings, as he was known, was born in a mining camp at Pierce City, Idaho. As a boy, he and his brother Oliver drew on slates – usually horses, complete with saddles and bridles. Although his formal schooling did not go beyond the eighth grade, he learned something about art, and he carefully studied Frederic Remington's drawings in *Harper's Weekly*. His admiration of Remington's work was to grow into an idolatry which lasted throughout his lifetime.

From Chicago, where his family moved when he was twelve, Gollings began to roam, taking whatever odd jobs he could find – working on railroad engines and in drafting rooms – but mainly working with cattle outfits, and absorbing every detail of ranch life.

Aside from the slate drawings, Gollings' early artistic endeavors included carving horse heads out of laundry soap, and his first paint set was ordered by mail from Montgomery Ward. He practiced industriously with these materials, and his drawings finally earned him a scholarship to the Chicago Academy of Fine Arts, where he learned to work in oil and watercolor. He also developed a fine technique in etching, much of which he learned from Hans Kleiber of Dayton, Wyoming. Gollings reached a wide audience with his etchings, as many of them appeared on Christmas cards.

He loved being a cowhand, but when he found that there was a market for his artwork, Gollings retired from the range and built a small studio in Sheridan, Wyoming. A brief marriage to Maude Scrivner, when he was forty-one, ended in divorce, and he never remarried. Devoting all his time to his painting, he reproduced the scenes which he himself had lived in earlier days on the plains, signing them in his distinctive way, simply "Gollings," followed by a pony track insignia – a fitting symbol for a man who was so devoted to the West.

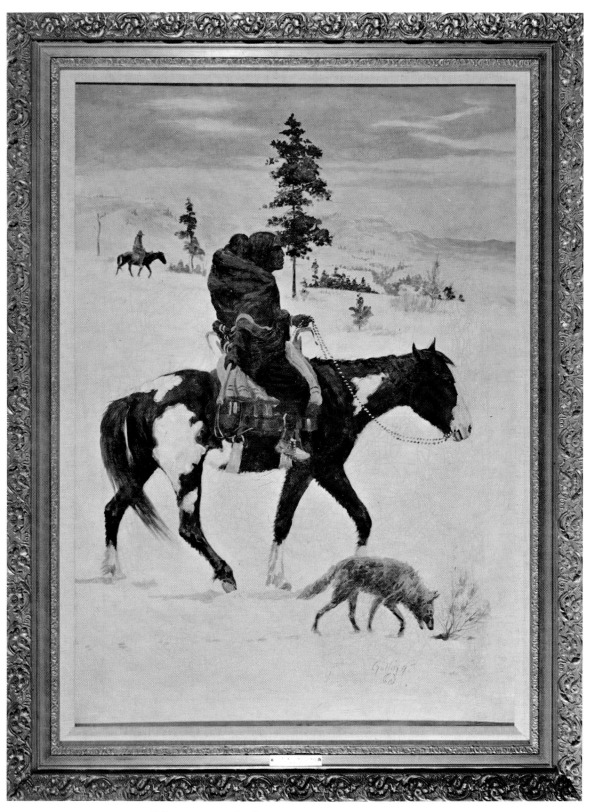

WINTER COUNTRY *Oil* 34 x 24 inches

Joe Grandee

b. 1929

JOE RUIZ GRANDEE is the owner of the largest and most inclusive private collection of Western memorabilia in the country. Aside from his personal fascination with these artifacts, he makes use of them in his paintings to assure complete historical accuracy. An example of his meticulous attention to authentic detail is seen in his well-known painting "The Twenty Mules of Death Valley," which was commissioned by the Borax Corporation. In preparation for this assignment, Grandee visited the U. S. Borax open-pit mine at Boron, California, in the Mojave desert. There he made numerous sketches of the old borax wagons, mule harnesses and traces; he even had several sets of trappings sent to his home in Texas, where he hitched up mules as models. This painting is now on permanent loan to the National Cowboy Hall of Fame in Oklahoma City.

Born in Dallas, Texas, Grandee is the descendant of illustrious ancestors who figured prominently in Texas history. He is the grandson of Castilian-born Benito Grandee, owner of the largest saloon and dance hall in Corpus Christi, Texas. After completing high school, he studied for a time at the Aunspaugh Art School in Dallas. His skill in portraying anatomy, both human and animal, he attributes to Vivian Aunspaugh, who encouraged him in this phase of his training. In his method of preparing his canvas and applying paint, he emulates the Flemish masters.

Grandee has done many military paintings; one of the Pima Indian, Ira Hayes, U. S. Marine Corps hero of World War II, is in the lobby of the U. S. Marine headquarters in Washington, D.C. A citation from the U. S. Cavalry Memorial Association, Inc. reads: "For the many colorful and historically accurate works of art depicting the Dragoons and Cavalrymen of the U. S. Army—for dedication and devotion to immortalizing the horse soldier, honorary membership is granted to Joe Ruiz Grandee."

He is presently engaged in a project to be completed by mid-1971 of six paintings depicting the life of George A. Custer. The paintings will be shown at museums across the country and are scheduled for their final showing at the Custer Battlefield National Monument in 1976.

The official military wedding portrait of Lynda Bird Johnson and Charles Robb was painted by Grandee in an 1880 period setting as requested by the bride.

In 1956 Grandee married and moved to Arlington, Texas.

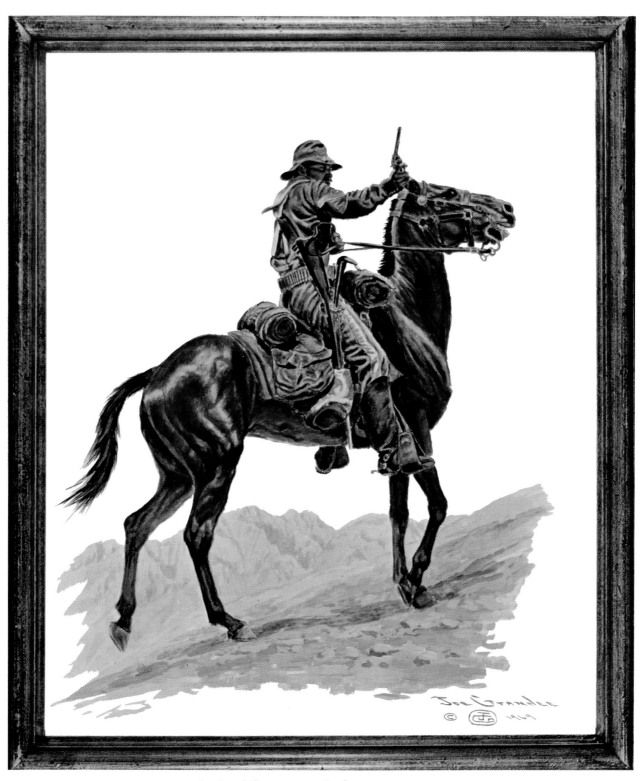

DANGEROUS COUNTRY IN 1876 *Oil* 24 x 20 inches

John Hampton CA

b. 1918

WINNING A CONTEST for sketch artists when he was sixteen was a red letter day for John Hampton. His drawing, a rodeo scene, was published in the *New York World Telegram*. He's been doing rodeo, roping, and roundup scenes ever since.

As a child in New York, Hampton knew that he wanted to be a cowboy when he grew up; he was forever practicing roping fire hydrants with his mother's clothesline. And when he was old enough to manage pencils and crayons he spent a lot of time drawing horses.

When he got his first car, a Model "A" Ford, young Hampton loaded his camping equipment, his sketching and painting materials, and set out to see the West. He arrived in Silver City, New Mexico. At the McMillan Cattle Company Ranch, approximately twenty-five miles west, he worked the roundups, learned the cow business, and practiced his art in his free time.

While he was working at the ranch the news of Japan's attack on Pearl Harbor came and he soon found himself in the Army, where he was trained as an intelligence scout. He saw action in the South Pacific, and came out of the service as a staff sergeant.

Returning to New Mexico after the war, Hampton bought a small ranch near the town of Gila, not far from the McMillan Ranch. He stayed there for twelve years before moving to Arizona, where at various times he has lived in Prescott, Cave Creek, and Scottsdale. Presently he has his home and studio in Phoenix.

While striving to become recognized as a serious painter in oils, he did layouts for Fred Harman's "Red Ryder," for "The Lone Ranger," "King of the Royal Mounted," and also illustrations for some of the pulp magazines.

Finally collectors began to take notice; he received commissions and exhibited in leading galleries. One of his paintings was selected for the permanent collection in the National Cowboy Hall of Fame. Martha McKelvie had him illustrate her books, *The Fenceless Range* and *The Empty Sleeve*. Hampton also attained warm acceptance by his fellow artists — he was one of the original five founders of the Cowboy Artists of America and has served as president of the organization.

88

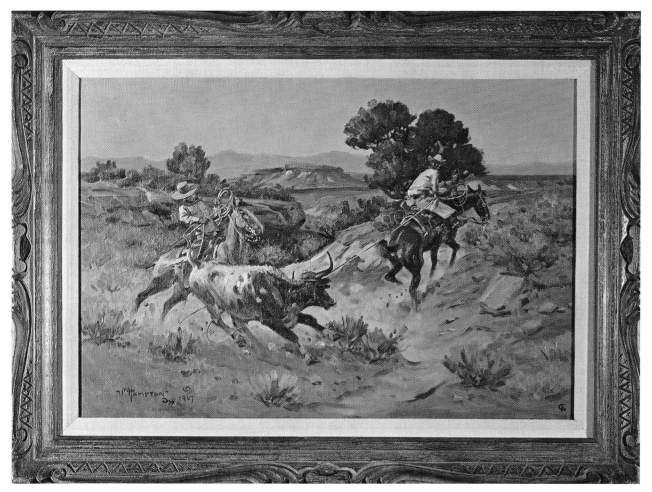

STRETCHIN' OUT *Oil* 20 x 30 inches

H.W. Hansen

1854–1924

THE READING OF James Fenimore Cooper's *Leather Stocking Tales* is partly responsible for Herman Wendelborg Hansen's becoming one of the greatest painters of Western life. For as a boy, in faraway Tellingstat in Schleswig-Holstein on the German-Danish border, he read Cooper's stirring account of the rugged and dangerous life in the American West and was seized with a yearning to see for himself the untamed country which had so fired his imagination. Not until 1879 when he was twenty-five years old was his dream realized.

His father, a school rector who was an excellent draftsman, recognized his son's creative ability early and sent him to Hamburg when he was in his teens. There he studied under the well-known painter of battle scenes, Professor Simmonsen, and Professor Heimerdinger, who was renowned for his brilliant technique in executing still lifes.

From Hamburg, Hansen went to London for a year, and from there sailed to New York where he continued his training. It was in Chicago, where he was doing further study, that he finally got his chance to see the wild frontier. He received a commission from the Northwestern Railways to do a series of transportation advertisements. His painting "The Pony Express" brought great success to the young artist, and copies of this work are now found all over the world.

After his travels throughout the West from Montana and the Dakotas in the north to Texas, New Mexico, and Arizona in the Southwest, Hansen finally settled in San Francisco when he was twenty-eight, and married Olga Josue. They had two children — a daughter, Frieda, and a son, Armin, who is a marine painter and etcher of national reputation. Except for brief absences, California remained Hansen's home until his death at seventy.

Toward the end of his life Hansen took up etching, and some of his plates show a remarkable affinity for the medium, but watercolor was always his favorite means of expression; he seldom worked in oils. He is particularly noted for the fine draftsmanship and feeling of surging power which he brings to his paintings of horses in action. Hansen's work is to be found in collections throughout the world, as he attained international recognition and acceptance.

90

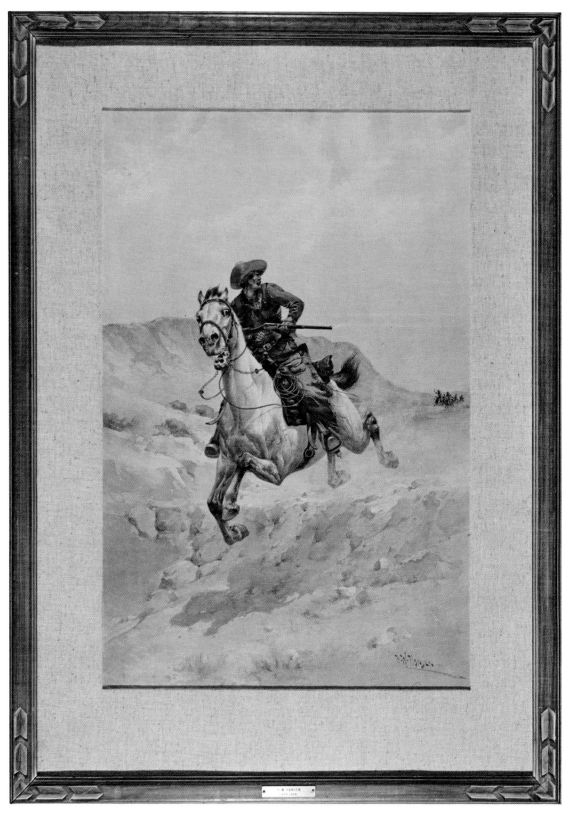

THE PURSUIT *Watercolor* 30 x 20 inches

John Hauser
1859–1913

IT WAS NOT UNTIL he was in his early thirties that John Hauser became interested in painting the American Indian, the subject for which he is best known. Most of his adult life until this time was devoted to studying art in Ohio and Europe.

The son of a cabinet maker from the Black Forest in Germany, John Hauser was born in Cincinnati. Showing a remarkable aptitude for painting at an early age he was enrolled at the Ohio Mechanic's Institute and at the Cincinnati Art Academy. In 1873 he was a pupil of Thomas A. Noble at the McMicken Art School, also in Cincinnati. Seven years later Hauser went to Munich where he studied at the Royal Academy of Fine Arts under Nicholas Gysis.

Upon his return to Cincinnati Hauser taught drawing in the public schools, but feeling the need for further training he returned to Munich. He also studied in Dusseldorf, under Zuegel, and to complete his European training, spent some time at the *Ecole des Beaux Arts* in Paris.

After touring various art centers of Europe, Hauser returned to the United States in 1891, and it was at this point in his life that he traveled in New Mexico and Arizona and became fascinated with the Indians of the West. Thereafter, for almost twenty years he made yearly visits to the reservations where he painted remarkable portraits of such famed chiefs as Lone Bear, High Horse, and Spotted Tail. An honorable and kindly man, he impressed the Indians and easily won their trust. In 1901 he was adopted into the Sioux nation and was given the name of Straight White Shield. His wife, Minnie, who was also taken into the tribe, was called Bring Us Sweets.

John Hauser's last work, completed before his death in Cincinnati, was a mural titled "Perry's Victory," under commission by the Put-in-Bay Yacht Club.

He was one of the founders of the Cincinnati Art Club, and among the organizations to which he belonged were the *Muenchener Kunstler* Club, *Muenchener Kunsterein*, and the Cincinnati Art League.

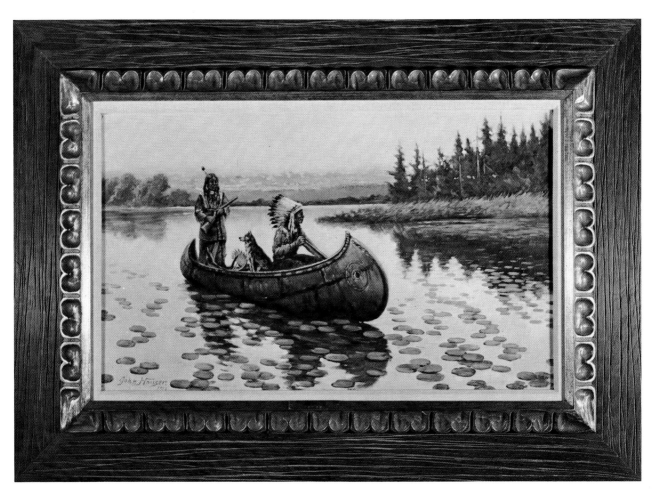

QUIET RETURN *Oil* 15 x 25 inches

E. Martin Hennings

1886–1956

AN ARTIST WHO REFUSED TO BOW to the demands of the newer and more popular art forms of his period, but whose work has always been in great demand, is Ernest Martin Hennings. He was a gentle, almost shy man and his benevolent outlook on life is reflected in his tapestry-like style which depicts Indian life in a delicate and spiritual manner, yet is combined with a marked degree of realism.

Pennsgrove, New Jersey, was the birthplace of Hennings. At an early age he moved with his family to Chicago, where he later studied at the Chicago Art Institute for five years. After graduating, with honors, he went to Europe where he had as his teachers Angelo Junk and Franz Van Stuck of the Royal Academy in Munich.

After two and a half years in Germany, World War I broke out and he was forced to leave. Returning to Chicago, he accepted employment with a commercial art studio and did murals for churches and other public institutions.

Hennings did not find the creative fulfillment he wanted in his job, and in 1917, at the suggestion of Carter Harrison who had sponsored the New Mexico venture for both Ufer and Higgins, he went to Taos. There he found impetus for his creativity, and succeeded to such an extent that he was elected to membership in the Taos Society of Artists in 1921.

His artistic stature having increased considerably, Hennings was invited to have a one-man show at Marshall Field and Company in Chicago. While there to prepare for his exhibit he met and married Helen Otte. Returning to Taos after a sixteen-months wedding trip in Europe, where Hennings painted in France, Italy, Spain, and Spanish Morocco, they rented an apartment in the Harwood Foundation in Taos. The paintings done on this journey were bright, happy, and filled with sunshine — qualities often characteristic of his work. He was particularly successful in suggesting the unity of his human figures with the setting of nature.

During the years between 1916 and 1938 his work won more than a dozen major national prizes. His paintings are in many important collections, including the Pennsylvania Academy of Fine Arts, Philadelphia; Los Angeles County Museum of Art; Museum of Fine Arts of Houston; Gilcrease Institute of Art, Tulsa; and in numerous private collections.

Hennings died of a heart attack in Taos at age seventy.

94

RABBIT HUNT *Oil* 36 x 40 inches

Robert Henri NA

1865–1929

AS A TEACHER, AUTHOR, AND LEADER of a revolutionary art movement, Robert Henri wielded tremendous influence over the artists of his day. Among art historians he is considered a link between the painters of the late nineteenth century and the radicals of the early twentieth century.

Born Robert Henry Cozad in Cincinnati, Ohio, he lived with his parents in various parts of the country including Nebraska, where the town of Cozad was named for his father. After studying at the Pennsylvania Academy of Fine Arts in Philadelphia, the *Académie Julien* and the *École des Beaux-Arts* in Paris, he settled in Philadelphia. In the 1890s he formed his circle of four disciples: Everett Shinn, George Luks, William Glackens, and John Sloan. Their approach to the American scene and the prevailing darkness in their paintings earned them the name, "The Revolutionary Black Gang." It was the beginning of the Ash-Can School of art. In his book, *The Art Spirit*, Henri called himself "a sort of sidewalk superintendent" of his times.

When the five artists moved to New York to teach and paint, the art world laughed, but listened to them. In 1908 they put on an exhibition in Manhattan with three other artists: Maurice Prendergast, Ernest Lawson, and Arthur B. Davies. Known as "The Eight," they shocked the public with their interpretations of the Bowery, baseball, and dance halls, which hitherto had not been considered fit subjects for art, but they paved the way for new concepts and techniques. In 1913, Henri helped to sponsor the historic New York Armory Show which was to change the whole course of American art.

Henri painted his first portraits of Southwest Indians in 1914 while visiting in San Diego. In 1916 he joined the thriving art colony in Santa Fe, New Mexico, painting some thirty oil portraits of the native Indians which are now in major museums and private collections throughout the country. His virtuosity as a painter and teacher soon established him as a leader among the Santa Fe and Taos artists and also influenced the styles of many of them. He was elected to associate membership in the Taos Society of Artists in 1918.

Before Henri died in New York, he persuaded many of his most talented students to paint in the Southwest. Among them were George Bellows, Edward Hopper, John Sloan, Yasuo Kuniyoshi, and Randall Davey.

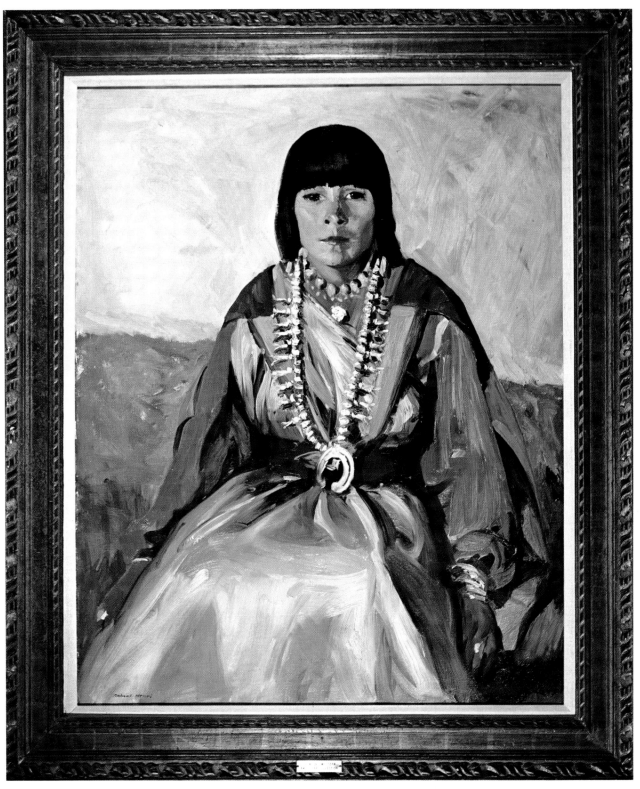

TOM PO QUI (Water of Antelope Lake) INDIAN GIRL, ROMACITA *Oil* 41 x 33 inches
Dated San Diego, 1914

Victor Higgins NA

1884-1949

A NATIVE MIDWESTERNER born in Shelbyville, Indiana, Victor Higgins gained his fame as a Western artist, painting the Indians and countryside of Taos, New Mexico. His art education began in Chicago at the Art Institute and the Academy of Fine Arts. After further study in Paris and Munich, he returned to Chicago to teach at the Academy of Fine Arts.

In 1914, he moved to Taos, the same year Walter Ufer arrived. Both men were sponsored in their New Mexico venture by Carter Harrison, a former mayor of Chicago, who on an earlier visit to Taos had become captivated by its beauties and artistic potential. They were promptly invited to join the Taos Society of Artists, the first new members to be taken in since its founding in 1912. Though both Higgins and Ufer became permanent residents of Taos, they continued to be claimed as "Chicago artists" and many of their awards came from the Chicago Art Institute shows.

From the year of his arrival in Taos, Higgins either won major awards or exhibited in major national shows every year until 1927. In the late twenties, he began to change his style, moving away from the representational toward the Cézanne type of impressionism. It was a great tribute to his courage and capacity for growth that he elected to switch from the style which had won him so much acclaim. Of the pioneer Taos artists, only he, Blumenschein, and Berninghaus chose to risk the loss of popular success to experiment with new approaches. Higgins was greatly influenced in his new style by Andrew Dasburg, also a member of the Taos art colony, and by John Marin who painted there in the summers of 1929 and 1930.

During this period of transition, little was heard from Higgins as far as awards or exhibitions were concerned, but in 1932 he won both the first Altman Prize of the National Academy of Design and the French Memorial Gold Medal from the Art Institute of Chicago for "Winter Funeral," one of his greatest and most memorable paintings (now in the Harwood Foundation, Taos). In 1933 his work was represented in the Museum of Modern Art exhibition, "Painting and Sculpture from Sixteen American Cities." What had emerged was a painter with greater depth and individuality and a distinctive talent for romantic imagery.

Taos remained his home until his death.

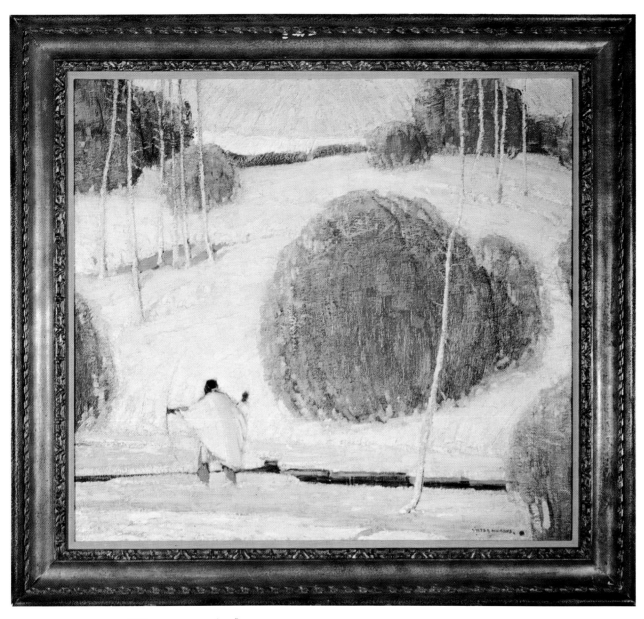

GAME HUNTER *Oil* 27 x 30 inches

Thomas Hill

1829–1908

SO RENOWNED IS THOMAS HILL as a landscape artist that it may be a surprise to some people that he achieved success earlier in his career as a portrait and historical painter. In the 1860s and 1870s, Hill along with other members of the Rocky Mountain School — Bierstadt, Moran, and Keith — discovered the West and began to portray its expansiveness. For a time their huge canvases were out of fashion, due to the European influence on the art market, but now they have regained their popularity.

Born in Birmingham, England, Hill came to the United States in 1840 with his parents who settled in Taunton, Massachusetts. He began his art career as a decorative painter in Boston, and later moved to Philadelphia, where he studied at the Pennsylvania Academy of Fine Arts. His portraits and flower paintings were successfully exhibited in the 1850s. In 1861 he moved to San Francisco and became an integral part of the fast-growing art colony. It was at this time that Hill started painting the magnificent landscapes for which he became famous.

Feeling the need for further study, he went to Paris during 1866 and 1867 and worked under Paul Meyerheim. Returning to America he established a studio in Boston, but after a few years moved to California where he remained until his death by suicide at Raymond.

Known principally for his views of the Yosemite, Hill also did many paintings of the Grand Canyon, Yellowstone National Park, Donner Lake, and the Sierra Nevada Mountains. His most famous work, however, is "Driving the Last Spike," which commemorates the completion of the first transcontinental railroad in 1869 at Promontory Point, Utah. This painting, a massive one measuring eight by eleven feet, now hangs in the State Capitol Building in Sacramento, California. Not only is this painting noted for its excellence as a landscape, but for its historical and ethnological value.

Other prominent canvases by Hill are "The Heart of the Sierras," "Yosemite Valley," and "The Yellowstone Canyon." He worked mainly in oil, and nearly all of his landscapes have a grandeur of scope and a dignity that make them truly awe inspiring.

Among the prizes and honors which Hill received were the First Medal of the Maryland Institute in Baltimore, 1853, and the First Prize at the San Francisco Art Union Exhibition in 1865.

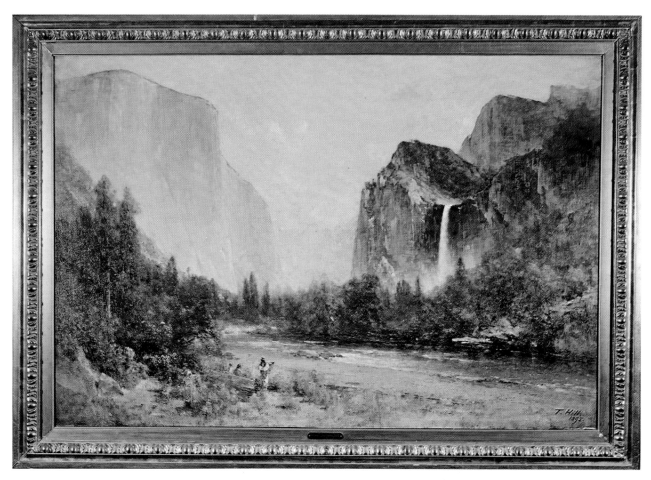

YOSEMITE VALLEY INDIAN WOODPICKERS *Oil* 36 x 54 inches
Dated 1895

Frank B. Hoffman

1888–1958

ALTHOUGH BORN IN CHICAGO, Frank Hoffman spent much of his boyhood in New Orleans where his father owned racing stables. As he was not a particularly good student his father let him race his thoroughbreds and do odd jobs around the stables. Already interested in drawing, young Hoffman found this an excellent opportunity to study and sketch the structure and movement of the horses he was later to paint so masterfully.

A few years afterward, a family friend who admired Hoffman's talent for drawing arranged a job for him on the *Chicago Daily American*. For the paper he drew not only horses and other animals but everything from opera stars to prizefighters. Eventually he became head of the art department. Realizing that he wanted to be a serious artist, he studied privately for five years with J. Wellington Reynolds, the well known portrait and figure painter.

Because of an eye defect Hoffman was rejected for military service during World War I, and decided to travel in the West. There he saw a buffalo roundup in Montana, mingled with the rugged men who settled the new frontier, and lived with various Indian tribes, learning their language and ways. While working at Glacier National Park as public relations director Hoffman met John Singer Sargent, from whom he learned a great deal about portrait painting.

In 1920 Hoffman was drawn to the art colony in Taos, New Mexico, where he became friends with Leon Gaspard. The two men often painted together, and came to know other artists of the group. His distinctive style and daring use of color attracted advertisers, and he handled many campaigns for such corporations as General Motors and General Electric. His illustrations appeared in the *Saturday Evening Post*, *McCall's*, *Cosmopolitan*, and other leading magazines. Financial success in the advertising field enabled him to buy his own ranch in Taos where he raised quarter horses and kept a variety of animals to use as models for his paintings.

Beginning in 1940, Hoffman was under exclusive contract to Brown and Bigelow for fourteen years, and during this time he painted one hundred and fifty western paintings which were used as calendar subjects. Many of the originals are in the private collection of the company.

He died in Taos on March 11, 1958.

102

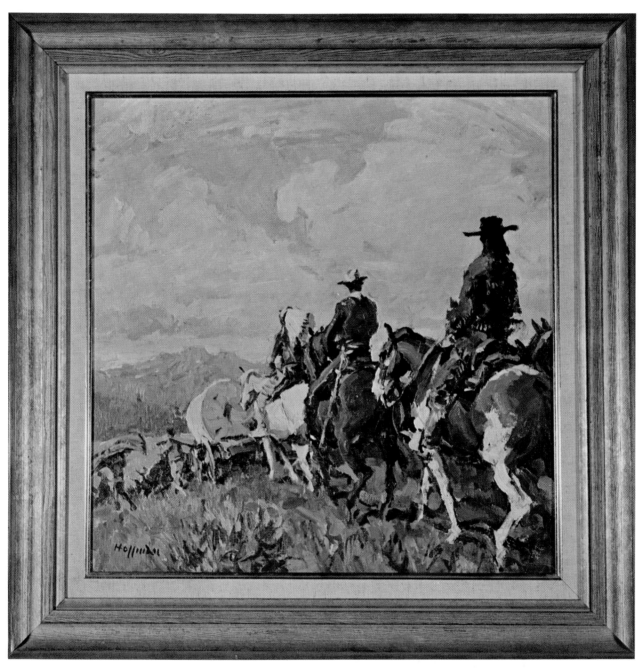

ON THE MOVE *Oil* 18 x 18 inches

John D. Howland

1842–1914

NAMED AFTER AN ANCESTOR who came to this country on the Mayflower, John Dare Howland also inherited the true pioneering spirit. He was born in Zanesville, Ohio, which his grandparents had helped to found. At the age of fourteen he ran away from home to seek adventure in the Far West, and managed to survive the shipwrecks of two riverboats en route. He joined the American Fur Company and traveled the Missouri and Platte Rivers, trading with the Sioux Indians as he went. A great favorite among them, he delighted the Indians by drawing pictures on tanned animal skins and their tepees. He was a friend of the Sioux Indian "Rain in the Face," who was accused of killing General Custer's brother, Tom.

In 1858 Howland went to Colorado for the first time, having heard of the riches to be found in the Pikes Peak region. His gold findings were so small, however, that he often had to earn a few pennies for food by dancing a jig for the entertainment-starved miners.

At the outbreak of the Civil War he enlisted in the Colorado Volunteers, and saw action in the decisive battles in New Mexico. Rising to the rank of Captain of Scouts, he took part in the Indian wars which followed. During his career as a soldier he did not neglect his artistic talent, and when he left the service he decided to study art seriously and make it his profession.

For over two years he studied in Paris under Armand Dumaresq and other well-known teachers, until he was appointed Secretary of the Indian Peace Commission to negotiate with the Sioux and other tribes. During this time he was also a correspondent for *Harper's Weekly* and *Leslie's Newspaper*, traveling, writing, and drawing in the Southwest and Mexico. In 1872 he again went to Europe where he continued his study of art.

Upon his return to the United States, Howland spent some time in Utah, but finally settled in Denver, Colorado. There he founded the Denver Art Club and was an active member of various cultural and civic organizations until his death in 1914.

Howland was particularly noted for his skillful interpretations of buffalo which he had often encountered in his life on the Plains, and he is one of the few artists whose paintings record the pre-railroad era of the West.

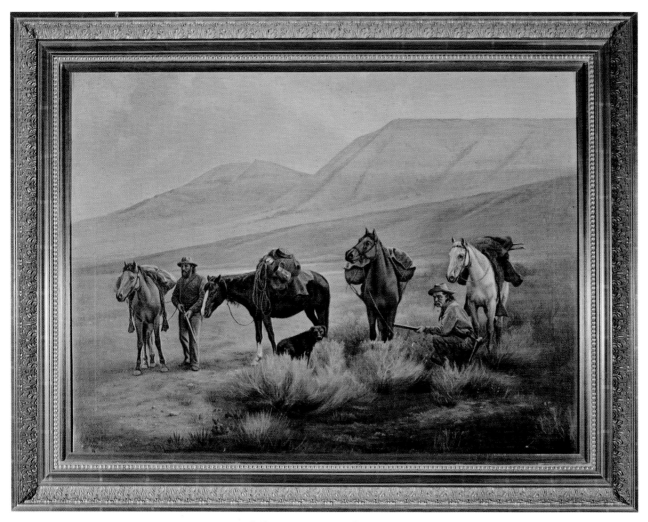

PROSPECTORS IN UTE COUNTRY *Oil* 20 x 30 inches

Grace Carpenter Hudson

1865–1937

LIVING AMONG THE POMO INDIAN TRIBES of northern California, Grace Carpenter Hudson came to know her subjects well. She particularly liked to do paintings of the Indian children, and had a special talent for capturing the volatile moods of childhood. Her work has a quiet enchantment, sometimes sentimental, but often realistic enough to cause one observer to ask, after studying a baby's portrait with a magnifying glass, "Mrs. Hudson, did you know he has dirt under his fingernails?"

Daughter of newspaperman and photographer, A. O. Carpenter, Grace Carpenter was born in Potter Valley, near Ukiah, California. Here she grew up with her twin brother, Grant, who was to become a lawyer and writer. She exhibited a talent for drawing at an early age, and after finishing elementary school in Ukiah, her family sent her to study at the California School of Design of the San Francisco Art Association under the direction of Virgil Williams. Among her teachers were Oscar Kunath and R. D. Yelland. Her ability developed rapidly, and she won the much sought after Alvord Gold Medal Prize while still in her teens. After completing her training she taught painting in Ukiah and did illustrations for *Sunset*, *Cosmopolitan*, and *Western Field*.

In 1890 she married Dr. John Wilz Napier Hudson, who gave up his practice to do research and writing on the language and art of the Pomo Indians. He also acted as Pacific Coast ethnologist for the Field Museum in Chicago (now Chicago Natural History Museum). Grace Hudson was commissioned by the museum in 1904 to do a series of paintings on the Pawnee Indians of Oklahoma. It was during this time that she did the portrait of Eagle Chief. As a leader of the four Pawnee tribes, the business affairs of his people often took him to Washington, where he was entertained as a highly honored guest by President Theodore Roosevelt. The "breath feather," which he is wearing in the painting here, is a warrior's symbol of vigilance, as it is always in motion.

Widely traveled, Grace Hudson twice made extended European tours to visit museums and art galleries with her husband; in 1901 she spent most of the year in Hawaii studying and doing paintings of children. Upon returning from their travels the Hudsons built a home in Ukiah where she lived and worked until her death.

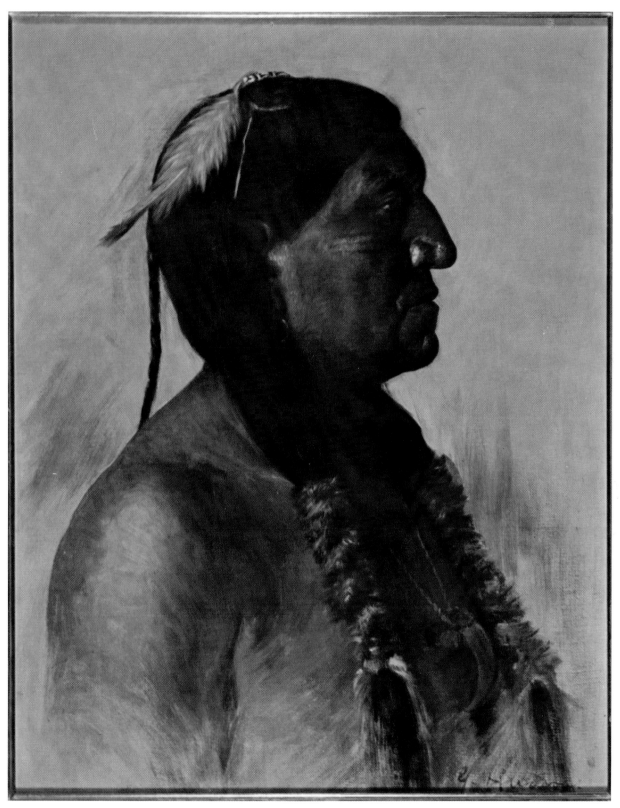

EAGLE CHIEF *Oil* 20 x 16 inches

Peter Hurd NA

b. 1904

FAILING A MATHEMATICS COURSE at West Point Military Academy, Peter Hurd was given the option of spending the summer being tutored or resigning from potential army life. He chose the former, but upon being readmitted to accredited standing, made a turnabout and decided to devote his life to a career in art.

Born in Roswell, New Mexico, Hurd often had compelling memories of the scenery of his boyhood which inspired him to paint while attempting to absorb the ways of military life. Upon his resignation from West Point he went to the Pennsylvania Academy of Fine Arts, and also applied to study as a private pupil under the great illustrator N. C. Wyeth. He spent the next several years in training at Wyeth's studio-home in Chadds Ford, Pennsylvania. In the second year of his apprenticeship he married Wyeth's eldest daughter, Henriette, already an accomplished painter; her brother, Andrew, was also to become a famous American artist.

After twelve years' training at Chadds Ford, during which time two of his three children were born, Hurd felt a persistent desire to return to his beloved Southwest. He went back to New Mexico and settled his family on a ranch near the village of San Patricio. Here the Hurds converted an ancient adobe ranch house into the lovely hacienda it is today.

Inspired by his native environment, Hurd began to experiment with egg tempera and gesso, and through these media achieved stunning effects; his paintings not only depict light but seem to become the source of it.

This was an important time in Hurd's life, creatively as well as financially, for national recognition came to him when he was the subject of an illustrated article in *Life* magazine. In later years his fame increased when he was commissioned to paint an official portrait of President Lyndon B. Johnson for the White House collection. The President did not like the finished work and said so in no uncertain terms; Hurd questioned Johnson's ability as an art critic, and the affair became the subject of numerous jokes, cartoons, and wide press coverage. The painting now hangs in the National Portrait Gallery of the Smithsonian Institution.

Peter Hurd's paintings and lithographs are in important collections throughout the world. He has illustrated books and published a volume of original lithographs. Also a sensitive writer, he has supplied the text for *The Peter Hurd Sketch Book* published in 1971.

LA POLVAREDA *Watercolor* 23 x 29 inches

William Henry Jackson

1843–1942

PIONEER PHOTOGRAPHER and painter William Henry Jackson should inspire the gratitude of all present-day conservationists. His photographs, the first taken of the Yellowstone region, influenced Congress to declare Yellowstone a national park in 1872. It was the beginning of our National Park System and the first system of its kind in the world.

Jackson was born on a farm near Peru, New York. After serving in the Union Army during the Civil War he went west by wagon train a year later. In 1871, he went with Thomas Moran on the Ferdinand Vandiveer Hayden Expedition to photograph the Yellowstone region in Wyoming. Later the expedition investigated the Mesa Verde, the Pueblo Indians in Colorado, and the Mount of the Holy Cross.

After finishing his work in Washington, D.C. with the Hayden Survey, Jackson moved to Denver, Colorado and established the William Henry Jackson Photographic Studio. Living in the days before color film was invented, Jackson reproduced his photographs on paper and canvas, then colored them with watercolor or oil. He was careful to observe historical and geological accuracy down to the most minute detail.

Commissions to do illustrations for *Harper's Weekly* took him on frequent visits to the Northwest, where he photographed and painted little-known places. His photos and paintings achieved worldwide popularity, and many of them now hang in national parks and museums.

Jackson's son, Clarence, a Colorado author, did much to perpetuate his father's work. He wrote three books about his father's career: *Quest of the Snowy Cross*, *Pageant of the Pioneers*, and *Picture Maker of the Old West*. He also had a Denver studio do black and white photographs of eighty-six of his father's watercolors; then he watercolored and categorized them into three portfolios. These portfolios are entitled "Early Western Scenes," "Along the Oregon Trail," and "Pony Express Series."

In the *New York Times*, Orville Prescott wrote of William Henry Jackson's pictures, ". . . They revealed that he was a magnificent photographer with a highly developed sense of beauty and composition. They show that he knew that a shabby mining camp, a stretch of uncompleted Union Pacific Railroad, or a view of the muddy streets of Omaha in 1866 could be as important and interesting as the most beautiful mountain scenery." This same critique could be applied to Jackson's paintings.

MITCHELL'S PASS, NEBRASKA *Watercolor* 22 x 30 inches

Ned Jacob CA

b. 1938

ALTHOUGH BORN IN ELIZBETHTON, TENNESSEE, Ned Jacob felt such a strong affinity for the West that at the age of eighteen as soon as he had completed his high school education, he hitchhiked to Montana. There he worked as a ranch hand and lived on the Blackfoot Indian Reservation. During his spare time he collected Indian artifacts and carefully studied the collections in the museum of the Plains Indians so that he might learn their tribal characteristics and styles. The thoroughness of his study at this time is reflected in the authenticity for which his paintings are now known.

Lacking direction during his early formative days of artistic endeavor Jacob credits artists Ace Powell, Robert Gilbert, and Bettina Steinke for giving focus to his work through their encouragement, faith, and good advice. Another artist whose work Jacob greatly admires is Joaquin Sorolla of Spain.

After leaving Montana Jacob went to Taos where he lived in Walter Ufer's old studio. The Taos School of artists and the paintings he studied in the galleries began to influence his own style and his work took on a strong regional quality. It was at this time too that a few sales strengthened his desire and determination to make art his future.

In 1965 Jacob moved to Denver to be more centrally located in the Western area and for the better facilities a larger city can provide. Within two years his work attained such a high degree of excellence that he was invited to become a member of the Cowboy Artists of America. He was awarded a Gold Medal for drawing at their annual exhibit in 1969. Recently he was elected to membership in the Salmagundi Club, the nation's oldest arts club.

Even though a young man, his work shows great maturity, and he is already represented in many private collections, galleries and museums, and in the permanent collection of the National Cowboy Hall of Fame in Oklahoma City.

Oil, charcoal, tempera, and gouache are the media in which Jacob chiefly works. He has little patience with "trends" in art; rather he is forming his career on a solid base of good draftsmanship, knowledge of design elements, sensitivity to color, and sympathetic understanding of his subject matter.

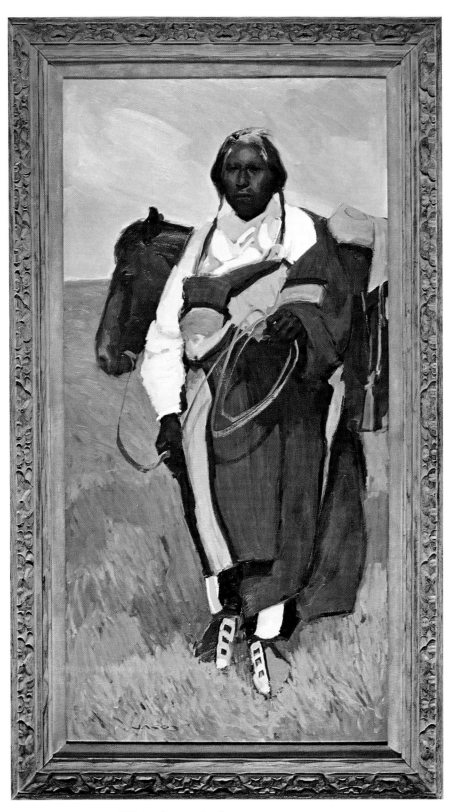

CREE INDIAN *Oil* 48 x 24 inches

Frank Tenney Johnson NA

1874–1939

WITNESSING THE WESTERN MIGRATION of adventurers, gold seekers, and homesteaders across the plains, Frank Tenney Johnson developed a deep and lasting interest in the West. Born in Big Grove, Iowa, he spent his childhood wandering along the Missouri River in the Council Bluffs area, the country explored by Lewis and Clark some eighty years before.

Greatly influenced by artist Richard Lorenz, he determined to make art his career. After learning all he could from the teachers available, he went to New York and studied under Robert Henri at the Art Students League. Having improved his skills and longing for the West where he could paint the subjects he liked best, he settled on a ranch in Colorado.

Not long after, his work attracted the attention of New York publishers and he was on his way as a successful illustrator for magazines, and books by such prominent writers of the period as Zane Grey. In 1920 one of his artist friends, Clyde Forsythe, left his lucrative career as a cartoonist in New York to return to California, and shortly after, Johnson and his wife followed. The two friends shared a studio in Alhambra for many years, and there Johnson painted his favorite themes — Indians, cowboys, and early settlers. The studio became the gathering place for some of the best known artists of the period — Charles Russell, Ed Borein, Dean Cornwell, and Norman Rockwell.

In time Frank Tenney Johnson became known for his paintings of cowboys under the stars — "The Johnson Moonlight Technique." As the art business flourished, Johnson and Forsythe founded the Biltmore Art Gallery in the Biltmore Hotel in Los Angeles. They also became enthusiastic participants in the group organized by Borein and other friends, Rancheros Visitadores, which met annually in Santa Barbara.

Johnson's art won him numerous awards and world-wide acclaim and was a source of inspiration for many of the younger artists, including Joe De Yong, Robert Wagoner, and Paul Salisbury. At the height of his career spinal meningitis took his life in Pasadena as the result of a kiss — a customary greeting to his hostess at the dinner party. Unknowingly she had contracted the contagious disease and they both died within two weeks. The painting shown here is his last and was on his easel when he died. Dr. Jack Loop, a friend who often painted with him, acquired the painting when he purchased Johnson's studio.

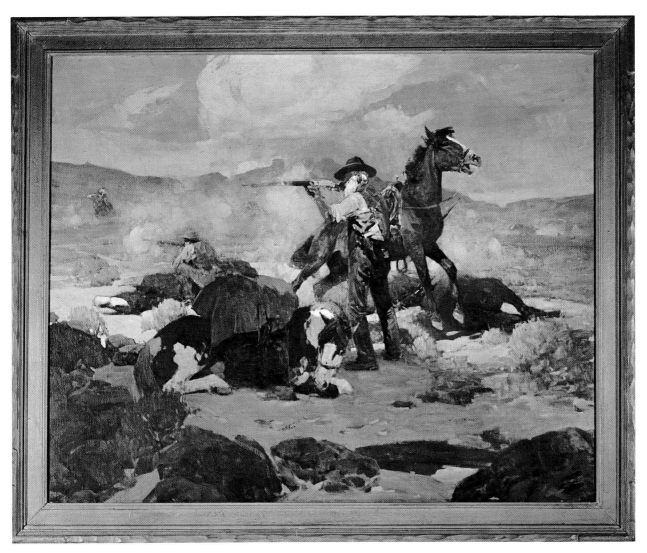

INDIAN ATTACK *Oil* 40 x 50 inches

William Keith

1839–1911

BORN IN SCOTLAND, William Keith came to New York at the age of twelve and there was apprenticed to a wood engraver. Within the next eight years he became so proficient at his craft that he was employed by Harper and Brothers to make plates for their magazines.

After moving to California in 1859, Keith established his own engraving shop, and carefully saved his money until he was able to finance a year in Europe, where he studied painting at Düsseldorf, Germany.

Keith was an important member of the Rocky Mountain School and, like Bierstadt, Moran, and Hill, chose to paint the monumental and dramatic aspects of the Western landscape. Most of his subject matter is concerned with the imposing scenery of the northwestern part of the United States. His engraving commissions frequently took him to this area, and while there he did many sketches and paintings. The Oregon Navigation and Railroad Company later assigned him to do a series of paintings which included Mt. Rainier, Mt. Hood, Mt. Baker, and scenes along the Columbia River. Throughout the years — from the 1860s to 1908 — Keith's love of this part of the country led him to return often.

At one time Keith and George Inness, who was a close friend, shared a studio in California. Keith's work was strongly influenced by Inness; later he was to fall under the spell of the Barbizon school, but his own effort to interpret the mystical quality of nature kept his paintings highly individual.

During the San Francisco earthquake and fire of 1906 a large group of Keith's paintings was destroyed. Most of these were done in his earlier technique which was lighter and more cheerful. Examples of this type are now rare, for later a combination of influences caused his work to become darker and more solemn in nature — his great admiration for the old masters began to alter his style. He started experimenting with bitumen and raw umber grounds, and became increasingly occupied with the introspective and philosophical aspects of painting.

Always seeking perfection, Keith was never satisfied with his work, even though he achieved fame and commercial acceptance. He said, "Impressions are dangerous to the artist when carried too far — I mean, when patience and industry are given the go-by for the sake of being artistic."

Keith died in California in 1911.

116

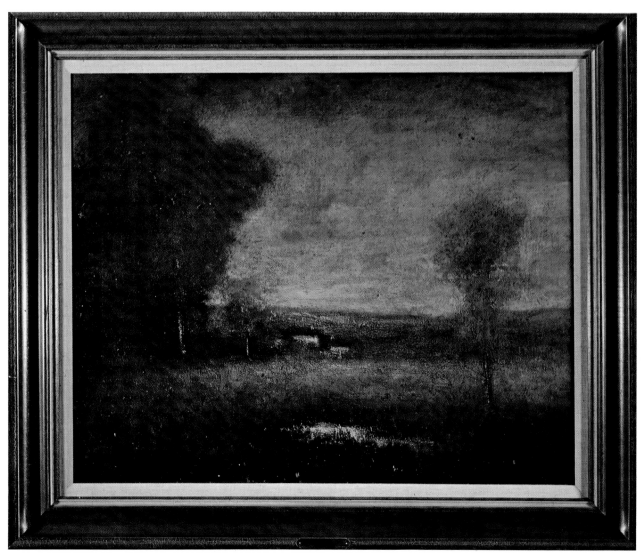

WESTERN SUNSET *Oil* 30 x 37 inches

Ramon Kelley

b. 1939

AS A THIRD GRADER, Ramon Kelley's interest in art was apparent by the vast number of drawings and doodles to be found on the margins of his textbooks, to the annoyance of most of his teachers. In the seventh grade, however, he found a sympathetic teacher who offered encouragement for his artistic ambitions.

Kelley, who signs his paintings simply "Ramon," is a Mexican-American and was born in Cheyenne, Wyoming. Working as a ranch hand in his youth gave him intimate knowledge of Western subject matter. His serious art training did not get under way until after he had served four years with the United States Navy. Upon his discharge he enrolled at the Colorado Institute of Art in Denver. He had originally planned to have a career in advertising design and illustration, but upon completion of his studies decided that easel painting would offer him more opportunity for the individualistic expression he desired.

Kelley has given careful attention to the work of the old masters, particularly Michelangelo, Rembrandt, Titian, and Rubens. Among the more recent artists who have influenced him are Sargent, Gaspard, and Nicolai Fechin, whom he idolizes.

His heritage and background have given Kelley insight and sensitivity to the subjects which he paints and draws so well — Mexican festivals and folklore, careworn faces, and scenes indigenous to the Southwest. These he depicts with a sure sense of line and value, a bold use of color, and an added quality of soul which gives his work an appealing individuality and meaningfulness. In a recent article for the *American Artist Magazine* Kelley said, "We expect artists as well as scientists to be forward looking, to fly in the face of what is established and create not what is acceptable but what will become accepted."

Ramon Kelley often went on painting and sketching trips in Taos, New Mexico, and it was here that his paintings started to sell. Since then he has had several one-man exhibitions in Denver, Santa Fe, and Kansas City, Missouri. His work has been represented in group shows in Palm Springs, Palm Desert, and La Jolla, California; and in Denver, Georgetown, and Golden, Colorado.

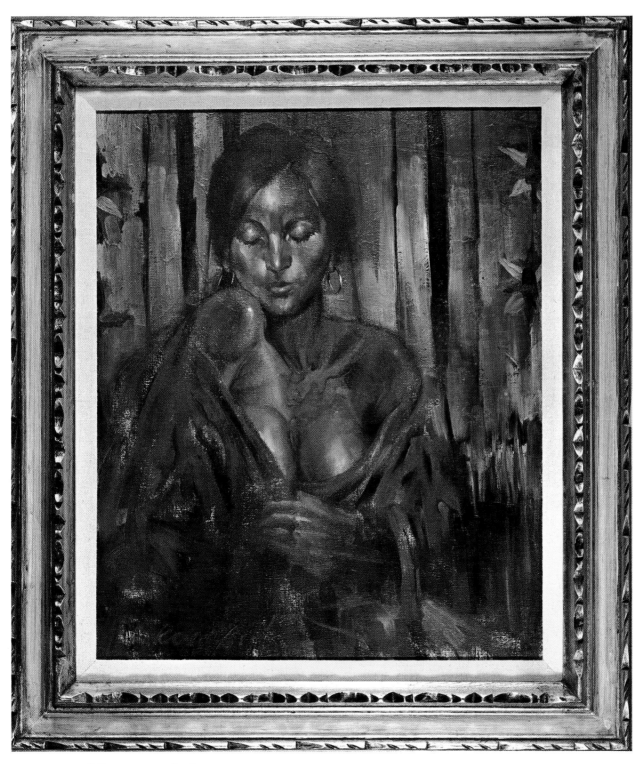

ADELITA *Oil* 24 x 20 inches

Charles Bird King

1785–1862

IN 1821 CHARLES BIRD KING completed portraits of Indian leaders from five different Great Plains tribes, almost a decade before George Catlin did his first paintings of the Western Indian. However, while Catlin traveled throughout the Western United States to paint the Indians in their home territory, King never set foot on land west of the Mississippi River. Yet, he, too, painted from life, but reversed the procedure — he remained in his Washington, D.C. studio and let the Indians come to him.

During the years between 1821 and 1837 hundreds of Indians from every part of the country flocked to the nation's capital as members of official delegations. In this sixteen-year period, King painted from life the leaders of some twenty tribes for the Government collection. In 1832, Secretary of War James Barbour praised King for his handling of this commission: "He executed it with fidelity and success, by producing the most exact resemblances, including the costume of each."

Charles Bird King showed an early affinity for painting and was encouraged by some of the finest artists of the period. He was born in Newport, Rhode Island and took his first art lessons there from Samuel King, the instructor of Allston and Malbone. After studying under Edward Savage in New York, he spent seven years in London, where he roomed with Thomas Sully and studied under Benjamin West. Returning to the United States in 1812, he painted in Philadelphia with little success, but in 1816, when he moved to Washington, D.C., he began to establish a reputation as a portraitist of prominent persons, such as John C. Calhoun, Henry Clay, and John Howard Payne, creator of "Home Sweet Home." He built a studio-gallery on the east side of Twelfth Street between E and F Streets N.W. and most of his Indian portraits were done there. He remained in Washington until his death. Three years later much of his Indian Gallery was destroyed by fire in the Smithsonian Institution.

Fortunately King painted replicas of a number of his Indian portraits. Two versions of "Eagle of Delight," shown here, have been preserved, one of which is in the White House. This pretty eighteen-year-old Indian woman, accompanied by her husband, the Oto chief Prairie Wolf, was in the 1821 delegation and became the darling of Washington society. However, shortly after returning home she died, and her grief-stricken husband nearly starved himself to death on her grave.

120

EAGLE OF DELIGHT *Oil* 17 x 13¾ inches
Hayne Hudjihini, the wife of *Shaumonekusse*

William R. Leigh NA

1866–1955

WILLIAM ROBINSON LEIGH'S DETERMINATION to follow his own style of painting rather than the trend of copying European techniques has given the world one of its most prolific and versatile proponents of Western art. His bold use of color met with scorn in the early days, but he persisted in depicting the clear light and brilliant hues of the West as he saw it.

Born in West Virginia, Leigh spent his boyhood on a farm. At fourteen he was sent to the Maryland Institute in Baltimore to begin his art training. In spite of poverty and having to do without many things, he managed to spend twelve years in Europe where he studied at the Royal Academy in Munich, Germany. His work there on murals and panoramas earned him numerous awards.

Returning to this country Leigh opened a studio in New York and did illustrations for *Scribner's Magazine*. Not until he was forty years old was he finally able to see the West which had occupied his thoughts for a long time. He was offered free passage to New Mexico in exchange for a painting commissioned by the Santa Fe Railroad. The painting was so well received that orders for more soon followed. This enabled him to remain in the Southwest for an extended period, sketching and painting every aspect of life in the region. It was during this phase of his career that he came to be known as the "Sagebrush Rembrandt."

In 1921 Leigh married Ethel Traphagen, a women's clothes designer, and together they established the successful Traphagen School of Fashion in New York City.

A few years later he made two trips to Africa, one with the 1926 Carl Akeley Expedition and the other with the Carlisle-Clark Expedition in 1928. On these trips he did many paintings of big game, and returning to New York he did the backgrounds for animal habitat groups in Akeley African Hall of the American Museum of Natural History.

After the death of Leigh, his widow presented his entire studio to the Gilcrease Institute of American History and Art in Tulsa, Oklahoma. The extensive collection includes many oils, charcoals, pencil and pen-and-ink sketches, books, and artifacts.

122

GREASED LIGHTNING *Oil* 28 x 22 inches

Thomas L. Lewis

b. 1907

THOMAS L. LEWIS, a professional artist since he was nineteen years old, was born in Bay City, Texas. In his youth he was mainly interested in portraying the life of the Deep South. The mysterious swamplands surrounded by cypress and beech trees, the bayous, and Negroes toiling in the fields — these were the subjects that filled his canvases. Etching also appealed to him as a means of expression and to supplement his income, but after entering a class of instruction in this medium he found that his slightly impaired eyesight prevented his doing the fine and close work necessary to produce a plate.

Later he turned to Western desert painting. As early as 1931 he began experimenting with sepia-toned paintings. He developed a highly sophisticated range of these sepia tones which he found expressive of the desert country, as before he had emphasized the lush green hues of the South. Bold and strong as his paintings are, they are nevertheless laced with intricate detail.

His career was reaching a high level of success when World War II postponed his creative activities. In the Navy his knowledge of pigments was put to use; his job was to mix paints for a camouflage division. Later he was sent to combat areas.

About a year after his release from the service in 1945, Lewis settled in Taos, New Mexico. The grandeur of the Sangre de Cristo Mountains soon inspired him to take up his brush again. Bert Phillips, one of the founders of the Taos Art Colony, befriended Lewis and the two spent hours trekking through the countryside sketching and painting together.

With his wife Sallie, Lewis founded the Taos Art Gallery, where thousands of tourists and customers visit each year. Through the gallery Lewis has been able to help other artists find markets for their work. Due to Sallie Lewis' devotion to her husband's career as an artist and her help in the management of the gallery, he has been able to spend enough time at his easel to become a prolific and popular artist. His paintings are in the Gilcrease Institute of American History and Art in Tulsa, Oklahoma, the Swope Museum in Terre Haute, Indiana, the University of Arizona Art Museum, the Witte Museum of San Antonio, Texas, and in many important private collections.

124

MOONLIGHT IN NEW MEXICO *Oil* 23 x 28 inches

Raphael Lillywhite

1891–1958

CHRISTENED RAPHAEL for the great Italian Renaissance artist, Lillywhite fulfilled the expectations suggested by his name and also became a painter. He was born in Woodruff, Arizona, and lived the first several years of his life in the Southwest.

Having received a comprehensive art education in various schools he also benefitted from individual training and guidance from many fine artists throughout the United States, including the original Taos group.

After his marriage in 1924 to Ilka Benko DeSzaak, who was herself a portrait artist from Hungary, his career advanced steadily. This was due in part to his wife's help in learning to do figure studies, and also to his ever increasing knowledge and ability to portray ranch life, the cowboy, and his working horses.

The Lillywhites bought a cabin on a river near Walden, Colorado, and it was here that a great body of his work was done. He worked mainly in oil, achieving luminous and glowing colors on his canvases which reveal a rather loose impressionistic but realistic style.

After nearly twenty years of marriage, Ilka Lillywhite died and her husband never fully recovered from his grief. As a tribute to her he donated all subsequent proceeds from his paintings to her church, which was of the Bahai faith.

Eventually Lillywhite remarried and had a child, but being a somewhat moody and taciturn man, he often indulged his desire to escape from society and would spend months at a time living among the Indians in Arizona and Wyoming, or staying in a sheepherder's camp. This behavior caused his wife to leave him, and he remained alone until his death in Evanston, Wyoming. He is buried in Laramie beside his beloved first wife, Ilka.

There have been rumors that Lillywhite became an alcoholic in his later life but in the authenticated biographical notes available, this is not substantiated.

Some of the finest backgrounds in the displays at the Museum of Natural History in Denver are his work, the fifty-foot "Alaska Tundra" and another, the "Bering Strait," background for the Walrus group.

RETURN OF THE STRAY *Oil* 24 x 30 inches

Robert Lindneux

1871–1970

AT THE AGE OF TWENTY-ONE while studying in Paris, Robert Lindneux met Colonel "Buffalo Bill" Cody, who was there with his Wild West Show. Shortly after, Lindneux made the friendship of Rosa Bonheur and was much impressed by her full-length portrait of Cody. These two events combined to create in Lindneux an overwhelming desire to go west himself. It is fortunate for the world that he eventually did, for he has created a rich legacy in his paintings of Western life and was one of the last links with a period important in American history.

Born in New York City, Lindneux was orphaned early, and his education by private tutors was sponsored by a well-to-do aunt. Going abroad, he studied in Munich, at the National Academy of Art in Düsseldorf, and at the *Ecole des Beaux Arts* in Paris. Among his teachers were prominent European artists such as Michael Munkacsy, Benjamin Vautier, and Franz Stuck.

Upon his return to the United States, he tried his hand at portrait painting in Boston for a year until he had saved enough money for the journey to the Indian country. Making Denver his home base, he roamed all over the cattle regions of Colorado, Wyoming, and Montana, working as a ranch hand to pay his way. For a time he lived with the Indians — the Crow and the Cheyenne in Montana, and in South Dakota with the Oglala Sioux, who made him an honorary chief.

Shortly after the turn of the century, Lindneux became friends with Charles Russell, and the two artists worked together in Russell's studio at Great Falls. Lindneux influenced Russell's use of color by encouraging him to use fewer pigments, thus achieving cleaner, fresher results. The two men even worked jointly on one scene which was signed by both; the painting came into possession of others, but after many years Lindneux was finally able to recover it.

Perhaps Lindneux's most famous work is the equestrian portrait "Buffalo Bill on Horseback," which shows the colonel on top of Lookout Mountain, Colorado, where he was later buried. The painting now hangs in the museum on Lookout Mountain. Lindneux's paintings have been widely exhibited in major cities of America as well as in Europe.

He had been a resident of Denver since 1915 and died there on November 24, 1970.

HARD GOIN' *Oil* 32 x 38 inches Dated 1943

Lone Wolf

1882–1970

ONE OF THE LAST LINKS with the colorful personalities of the Old West at the turn of the century was a Blackfoot named Hart Merriman Schultz, but who was more widely known by his Indian name, Lone Wolf. Theodore Roosevelt, Owen Wister, William 'Buffalo Bill" Cody, Charles Russell, Frederic Remington, and many others befriended and encouraged the young Indian in his artistic ambitions.

Born on Birch Creek, the southern boundary of the Blackfoot Reservation in Montana, he was the son of James Willard Schultz, whose book *My Life as an Indian* has become an American classic. As a boy Lone Wolf was taught by his grandfather, Yellow Wolf, where to find clay on the riverbanks and how to model it into horses and wild buffaloes. He also learned to draw and paint on buckskin.

His later sketches, done while he was a cowboy, attracted the attention of Thomas Moran, who became his teacher, and urged the young man to make art his profession and seek further training. Another famous western artist, Charles Schreyvogel, gave him his first set of oils. Lone Wolf entered the Art Students League in 1910, and later studied at the Art Institute of Chicago. After completion of his formal education he returned to the West, and at the Grand Canyon and Glacier National Park, established tepee studios as outlets for his work.

His first New York show, held in 1917, was a sellout. In 1922, while in New York for another exhibition of his paintings, he took some private lessons in sculpture and made several models which were cast in bronze. One of his bronzes, done in 1930, titled "Riding High," is considered one of his best works, capturing as it does the dramatic spirit of the Old West.

Another famous bronze may be seen in the Brookgreen Gardens, Brookgreen, South Carolina. It is called "Camouflage," and depicts an old Indian hunting trick. Three of his paintings are in the collection of the University of Nebraska, and the book, *Indians of Yesterday*, by Marion E. Gridley, contains line drawings and colored plates from Lone Wolf's paintings.

For the last fifteen years of his life, Lone Wolf lived in retirement with his wife Naoma on the outskirts of Tucson, Arizona. He died on February 9, 1970. The following summer his widow and adopted son, artist Paul Dyck, took his ashes to the Blackfoot Reservation, fulfilling his last wish: that he be returned to the country of his ancestors.

WARRIOR'S RETURN *Oil* 24 x 34 inches

Richard Lorenz

1858–1915

AS A YOUTH IN HIS NATIVE GERMANY, Richard Lorenz wanted to become a Biblical painter. The nomadic life of early Biblical peoples in the vast desert wilderness was especially appealing to him, and may explain his later affinity for the American West.

He was born on the family farm in Thuringia, and enrolled in a preparatory art school in Weimar at the age of fifteen. At eighteen he began attending free evening classes at the Royal Academy of Arts in Weimar and soon after became a regular student on a scholarship endowed by Franz Liszt. Among his teachers was Heinrich Albert Brendel, one of the foremost animal painters in Europe. While there, Lorenz was twice awarded the Carl Alexander Prize, the highest honor given in Weimar, and his work was sent to major Berlin and Antwerp exhibitions.

At the urging of a former Weimar comrade, he came to Milwaukee, Wisconsin in 1886 to join a group of panoramists, artists who painted enormous historical and religious canvases. These measured 25 x 350 feet and were unrolled from huge spools. The massive scenes were designed by the panorama director and it was Lorenz' job to paint in the horses — horses in every kind of action and dimension, from life-size in the foreground to hand-size fading into the far horizon. A year later, after helping to install one of the panoramas in San Francisco, Lorenz left the group and spent nearly two years roaming the Western states.

On his return to Milwaukee, he taught at the new Milwaukee School of Art and developed finished paintings from the hundreds of sketches he had brought back from his Western travels. It was then that his true genius emerged: his Western and Wisconsin scenes, with their unique lighting, exude the expansive air of young America, yet convey a highly personal, universal quality which transcends any one time or place.

Around 1898 Lorenz painted his first Indians at the Crow Reservation in Montana. The Sioux there told him about the massacre of the Seventh Cavalry at the Little Big Horn, which inspired his painting, "Last Glow of a Passing Nation," an almost visionary conception, and psychologically very different from any other painter's depiction of the massacre.

His paintings were popular among Milwaukee collectors and were featured in local, national, and international exhibitions. He was a member of the Society of Western Artists from 1896 until a year before his death.

FADING HORSES *Oil* 20 x 30 inches

Robert Lougheed CA

b. 1910

DRAWING, AS A CHILD, came naturally for Robert Lougheed. He was born on a farm in Ontario, Canada, where horses, cattle, and wild animals were his first models. So adept was he in the use of the artist's tools that by the time he was nineteen he was doing illustrations for a mail-order catalog. This, and drawing for the *Toronto Star Weekly*, helped him to keep working during the depression years.

He was a student in night classes at the Ontario College of Art, Toronto, and later at the *Ecole Des Beaux Arts* in Montreal. In 1935 he went to New York where he studied under Frank Vincent DuMond in the studio during the winter months, and in his outdoor classes at Nova Scotia during the summer. In the fall he went west and spent most of his time painting and gathering material for his Western themes. This he has done each fall for over twenty years.

In addition to his fine art painting in oil and watercolor Lougheed's work is widely represented in the advertising and illustration fields. He painted the "Flying Red Horse" for Mobil advertisements, calendars for Dupont, Brown and Bigelow, and Coca Cola. His illustrations have appeared in such magazines as *True*, *Sports Afield*, *Reader's Digest*, *National Geographic*, *The Cattleman*, and *Arizona Highways*. His great skill in painting horses, dogs, and wild animals also gained him contracts to do book illustrations for Rand McNally.

One of Lougheed's favorite subjects is the Mustang, the sturdy little animal whose ancestors carried the Spanish Conquistadors into America during the sixteenth century and who figured greatly in the settling of the West. A series of Mustang paintings, donated by the Ford Motor Company, is in the permanent collection of the Cowboy Hall of Fame.

Among the numerous awards that Lougheed has won are the Grumbacher Award in 1962, the Jasper Gropsey Award in 1964, the Miriam B. Beline Memorial Award, 1967, the Western Heritage Award of the National Cowboy Hall of Fame in 1966, and First Place Purchase Prize and Gold Medal for the Cowboy Artists of America Fourth Annual Exhibit in 1969. He was commissioned by the Post Office Department in 1970 to do the Six Cent Buffalo Stamp for the Wildlife Conservation Series.

Lougheed is married, and at present has his home and studio in a renovated 100-year-old barn in Newtown, Connecticut.

THE MUSTANGER *Oil* 19 x 27 inches

John N. Marchand

1875–1921

DURING THE FIRST DECADES of the twentieth century the illustrations of John Norval Marchand appeared in more than thirty-five books and countless magazines. Born in Leavenworth, Kansas, Marchand spent his early years in Indian territory, developing a firsthand acquaintance with the Indian and cowboy. His work reflects a secure knowledge of the West and a flair for capturing its great dramatic moments.

At sixteen he moved to St. Paul, Minnesota and attended St. Paul High School. Later he was employed on the staff of the *Minneapolis Journal*, studied at the Harwood Art School in Minneapolis, and was a member of the Harwood Summer School's art colony at Mendota. Arriving in New York in 1895, he became a staff artist for the *New York World*, and in 1897 he and artist Albert Levering went to Germany where they spent two years at Munich's famous art school. Returning to New York, he began illustrating for the leading magazine and book publishers.

Marchand made frequent trips to the West to gather material for his illustrations, and in 1902, while at the Wallace Coburn Ranch in Montana, he met Charles M. Russell. The two men were drawn to each other immediately and it was Marchand who persuaded Russell to make his first trip to New York. There Marchand introduced him to the major art editors, publishers, and prominent personalities of the day. During this and a subsequent visit in 1905, Russell shared Marchand's studio along with Levering and cartoonist Will Crawford.

Among the books Marchand illustrated were such best sellers as *Girl of the Golden West* by David Belasco and *Arizona: A Romance of the Great Southwest*, which Augustus Thomas had adapted from Cyrus Townsend Brady's popular play. He illustrated seven of Brady's books; three by Hamlin Garland and fellow Kansan, Margaret Hill McCarter, and others by Thomas Dixon and Alfred Henry Lewis. An example of his magazine illustrations may be found in the September, 1912 issue of *Cosmopolitan*. One of his most famous paintings, "DeSoto Discovering the Mississippi," was exhibited at the Buffalo Exposition.

After his marriage in 1904, Marchand purchased a Revolutionary period home in Westport, Connecticut. He was a charter member of the Westport Country Club and a member of the Illustrators Club and Salmagundi Club. He died at his home in Westport at the age of forty-six.

RIDIN' HARD *Oil* 32 x 22 inches

John Marin

1870–1953

CONSIDERED ONE OF AMERICA's greatest artists, John Marin is famous for his paintings of the Maine coastline. He can also be claimed by the West as he did one hundred watercolors of the New Mexico landscape and its native Indians. Arriving at the same time as Georgia O'Keeffe, he made his first visit to Taos in the summer of 1929 at the invitation of Mabel Dodge Luhan, and returned in the summer of 1930.

Nine days after his birth in Rutherford, New Jersey, Marin's mother died and he was sent to live with his grandparents in Delaware. He attended school for eight years in Weehawken, New Jersey, and after a series of undistinguished jobs, his father was persuaded to send him to art school. He was twenty-eight when he began his art studies at the Pennsylvania Academy. In 1905 he went to Europe and spent the next four years traveling and doing etchings, paintings, and sketches. Marin was almost forty when he returned to the United States and to immediate fame with the 1910 one-man exhibition of his work in Alfred Stieglitz' "291" gallery in New York. After seeing his work, Marsden Hartley said "Marin has taken watercolor out of the class of embroidery." He had invented a new kind of serious, rapid, and pictorial shorthand. "It is like golf," Marin wrote Stieglitz," the fewer the strokes the better the picture."

For almost twenty years Marin, his wife Marie, and their son John, Jr. traveled, chiefly in the northeastern states. In 1933 they settled in Cape Split, Maine, and this was "home" to Marin until his death.

Disliking studios, Marin preferred to work outdoors where he could catch the true pulse and movement of nature, and while in New Mexico, he did this even more than usual. His artist friends there, Ward Lockwood, Andrew Dasburg, and Loren Mozley, often accompanied him on combination fishing and painting trips. He found many favorite spots in the Taos area as subjects for his paintings. To aid in identification of the the paintings after his death, Andrew Dasburg, Mrs. Ward Lockwood, and William A. Mingenbach helped to prepare a map of his favorite sites. The watercolor shown here was done at the west end of the Hondo Valley looking north, and is the only painting which included horses. "The horse still exists here. . . ." he wrote Stieglitz. The first large-scale showing of these New Mexico watercolors was presented in 1936 at the Museum of Modern Art's Marin Retrospective Exhibition.

138

NEAR TAOS #5 *Watercolor* 13¼ x 17½ inches

R. Brownell McGrew CA

b. 1916

IN THE CANVASES OF Ralph Brownell McGrew two widely diverse cultures are united. His favorite subjects — the Navajo Indians, their small wiry horses, and the vast panorama of the southwestern desert — are handled in the rich, highly refined style of the Renaissance. This unusual combination results in paintings of striking individuality and power.

McGrew came to the Southwest as a child when his parents moved from his birthplace, Columbus, Ohio, to Alhambra, California. His art career had started in grade school when he was sent around to the upper classes to display examples of his art. The years at Alhambra High School studying art under Lester Bonar were followed by private study, then by training at the Otis Art Institute of Los Angeles under Ralph Holmes. By his fourth year at the Institute he had become so competent technically that he spent the year as a teacher rather than a student. Though portraits were his greatest interest, he was awarded the first grant to be offered by the John F. and Anna Lee Stacey Foundation for landscape painting.

After working for a time doing murals and portraits as a set decorator for the movie studios in Hollywood, he started to take trips into the desert. He had never been very enthusiastic about its landscape, but now he began to see its enormous range of subtle colors — grays and browns which broke into myriad tones. He decided to move to this challenging country and settled in Palm Springs, California. There he frequently went on sketching trips with Jimmie Swinnerton who introduced him to the Indian country. This eventually enticed McGrew into moving to Cottonwood in Arizona's Verde Valley where he now makes his home with his wife Ann and the youngest of his three daughters, and continues to "find the fascination of Indian themes too strong to leave for long."

Of his painting technique, McGrew says, "I like to have a painting look wet after it is completed and dried because I think it is most effective that way." He achieves his distinctive quality of luminescence by the subtle mingling of colors and by painting thinly on a smooth background. This is followed by a heavy varnish finish which has become his trademark and is in the tradition of the old masters of the Renaissance.

At the 1970 Cowboy Artists of America Show he won a Gold Medal in drawing and a Silver Medal in oil, the first time anyone has won an award in two different media at the same show.

140

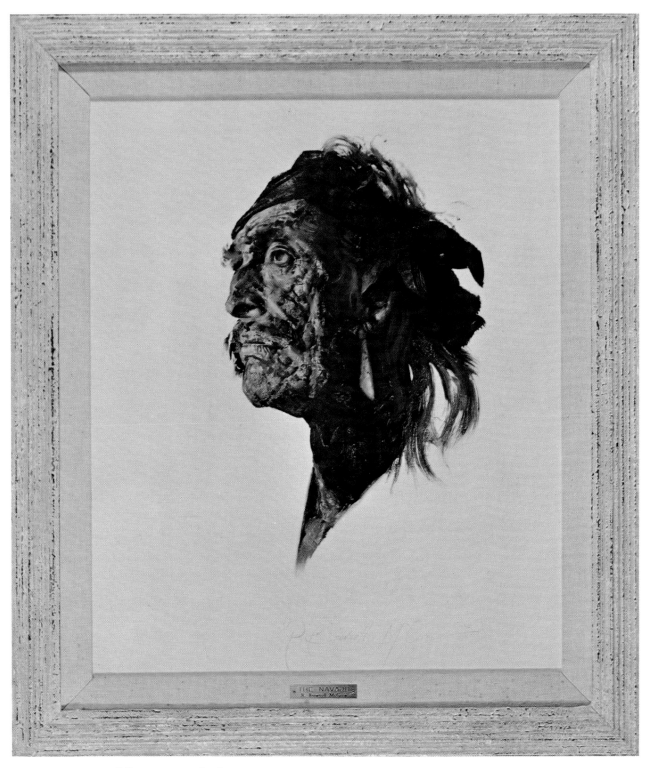

THE NAVAJO *Oil* 24 x 20 inches

Alfred Jacob Miller

1810–1874

ONE OF THE FAMOUS FOREBEARS of Western art, Alfred Jacob Miller was the first artist to go into the wilds of the Rocky Mountains. The sketches he did there of the rough mountain men — the Indians, trappers, and fur traders — are the earliest pictorial records we have of the Rocky Mountain fur trade. He was also the first artist to travel the historic Oregon Trail.

A native of Baltimore, Maryland, he studied at an early age with Thomas Sully, of the same city. So impressive was his talent that he was later sent to Paris where he studied at the *Ecole des Beaux Arts*. It was the custom in those days for aspiring young artists to copy the works of the old masters in the Louvre; so accomplished was Miller at this phase of his training that he soon became known among his fellow students as "the American Raphael." Some of the other artists working in Paris at that time were Delacroix, Charlet, and Horace Vernet. The influence of his French training is noticeable in his work, especially in his somewhat stylized way of painting horses.

After further study in Rome, Miller returned to the United States and by 1837 was painting in New Orleans. Here he met Captain William Drummond Stewart, a Scotsman who served as a caravan leader for the American Fur Company. These caravans consisted of representatives from fur companies, private parties, and sometimes Indians. Stewart informed Miller that he was planning a trip to the Rocky Mountains and needed an artist to make on-the-scene sketches.

Miller, the "city boy," went along on the arduous journey which took weeks of slow travel to reach the point of rendezvous with the trappers in the Rocky Mountains. Throughout the trip he made hundreds of sketches, to be done in oils on his return to Baltimore.

Stewart commissioned a series of oil paintings depicting their travels and these were later shipped to his family estate in Scotland, Murthly Castle, Perthshire. From the fall of 1840 until 1842, Miller was artist-in-residence at the Castle painting Stewart's favorite Western subjects.

Miller's reputation as a painter of the West was soon established, and he began to receive many commissions. In addition to oil he worked in watercolor, and two hundred of these can be seen in the Walters Art Gallery in Baltimore.

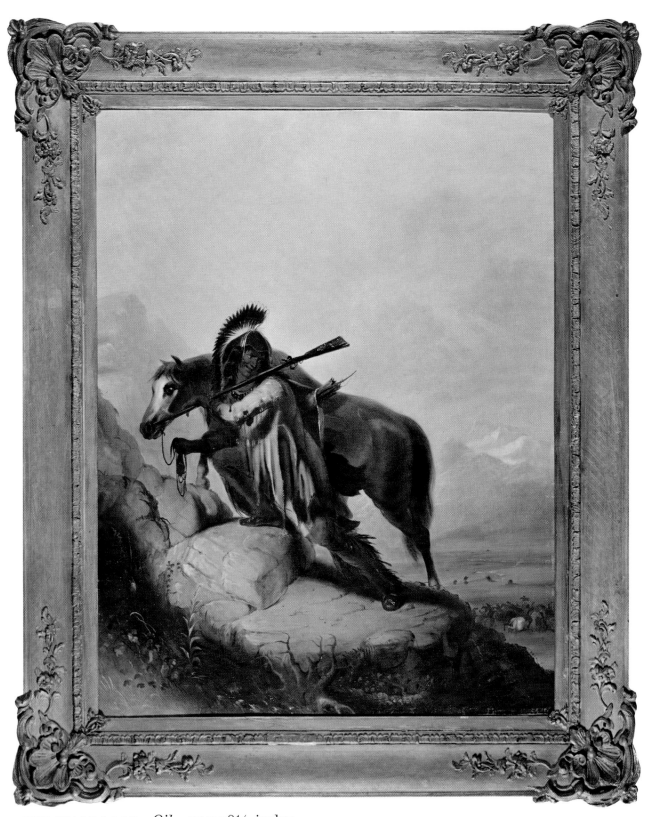

THE SCALP LOCK *Oil* 35 x 28½ inches

Arthur Mitchell

b. 1889

BORN ON HIS FATHER'S HOMESTEAD just west of Trinidad, Colorado, Arthur Mitchell spent his boyhood and early school years in and around Trinidad. This southern Colorado country and the man on horseback, who was the dominating personality of his youth, have influenced Mitchell's entire career as an artist and led very naturally to his love of Western subject matter.

In 1907 he "made a hand" with the Adams Cattle Company on the Vermejo in northern New Mexico and worked with their A6 roundup wagon when New Mexico was still a territory. While still in his teens he did pen and ink drawings and political cartoons for his hometown newspaper, and also experimented with paint.

In the early 1920s, following his army service in World War I, he went to New York where he studied under Harvey Dunn at the Grand Central School of Art. This resulted in a close friendship with Dunn which continued until Dunn's death in 1952. In the late twenties he gave up his New York studio and established a studio at Leonia, New Jersey where he joined a noted group of artists and illustrators: Charles Chapman, Grant Reynard, Frank Street, and Howard McCormick. During the eighteen years he lived there he did magazine illustrations, book jackets, and produced 160 cover paintings for the Western pulp magazines, which were then in their heyday. During this period he also continued to develop and exhibit his easel painting.

Upon his return to his native southern Colorado in the 1940s, Mitchell started the first art class at the Trinidad State Junior College and continued to teach there for the next fourteen years. In 1959 he designed the official Colorado centennial emblem, "Rush to the Rockies," commemorating the Gold Rush of 1859.

Mitchell has this to say about his work: "Maybe my approach to the making of a picture can be described as an interpretation of realism, of natural forms, distilled, refined, touched with imagination, and transformed into pictorial ideas."

Arthur Mitchell's paintings are in important collections throughout the country and in his private collection in the old Baca House Pioneer Museum in Trinidad, a museum he founded in a historic adobe building to preserve the West as he knew it for the generations to come.

144

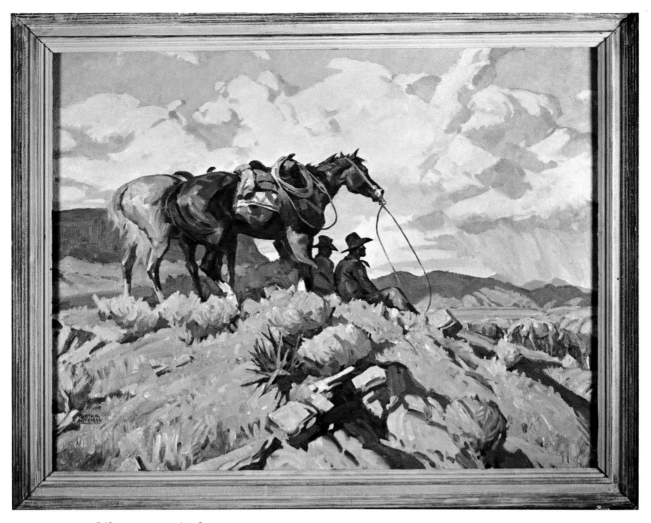

LAZY DAY *Oil* 30 x 40 inches

Frederic Mizen

1888–1964

GEORGE MIZEN, the father of Frederic Mizen, served as secretary to three generals during a significant period in the settling of the West, and was thus able to give his son firsthand impressions of dramatic episodes in Western and Indian lore. The stories which his father related to him undoubtedly created in young Mizen the interest in the Western genre which was later to develop into his great success as an artist in this field.

Born in Chicago, where he attended public schools, Mizen showed an early interest in art by making numerous visits to the galleries of the Art Institute of Chicago. After graduating from high school, Mizen attended the J. Francis Smith Academy of Art, where he came under the influence of Walter Ufer, and two years later enrolled at the Art Institute of Chicago.

By the time he was twenty, he was proficient enough to accept a job with the Joseph P. Berren Studios where his first assignment was doing illustrations for a Sears catalog. During the next few years he alternated between working for advertising agencies and doing free-lance commissions on his own. One of these was the first billboard advertisement for Coca-Cola, which was to become internationally recognized. He continued doing these advertisements for the next fourteen years. Cover illustrations for such magazines as *Saturday Evening Post*, the *American*, and *Collier's* soon followed.

During his summer vacations Mizen traveled and painted in the West, a place which had fascinated him since boyhood. At Taos, where he frequently went to study, he again met Walter Ufer and worked under him for a time.

In 1936 Mizen founded his own school, the Frederic Mizen Academy of Art in Chicago. By now an artist of national reputation, he received important commissions from galleries, portrait commissions from prominent individuals, and assignments from industries, such as a series of Indian studies and Southwestern landscapes for the Santa Fe Railroad.

For eight years toward the end of his career he was chairman of the art department of Baylor University. He was a member of the Art Institute of Chicago, and six months before his death in Chicago he was also elected associate fellow of the American Institute of Fine Arts.

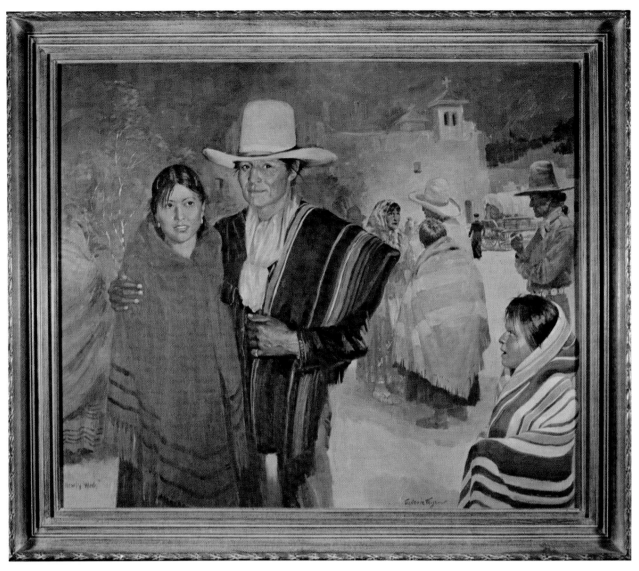

THE NEWLYWEDS *Oil* 30 x 36 inches

Thomas Moran NA

1837–1926

WHEN HE WAS SEVEN YEARS OLD Thomas Moran came to this country from his birthplace in Bolton, England. He was one of seven children, and three of his brothers, Edward, John, and Peter, also became famous artists. Largely self-taught, Moran worked in his youth for a wood engraver in Philadelphia, then shared a studio with his brother Edward.

He experimented with pencil, charcoal, ink, wash drawings, wood engraving, watercolor, and oil. Going to Europe with his wife, Mary Nimmo, he studied the work of J. M. W. Turner and came under the influence of the old masters.

His first opportunity to travel in the West came when he joined the Ferdinand V. Hayden Geological Survey Expedition to the Yellowstone territory in 1871. On this trip he became the friend of William Henry Jackson, the pioneer photographer, and through Jackson's photographs and Moran's paintings of the Yellowstone area, Congress was influenced to declare it a national park.

Many times afterward Moran traveled throughout Colorado, Wyoming, Arizona, Utah, and Old Mexico painting their scenic grandeurs. His enormous panorama, "The Grand Canyon of the Yellowstone," one of his many variations on the subject, hung in the national Capitol building for many years, as did another massive painting, "The Chasm of the Colorado." Both were purchased by Congress at ten thousand dollars each.

In 1876 Louis Prang of Boston issued a portfolio of fifteen large Moran chromolithograph illustrations which accompanied a report of the Hayden expedition. Other famous and representative paintings are "Zoroaster Temple at Sunset, "Mountain of the Holy Cross, Colorado," "Ruins of an Old Church Near Cuernavaca," and "Clouds in the Canyon."

Later in his career he visited New Mexico and became interested in painting the Indians and their surroundings near Acoma and Laguna. But his most lasting fame will probably rest on his vivid and dramatic scenes of Western America's many national parks and monuments. He continued to paint well into an advanced age, and died in Santa Barbara, California at eighty-nine.

A former director of the Park Service wrote, ". . . Moran showed the plain American citizen that he did not have to leave his native shores to look upon something more wonderful than the Alps."

148

INDIAN RETREAT *Oil* 31 x 13 inches Dated 1896

William Moyers CA

b. 1916

SINCE THE AGE OF FOURTEEN, when he moved from his Atlanta, Georgia birthplace to Alamosa, Colorado, William Moyers has absorbed knowledge of Western culture from first-hand experience and from his father who was an authority on Western history. Living on a ranch he worked as a bronc buster and all-around hand. He also entered rodeos to help pay for his education at Adams State College in Colorado, and after graduating attended the Otis Art Institute in Los Angeles. He then worked for Walt Disney Studios for a year.

Returning to Colorado, Moyers taught school and continued to develop his talent as a portrayer of the American cowboy. This specialized study and experience were rewarded in 1945 when he won the Limited Edition Club's national competition for illustrators with drawings for the novel, *The Virginian*. It led to a full-time career in book illustrating with most of the leading publishers, including the Limited Editions Club, Random House, Macmillan, Houghton Mifflin, and Grossett and Dunlap. He also is a writer himself, authoring two juvenile books on American Indians and on Western and historical subjects.

His work is characterized by an exacting attention to detail, and a keenness of observation which make his paintings not only objects of beauty but historically accurate portrayals of the culture they depict.

With his family, Bill Moyers now resides on a quiet street in Albuquerque, New Mexico, where his studio is filled with Indian artifacts and cowboy gear, some of which belonged to the famous artists he idolized in his youth. His favorites included Frederic Remington, Charles Russell, Will James, and the illustrators, Nick Eggenhofer and Harold Von Schmidt. Von Schmidt in particular Moyers remembers with grateful affection, for when he was a young artist visiting in New York he called the older man to seek his advice; Von Schmidt not only gave freely of his valuable time in talking to the young man, but introduced Moyers to other leading painters working in New York at the time. Moyers now returns that early kindness by assisting other aspiring young artists.

150

FOREFOOTED *Oil* 28 x 36 inches

Georgia O'Keeffe

b. 1887

GEORGIA O'KEEFFE HAS HELD a distinguished place in American art for more than five decades. When she arrived in New Mexico for the first time in 1929, she was forty-two years old and had already established her reputation in the East, but her love for New Mexico was immediate and overwhelming. She returned to it faithfully each summer and in 1946, following the death of her husband, became a permanent resident.

One of seven children, O'Keeffe was born on a farm in Wisconsin and later moved to Virginia. She studied art in Chicago and at the Art Students League in New York. Even as a student, she was a skilled technician and won first prize for a still life, but was not happy. "I'd been taught to paint like other people . . . just adding to the brushpile." She destroyed her early work, tried commercial art, and then went home to Virginia.

In 1915, after a severe analysis of her work, O'Keeffe selected those pieces which represented her alone, and not long after, sent a group of highly individual abstract drawings to a friend in New York, requesting that they be shown to no one. The friend, impressed by the drawings, took them to the famous "291" gallery of pioneer photographer Alfred Stieglitz, who promptly put on a show which introduced the "real Georgia O'Keeffe" to a very excited art audience. O'Keeffe was furious, berated Stieglitz, and demanded that the drawings be taken down. This unpromising beginning led to marriage in 1924 and twenty-two years together. Stieglitz was an important influence in her career, as he was in that of other artists, including John Marin and Marsden Hartley.

O'Keeffe has often chosen certain objects or landscapes and developed them into an extended series of paintings. Among the most famous are her flower series which range from abstract to botanically precise. In 1939 she did a series of Hawaiian landscapes, but, perhaps, her most memorable series are those of the New Mexican hill country, its adobe buildings, and the striking still lifes of crosses, skulls, and shells.

Now, at the age of eighty-four, she continues to live and paint on her ranch in Abiquiu, New Mexico. In 1968 her life and art were the subject of a cover story in *Life* magazine, and in October, 1970, she was featured in *Time* on the occasion of a major retrospective showing of her work at New York's Whitney Museum — a tribute to the durability and importance of her unique perception.

152

SELF-PORTRAIT
Watercolor 15 x 4½ inches

Edgar Samuel Paxson

1852–1919

SIGN PAINTER, CARRIAGE DECORATOR, cowpuncher, stage driver, Indian scout, and soldier — all these Edgar Samuel Paxson tried before becoming a full-time artist who excelled in depicting the panoramic drama of the West. His wealth of experience and wide firsthand knowledge of the subjects he painted impart a documentary authenticity to his work.

After completing school in Buffalo, New York, where he was born, Paxson went into business with his father who was a sign painter and decorator of carriages. Other than the training he received from his father there is no evidence that he ever had any formal instruction.

The novels of James Fenimore Cooper fired Paxson with the desire to see Indians in their original surroundings, and so, at the age of twenty-five, he left his wife and child in New York and went to Montana to seek his fortune. He arrived in the winter of 1877, a year after the Custer Battle. Bold, daring, and filled with the spirit of adventure he worked at whatever jobs were available, reveling in danger, and absorbing the myriad details of frontier life which would later serve him well as he recreated his experiences on canvas.

Two years after his arrival in Montana he sent for his family, and they lived for a time at Deer Lodge, but since there was little demand for sign painting, they later moved to Butte, where they resided for twenty-four years.

Completing service in the Spanish-American War, Paxson turned to easel painting as his means of livelihood. He wished to preserve great moments in the history of the West, and so undertook a series of murals for the Missoula County Courthouse depicting the Lewis and Clark Expedition, and six others which can be seen in the State Capitol building at Helena, Montana.

His most famous work, however, is the massive painting "Custer's Last Battle on the Little Big Horn." So all encompassing was his conception of this historic battle that it took him six years to complete it. Some of the Indian chiefs who had participated in the actual massacre posed for him.

Following the exhibition of this painting in major cities throughout the country, lasting popularity and success came to Edgar Paxson, and until his death in Missoula, he continued to paint and receive wide recognition and acclaim.

A PUEBLO GIRL PLAYING MOTHER *Oil* 22 x 14 inches

Edgar Alwin Payne

1881–1947

AN INNATE RESTLESSNESS caused Edgar Alwin Payne to live in different parts of the United States, Mexico, and Europe. It also probably accounted for his mastery of so many divergent techniques and media and his desire to paint a great variety of subject matter. But his landscapes perhaps reveal his best work, for he had a deep and lasting love of the great out-of-doors. Whether mountain, sky or desert, he painted it with an unsurpassed sweep and grandeur.

Born in Washburn, Missouri, his love of nature was fostered by the Ozarks where he grew up. He knew at an early age that he wanted to be an artist, but meeting with his father's disapproval, left home while very young to pursue his ambition.

He worked as a house and sign painter, later did murals, and finally became a top-ranking scenic artist. Although he attended the Chicago Art Institute for a brief period, he was largely self-taught.

His first trip to the West occurred in 1911 when he spent several months sketching in Laguna Beach, California. He returned about six years later with his wife and daughter who were also enchanted with the place. They built a house and remained there for several years. It was during this period that Payne founded the Laguna Art Gallery and was elected first president of the Art Association. Both organizations were influential in establishing Laguna as one of the leading art colonies on the West Coast.

From his Laguna home Payne made frequent sketching trips into the High Sierras; he was so highly esteemed in the area that a lake was named for him — Payne Lake. Later he also spent some time in Arizona where he painted the Grand Canyon and Canyon de Chelly, and in New Mexico, where he painted the colorful mesa land.

In the early 1920s he traveled about Europe painting and exhibiting. He wrote and published a book, now in its third edition, on composition and outdoor painting. He also produced a memorable color film called *Sierra Journey*.

Among the numerous awards that Payne received during his career were the Martin Kahn Prize at the Chicago Art Institute, the Ranger Fund Purchase Award at the National Academy of New York, and at the time of his death in Hollywood, a prize from the California Art Club.

156

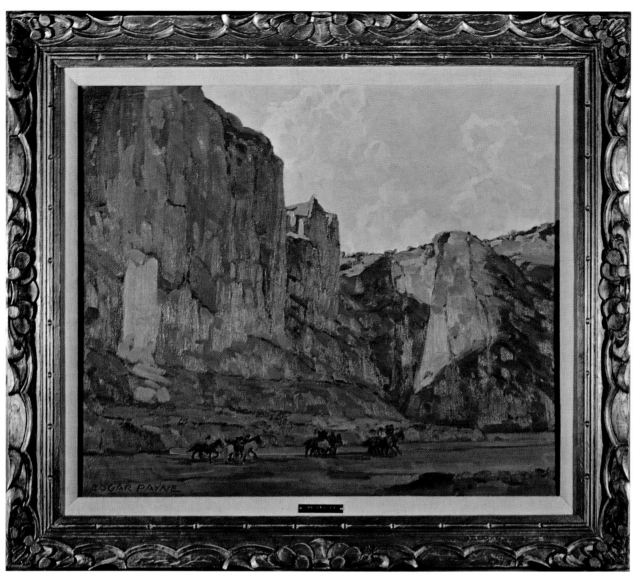

NAVAJO DAY'S END, CANYON DE CHELLY *Oil* 25 x 30 inches

Bert Phillips

1868–1956

THE GREAT HEROES OF Bert Greer Phillips' youth were Kit Carson and the American Indian. Years later he was able to pay tribute to both of them in a unique and gratifying way.

Born in Hudson, New York, he began drawing before he could write, and when still a small boy won first prize at the county fair for a collection of watercolors. After studying at the Art Students League and the National Academy of Design, he set up a studio in New York where he painted for the next five years. He then spent seven months in England where he produced some charming watercolors of pastoral scenes. In Paris he studied at the *Académie Julien* with Benjamin Constant and Jean Paul Laurens. There he met Joseph Sharp and Ernest Blumenschein, who shared his desire to paint the American Indian. Sharp, who had visited Taos in 1893, told the two young artists about the beauties of the New Mexico village and its Indians.

Returning to New York, Phillips and Blumenschein shared a studio and planned a sketching trip by horse and wagon from Denver to Old Mexico. The trip ended in Taos in 1898. Neither one cared to go farther, and Phillips settled immediately, becoming the first of the pioneer Taos artists to establish permanent residence there. In 1899 he married Rose Martin, an eastern girl who was visiting her brother, Dr. T. P. Martin. It was at Dr. Martin's house in 1912 that the Taos Society of Artists was organized with Phillips, Blumenschein, Sharp, Irving Couse, Oscar Berninghaus, and Herbert Dunton as the six charter members.

Of Taos, Phillips said, "I believe it is the romance of this great pure-aired land that makes the most lasting impression on my mind and heart." He infused his paintings of the Indians with a romantic, lyrical quality. Among the many New Mexican artists, he probably achieved the closest relationship with the Indians, breaking through their natural reserve with patience and understanding.

Through his intercession with the government, the "sacred mountain" of the Taos Pueblo Indians was protected from prospectors, and when the great forest lands were made a national preserve, it was Bert Phillips who named them "the Kit Carson National Forest." In December 1970 the title to the vast preserve was returned to the Indians.

Phillips died in San Diego, three years after the death of his wife.

TUDL-WHEE-LA-NA *Oil* 18 x 14 inches

J. K. Ralston

b. 1896

THE BREADTH OF HIS KNOWLEDGE and the thoroughness with which he researches his subjects have brought James Kenneth Ralston recognition as a scholarly historian as well as an artist of distinction. His log cabin studio in Billings, Montana is filled with books, manuscripts, old photographs, and historical documents which he constantly uses to authenticate his work.

But Ralston does not have to rely solely on research. He is descended from a long line of Western pioneers. He saw his first roundup when he was ten, and later worked as a cowboy on the old "79," CK, F Bar, and other ranches. He worked with men who came over the trail in the eighties, and listened to the stories of Indian fights from men who had taken part in them. He was born on his father's ranch in Choteau, Montana. The family moved frequently during his early years as his father explored the gold fields of the Northwest before settling down.

From the time he was ten Ralston was keenly interested in drawing and was encouraged by art teachers at the schools he attended in Helena and Culbertson, Montana. In 1917 he accompanied a cattle train to Chicago and while there enrolled at the Chicago Art Institute, having decided to be an artist instead of a cowboy. His studies were interrupted by World War I, during which he served as a machine gunner in the infantry. The war over, he again attended the Chicago Art Institute.

After returning home, he married a young school teacher, Willo Arthaud. The couple soon went to Washington and Vancouver, British Columbia, where Ralston worked as a commercial artist. Upon the death of his father, he went back to Montana to manage the family ranch. He moved to Billings in 1935 and by the early 1940s, his canvases were in great demand. Though he has worked in almost every medium, he is best known for his murals and massive historical paintings. The latter may be seen at Custer Battlefield National Monument, Montana Historical Society Museum, Whitney Gallery of Western Art in Cody, Wyoming, and the Jefferson National Expansion Memorial in St. Louis, Missouri.

J. K. Ralston draws on his experience as a cowboy for the painting shown here. A wagon pilot's job is to go with the roundup wagons when they move; he sounds out the creek crossings, chooses the place to set up camp, and gives help in case of trouble.

160

THE WAGON PILOT *Oil* 24 x 24 inches

Henry Raschen

1854–1937

HIS VERSATILITY makes Henry Raschen equally adept at any form of painting. Portraits, Indian studies, or landscapes — all display his sureness of technique, and the lifelike quality which distinguishes his work. But it is in his California landscapes, with their strong interplay of golden sunshine and purple shadows, that he seems most at ease.

As a small boy, Raschen emigrated with his family from Oldenburg, Germany to Fort Ross, California. He received his early art training at the old San Francisco Art Association, and was influenced by Charles Nahl. Feeling that Europe could offer him a more comprehensive art education, Raschen went to Munich when he was twenty-one. There, for many years, he pursued his studies under such teachers as Streihuber, Barth, Dietz, and Loefftz. Among his associates, who were later to become famous themselves, were Walter McEwen, William Chase, Walt Shirlaw, and Reginald Birch, who did the illustrations for Mark Twain's classic *A Connecticut Yankee at King Arthur's Court*. Upon the completion of his training in Munich, Raschen traveled in Italy and France, then returned to San Francisco, where he settled.

During the next eight years Raschen, accompanied by the landscape painter C. Von Perbandt, made many excursions among the different Indian tribes of California. He became an accomplished Indian painter, and his work done at this time shows a remarkable faithfulness to nature.

Taking another trip to Europe, Raschen opened a studio in Munich. His success at selling his paintings and teaching art was such that he was later able to spend a year in Italy before returning to California, where he continued living until his death in Oakland in 1937.

Raschen's paintings are in collections and galleries all over the world, but one person who assisted in establishing him as a major artist was the generous art patroness Mrs. Phoebe Hearst. As an early member of the San Francisco Art Association and the Bohemian Club, Raschen's influence was felt in West Coast art circles. In 1898 and 1899 he was manager of the art division of the 31st Annual Exposition of the Mechanics' Institute of San Francisco. Among his other honors and awards are the Gold Medal, Crystal Palace Exhibition in Munich, 1898; and the Gold Medal, Alaska-Yukon-Pacific Exposition in Seattle, Washington, 1909.

HIGH COUNTRY TRAIL *Oil* 26 x 46 inches

Robert D. Ray

b. 1924

NOW A RESIDENT OF TAOS, NEW MEXICO, Robert D. Ray considers himself a painter of "light." He believes that the light around Taos is of a particularly crystalline quality which cannot be found anywhere else; and the Sangre de Cristo Mountains, frequently included in his landscapes, are there principally as objects on which to hang the light.

A native of Denver, Colorado, Ray was strongly influenced and encouraged by an unusually competent art teacher to further develop his artistic ability. But acceding to his family's wishes, he enrolled in business courses when he went on to Drake University in Des Moines, Iowa.

World War II interrupted his college training, and he served for three years in the Navy Seabees. After his discharge from the service he returned to Drake, convinced that painting was the most suitable career for him. At the close of one semester he transferred to the University of Southern California and, in 1950, graduated with a Bachelor of Fine Arts degree, *cum laude*.

More comprehensive art training followed when he studied at the *Centro de Estudios Universitarios*, Mexico. There he worked under Justino Fernandez, and after doing both a written and a painted thesis he received a Master of Arts degree, *magna cum laude*.

Traveling in Europe for a year, Ray spent considerable time in Italy where he was greatly influenced by the Italian Renaissance painters. In the meantime, his work was being accepted by an increasing number of galleries, and through a gallery in Taos he received a Wurlitzer Foundation grant. One of his proudest achievements is the painting shown here. It was originally commissioned by the New York World's Fair, and was to be a composite of all New Mexico. He traveled throughout the state making numerous sketches preliminary to doing the finished painting. The canvas, in addition to being exhibited at the fair, has won many awards and was reproduced in the *New Mexico Magazine*.

In his studio-home, which he built himself, Ray applies his far-reaching imagination and meticulous craftsmanship to a variety of media — painting, drawing, sculptures, and prints. Recently he has been working in a new medium, a form of glass sculpturing, which he calls "splintered light." He has received many honors and awards, and his work is widely represented in public and private collections.

164

NEW MEXICO I *Oil* 36 x 32 inches

Doel Reed NA

b. 1894

OF HIS WORK DOEL REED SAYS, "I am deeply interested in life and nature, not as a reflection but rather as an emotional expression, which in turn excites and stimulates the creative impulse. From this point, I set down my findings in a manner which I hope will convey the same emotional experience to others. Over a period of many years, I have worked to develop a manner that would be my signature, something of myself unaffected by the great number of styles that have come and gone." This is a revealing, informative self-assessment of his purpose and style.

Reed was born in Logansport, Indiana, and attended school there. His first interest was architecture, but after working in the field for several years, the urge to draw and paint led him to enroll in the Art Academy of Cincinnati. His studies were interrupted by World War I, during which he served overseas as an observer with the 47th Infantry, 4th Division. He was gassed and temporarily blinded, and after months in the base hospital in Tours, France, he was returned to the United States. Following his discharge he returned to the Art Academy.

Reed became interested in graphics, but as few schools had courses in this subject at that time, he learned printmaking by the trial and error method and by observing his fellow craftsmen. Studying the aquatints of Goya led him to do his first experiments in this challenging field.

From 1924, when Reed accepted a position in the art department at Oklahoma State University, he and his family spent many summers in Taos, New Mexico. After thirty-five years as head of the art department, Reed retired from the university and moved to Taos permanently. As a firm believer in drawing from life, he often goes out from his studio to explore the little Spanish villages in the foothills and canyons of the beautiful Sangre de Cristo mountain range. Los Cordovas, the village shown here, has been in existence since the early 1600s. On these trips he makes drawings which he later develops into finished paintings.

Reed has won many awards for his work in various media — oil, casein, and aquatints. He was elected in 1952 to the National Academy of Design as a worker in the graphic arts. He is represented in many major museums, including the Metropolitan Museum of Art in New York; *Bibliotheque Nationale*, Paris; Victoria and Albert Museum, London; and the Pennsylvania Academy of Art, Philadelphia.

166

LOS CORDOVAS SHEEP VILLAGE *Oil* 25 x 50 inches Dated 1967

Warren E. Rollins

1861–1962

FOR MANY YEARS Warren Eliphalet Rollins has been known as the "Dean of the Santa Fe art colony." He was the first artist to have a formal exhibition there; it was held in 1906 in the old Palace of the Governors. He was a close friend of Carlos Vierra, Gerald Cassidy, Kenneth Chapman, Sheldon Parsons, and most of the other famous artists who assembled in the New Mexican capital during the first half of this century.

Born in Carson City, Nevada, Rollins was raised in California and attended the San Francisco School of Design where he studied under Virgil Williams. At the completion of his studies, he was awarded the Avery Gold Medal and made assistant director of the school. Following his marriage in 1887, he and his wife settled in San Diego, and it was during this period that Rollins became interested in the Indian as subject matter. In search of material, Rollins, his wife, and their two daughters, Ramona and Ruth, traveled through every Western state from the Mexican to the Canadian borders. While in Montana, Rollins was commissioned by a club in Billings to do a portrait of Calamity Jane. The sitting took place in a saloon, and while Rollins drew, Calamity drank, wept, and poured out the story of her life to him. The portrait, which is the only one ever made of her, was lost in a fire at the Billings Club.

In 1900 he spent a year in Arizona painting the Hopi Indians and at other periods the Navajo and Zuñi Indians, and these studies became very popular. His constant search for new subject matter took him to Taos, where he had a studio near his friend Irving Couse; to Chaco Canyon in northwestern New Mexico, sketching and painting its ancient ruins; to the Grand Canyon where he had a studio near the El Tovar. His dramatic canyon painting was purchased by the Santa Fe Railroad.

Rollins was the first president of the Santa Fe Art Club, and active in the Museum of New Mexico, Santa Fe, which has an extensive collection of his work, including "Grief," one of his most famous paintings. He did murals for the Museum, the post office and Harvey House in Gallup, and triptychs depicting Zuñi life for Bishop's Lodge, Santa Fe. His "Mayflower Series," done in Crayo-tone, a medium he developed and used almost exclusively in later years, was widely exhibited on the East Coast.

Warren E. Rollins continued painting well into his nineties and died at the age of 100 years and five months in Winslow, Arizona.

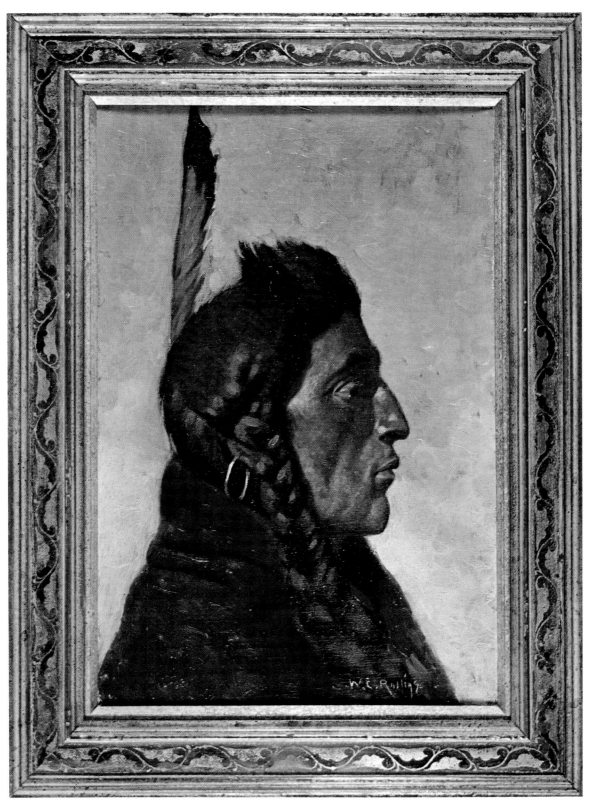

NORTHERN PLAINS INDIAN *Oil* 16 x 11 inches

Carl Rungius NA

1869–1959

GERMAN-BORN CARL RUNGIUS was our foremost painter of North American big game animals. He was a great naturalist, a fine draftsman, and an anatomist with a thorough knowledge of musculature and bone structure. In many of his paintings he achieved the feeling of rotating movement so common to animals in a herd. His sense of color was also well developed, and he used it boldly or with much subtlety, as the particular situation seemed to merit.

Carl Rungius was born near Berlin. Even during his boyhood he was completely captivated by big game animals, and his earliest ambition was to come to America where he could study and paint them.

After his arrival in this country, Rungius established his winter quarters in New York City, and a summer home and studio in Banff, Alberta, Canada. An outdoorsman completely in love with nature, he frequently stayed away from both homes for weeks at a time, as he hunted through the untamed regions of Wyoming, the Yukon, and the Canadian Rockies. For over fifty years he stalked moose, caribou, and the ferocious grizzly bear; he also sought the smaller animals such as mountain sheep, goat, elk, deer, and antelope.

Sometimes on these Western field trips his path crossed that of cowboys on a cattle drive or roundup. He became friendly with these men and did a series of oil paintings depicting their way of life. His output on this subject matter is comparatively small. These cowboy painting are in great demand, not only for their rarity but for their on-the-spot sense of reality and honesty. This was true of all his work, for each canvas, no matter what the subject, was done directly from nature.

Rungius received many honors and prizes. He was elected Associate of the National Academy in 1913 and National Academician in 1920. One of his admirers was Theodore Roosevelt, who was also a personal friend. Roosevelt owned a moose done in bronze by Rungius and several of his paintings. Considering the purchase of one, Roosevelt said, "This is the most spirited animal painting I have ever seen. I'll take it."

Some of Rungius' Western paintings are in the Beach Memorial at the Shelburne Museum, Shelburne, Vermont.

SUPPLY TRAIN *Oil* 16 x 20 inches

Charles M. Russell

1864–1926

IT IS GENERALLY CONCEDED that two men stand out as the greatest exponents of Western cowboy and Indian art — Frederic Remington and Charles Marion Russell. Their lives had certain parallels — they were born in the same decade; both were largely self-taught; both were drawn to the frontier from birthplaces elsewhere; both recorded in paintings, drawings, and sculptures the last days of the Old West. However, Remington attained early success and died in middle age, while Russell had to struggle to gain recognition, but once having achieved it, enjoyed the rewards of a long and fruitful career.

From his birthplace, Oak Hill in the outskirts of St. Louis, Russell ran away to the wilds of Montana when he was fourteen. He was returned, but realizing the futility of thwarting the young boy's desires, his family allowed him to go back to Montana the following year. There Russell lived and painted for most of his life until his death at Great Falls.

Living the life of a territorial hunter, trapper, and cowboy, Russell became thoroughly familiar with the ways of the West. As a compassionate friend of the Indian people he lived with the Blackfeet in Canada for a time, learning their language and depicting their civilization in many drawings, paintings, and writings.

In the early days, having little sense of economic responsibility, Russell frequently gave away paintings to friends, left them on bunkhouse walls, or kept them for himself. After marriage, however, his wife Nancy marketed his work, and within a few years he commanded prices well up into the thousands.

Preparatory to doing a finished painting Russell often made wax images of the figures to be included in the composition. This, he said, gave him the feel of light and shadow, thus increasing the strength of form so evident in his work. In more permanent sculptures he has left a rich legacy of bronzes.

Major collections of his work are in the new C. M. Russell Gallery in Great Falls; Montana Historical Society, Helena; Amon Carter Museum, Fort Worth, Texas; Whitney Gallery, Cody, Wyoming; Gilcrease Institute, Tulsa, Oklahoma; and National Cowboy Hall of Fame, Oklahoma City.

172

POTLATCH AT JUNEAU *Gouache* 14 x 18 inches
From the book *Fifteen Thousand Miles by Stage* by Carrie Adell Strahorn

Tom Ryan CA

b. 1922

AMONG THE MANY HONORS which have come Tom Ryan's way in recent years, none has given him greater satisfaction than his adopted citizenship in the state of Texas. His residency there has placed him in the mainstream of Western life and inspired many of his finest canvases. Born in Springfield, Illinois to parents who had an avid love of Western history, he developed a strong affinity for the West at an early age.

Ryan began his art education at the St. Louis School of Fine Arts after two years at Springfield Junior College. His studies were interrupted by World War II, and in 1942 he entered the U. S. Coast Guard serving with Kincaid's 7th Amphibious Fleet in the South Pacific. After his discharge he held a G.I. sponsored on-the-job training position as an artist with an advertising agency in Springfield. Following this he spent three years at the American Academy of Art in Chicago where he studied under Antoine Sturba and William Mosby.

A persistent desire to be a fine arts painter led him to New York for further training. While studying at the Art Students League under Frank Reilly, he worked as an assistant to Dean Cornwell, and became acquainted with several of Howard Pyle's students. After winning a book cover contest he spent the next eight years doing paintings for Western book jackets. On his numerous sketching and research trips in the Southwest, Ryan came to love the rugged country and within a few years he moved with his family to Lubbock, Texas, where he now resides.

Ryan's highly realistic style and meticulous detail cause him to spend a great deal of time on a canvas — often as long as two months. He feels that he is at his best depicting the present-day cowboy, and he gets much of his subject matter from the Four Sixes (6666) Ranch at Guthrie, not far from his home. It is one of the few ranches still using night horses on occasion. These older more experienced animals are not up to the rigors of a full day's work. They are staked out at night, as shown in the background of the painting here, until they are needed to round up the remuda, the working horses, before dawn.

Three of Ryan's paintings are in the permanent collection of the National Cowboy Hall of Fame at Oklahoma City. In 1968 he won the Gold Medal Award in the Cowboy Artists of America competition, and in 1969 he received the coveted George Phippen Memorial Award.

174

NIGHT HORSE *Oil* 20 x 36 inches

Olaf C. Seltzer

1877–1957

LACKING THE ROBUST and colorful personality of his friend and mentor, Charles Russell, Olaf Carl Seltzer did not receive recognition as a first-rate Western artist until recent years. As the leading painter of the "Russell School," his style shows the influence of Russell, but his own individuality — especially in his subtle use of color and decisiveness of line — permits his work to take its place among the finest examples of Western art.

The first fourteen years of Seltzer's life were spent in Copenhagen, Denmark. He attended the public schools there, and when he was only twelve his exceptional talent in draftsmanship warranted his admittance as a special student to the Technical Institute of Copenhagen.

Upon his father's death, his mother moved the family to Great Falls, Montana. For a time the young boy worked for several horse outfits, then became an apprentice machinist in the Great Northern Railroad shops. After completing his apprenticeship he became a railway and locomotive repairman and worked industriously at this occupation for more than a quarter of a century.

It was during the early period of his job with the railroad that Seltzer met Charles Russell, who taught and encouraged him to paint in both watercolor and oil. For many years Seltzer practiced his painting on the side, while still holding his job with the railroad. It was not until 1921, however, when there was a mass layoff in the machine repair shops that he attempted to make a living with his art. To his surprise and delight he found that he could. Local eminence and commissions started to come his way.

In 1926 and 1927 he stayed in New York, studying paintings in the museums and galleries and making contacts with eastern buyers. During the following years he made many trips to New York and other eastern cities as his work was receiving acceptance there as well as in the West.

Poor eyesight, caused by executing over a hundred miniatures under a powerful magnifying glass, did not prevent Seltzer from being a prolific artist; he turned out over 2500 paintings. A large collection of his work is owned by the Gilcrease Institute in Tulsa, Oklahoma.

Seltzer died in Great Falls in his eightieth year.

THE WATER HOLE *Watercolor* 9 x 12 inches

Joseph H. Sharp

1859–1953

KNOWN AS "the father of the Taos art colony," Joseph Henry Sharp was one of the first artists to visit New Mexico, arriving there in 1883. When he returned in 1893, he visited Taos, and from that time on became its most enthusiastic promoter, setting up a chain reaction which brought the leading artists of three decades to this small Indian village.

Though completely deaf as a result of a childhood accident, he never allowed it to handicap him. He had a cheerful, generous nature, was an avid traveler, and a very prolific artist. Born in Bridgeport, Ohio, he saw his first Indians in Wheeling, West Virginia, just across the Ohio River. He said, "I was first interested in Indians before becoming an artist."

After the death of his father, he lived with an aunt in Cincinnati where he attended the McMicken School of Design and later the Cincinnati Art Academy. In 1881 he went to Europe, studying with Charles Verlat in Antwerp and on successive trips, with Carl Marr in Munich and Benjamin Constant and Jean Paul Laurens in Paris. From 1892 to 1902 he taught the life class at the Cincinnati Art Academy during the winter, leaving his summers free for sketching trips which covered the entire West.

Just prior to 1900, he went to the Sioux country in southeastern Montana. A year later, President Theodore Roosevelt had his Indian Commissioners build Sharp a studio and cabin at the Crow Agency on the old Custer battlefield. Though he endured hardships in the bitter climate, struggling with frozen fingers and frozen paints, Sharp traveled throughout the Plains country doing hundreds of Indian paintings.

In 1902 Sharp began spending several months each year in Taos, painting the Pueblo Indians. In 1909 he acquired a permanent studio there and in 1912 became a charter member of the Taos Society of Artists. During visits to Hawaii, he produced a series of brilliant landscapes, seascapes, and florals. He died in Pasadena where he had a winter home.

Of all the Indian painters, Joseph Sharp was the most objective. His faithful accuracy in depicting the differences between the various tribes — in facial structures, costumes, artifacts, and ceremonials — make his work as highly prized by anthropologists as by art lovers. Nearly 100 of his paintings are owned by the Department of Anthropology, University of California at Berkeley. Others are in the Bureau of Ethnology of the Smithsonian and in museums throughout the country.

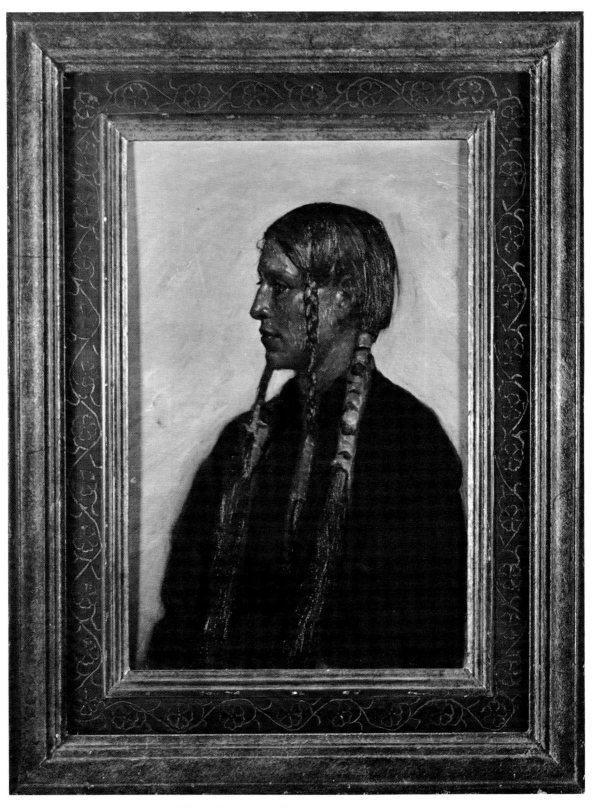

YOUNG CROW INDIAN *Oil* 18 x 12 inches

Will Shuster

1893–1969

COMING WEST IN 1920 with the intention of settling in Taos, New Mexico, Will Shuster decided instead on making his home in Santa Fe, and thus began what was to be a lifelong love affair with the "City Different."

Born in Philadelphia, Pennsylvania, Shuster also attended schools there. During World War I he saw action in France and was the victim of German gas attacks. Upon his return to Philadelphia he studied art for a time under J. William Server, but was advised by his doctors to seek the dry clear air of New Mexico as an aid to his damaged lungs.

The presence in Santa Fe of such eminent artists as Carlos Vierra, Randall Davey, and John Sloan was a decisive factor in his resolve to settle in that city. He was at once accepted by the artists in residence, and he learned much from them; Sloan particularly was a strong influence in his artistic development. Later Shuster joined four other painters — Willard Nash, Jozef Bakos, Fremont Ellis, and Walter Mruk — and they became known as *"Los Cinco Pintores."* The five men established studios and homes in the same neighborhood, painted together, and experimented with newer art forms. Of his beliefs about art Shuster said, "Art is the flowering of humanity. It embellishes life and reveals timelessly the nature of the plant on which it grew."

No matter what his subject matter — Pueblo Indian ceremonials, mountains and clouds, or scenes depicting the convictions of the folk religion cult known as the *Penitentes* — he was singularly successful in capturing the spirit of New Mexico.

In addition to painting Shuster also did sculptures and life masks. He is credited with originating the famous Zozobra, or "Old Man Gloom," the towering figure which is burned each year at Santa Fe's fiesta. In later years he created a float which took first place at the Tournament of Roses, and in 1952 he designed and executed "El Toro," a rakish bull which has become the permanent symbol for the rodeos of Santa Fe.

Until his death in Albuquerque of acute emphysema Shuster continued to paint, to banish gloom around him, and to take an active and integral part in the life of the city which he loved so dearly.

PENITENTE CRUCIFIXION Oil 40 x 30 inches

DeCost Smith

1864-1939

WHEN ONLY TWENTY YEARS OLD, DeCost Smith went among the Indians at the Lower Brulé, Rosebud, and Standing Rock Indian agencies in Dakota territory. This was his first venture into the West, and for such a young man he showed extraordinary maturity and wisdom in his relationships with the Indians. His sympathetic understanding and warmly human compassion gained him their confidence to a marked degree. So profound was his concern with Indian culture that he learned to speak several dialects. Their open-hearted acceptance of him allowed his paintings to be done with an unusual amount of accuracy and honesty.

Smith was born in Skaneateles, New York. Even as a small boy his fascination with Indians was apparent. He made frequent visits to the Onondaga Reservation near his home and was initiated into the Onondaga tribe. It was after he saw paintings by George de Forest Brush in the early 1880s that he decided to become an Indian artist.

In New York, Smith studied at the McMullin School and at the Art Students League; in Paris, at the *Académie Julien*; while there he had an exhibition of Indian paintings in the Paris Salon.

A writer as well as a painter, his many trips to the West, and his experiences with the Indians, resulted in a series of articles, done in collaboration with Edwin Willard Deming, for *Outing Magazine* — "Sketching Among the Sioux," "Sketching Among the Crow Indians," and "With Gun and Palette Among the Redskins." Smith's autobiography, *Indian Experiences*, was published after his death, which occurred at age seventy-five in Amenia, New York; it contains many illustrations and fascinating stories of his close association with the different Indian tribes.

In addition to the illustrations he did to accompany his own writings, Smith received commissions from *Century Magazine* and other leading periodicals of the day; he was listed as an illustrator in the American Art Annuals from 1905 to 1934. But it is for his Indian paintings that he will best be remembered. He was a member of the Salmagundi Club, the American Ethnological Society, and the Moravian and Dutchess County Historical societies. A large collection of his work was divided between two museums in New York City: the American Museum of Natural History and the Museum of the American Indian, Heye Foundation.

WINTER HUNT *Oil* 20 x 16 inches Dated 1895

John Mix Stanley

1814–1872

JOHN MIX STANLEY was one of the most prolific and widely traveled artists of the early West. Both on his own and as a draftsman and artist with some of the period's most important surveying expeditions, he covered the entire Western territory, from the Southwest to the Pacific Northwest. His portrayals of the Indian stemmed from close personal experience, and were noted for their accuracy.

Stanley was born in Canandaigua in the Finger Lakes country of New York. When he was five his mother died, leaving him to the care of his father, a tavern keeper. Friendly Indians who frequented the tavern gave the motherless boy their affection and aroused in him a lasting interest in their race. At twenty-one Stanley left home and traveled about Michigan, Illinois, Wisconsin, and Minnesota, working as a house and sign painter and as an itinerant artist whose specialty was Indian life. He made his first trip to the West in 1842, and in 1843 attended the Indian Council of ten thousand tribesmen in Tahlequah, Oklahoma Territory, the capital of the Cherokee nation, where he produced more than eighty canvases.

For the next three years he roamed through Oklahoma, Texas, Kansas, and the Plains area. At Independence, Missouri, he joined Col. S. C. Owens' train. The party included Susan Magoffin whose diary of the trip became the most famous written record of the Santa Fe Trail. Arriving in Santa Fe in 1846, Stanley joined Col. Stephen W. Kearny's expedition and, with Kit Carson as scout, they headed for San Diego. He then traveled to San Francisco, the Pacific Northwest, and Hawaii, where he remained for a year and painted two portraits of King Kamehameha and his queen.

When he returned to the United States he took his Indian Gallery on a tour of eastern cities. In 1852 he placed over 150 of the paintings on exhibition in the Smithsonian Institution and started negotiations with the government to purchase them for a permanent display. A year later he accompanied Isaac I. Stevens, Governor of the Territory of Washington, on his extensive railroad survey expedition to the Northwest.

After marrying Alice C. English in 1854, he spent the rest of his life painting Indians in his studios in Washington, D.C., Buffalo, and finally, Detroit, where he died at the age of fifty-eight. Ironically, in 1865, while Congress was still deliberating over the purchase of his paintings, all but five on exhibition were destroyed by a fire in the Smithsonian.

KIDNAPPED *Oil* 30 x 42 inches

Ross Stefan

b. 1934

THE SON OF A MAN WHO WORKED in the advertising business, young Ross Stefan had countless opportunities to meet and know many artists. The one he credits with having the strongest influence on him was Dan Muller, the adopted son of "Buffalo Bill." Muller lived on the outskirts of Milwaukee, Wisconsin, where Stefan was born, and his studio was often visited by the young boy who was filled with wonder at the trappings of an artist's life. It was then that he determined to follow the same career.

In his boyhood Stefan was fascinated by horses, Indians, and cowboys. When he was only six he drew comic books of these subjects and sold them to his friends for ten cents. When the family moved to Tucson, Arizona, Stefan seemed to fall into his rightful realm. He shows a remarkable penchant for capturing the feel of desert sunlight on adobe walls, the weathered faces of Indians and work-hardened cowhands, and he is equally adept at depicting horses.

When Stefan was twenty-one, he began painting full time and opened a gallery and studio in Tubac, Arizona, where he lived for several years. He now lives on several acres in Tucson's Catalina Foothills with his wife and two sons. He puts in a full day's work at the easel after starting the morning with breakfast in town. He says, "It's the secret of a happy marriage." This breakfast in town is his way of keeping in touch with the "outside world," for upon his return to his studio he spends many hours at his work. At the end of the day he heads for the pool where he finds swimming an excellent way to relax.

Stefan's wife, though not an artist herself, understands the rigorous regime her husband has set for himself. When they met she was an art history student at the University of Arizona, and she is now Stefan's severest critic.

Of his work Stefan says, "You could say that this is my purpose: to paint remnants of a bygone era — as still found today — the Indian, the cowboy, their land."

His work is in many private collections and in galleries and museums in California, New York, Colorado, Texas, and Arizona.

MEETING OF THE CLAN *Oil* 26 x 40 inches

James Swinnerton
b. 1875

THE EARLY YEARS OF James Guilford Swinnerton were closely bound to the towns of northern California. He was born in Eureka and raised in Santa Clara. His grandfather was a Forty-Niner who found gold at Dutch Flat. His father was founder and editor of the *Humboldt Star*, and later became a lawyer and judge in Stockton.

At sixteen, Swinnerton enrolled at the California School of Art in San Francisco. Ignoring the Greek figures assigned to the class, he sketched landscapes and caricatures of the professors. When William Randolph Hearst saw these sketches he offered him a job on the *San Francisco Examiner* and the two formed a friendship which lasted through the years. In addition to doing cartoons of sporting events and the news, Swinnerton drew comic little bears to give a daily pantomime of the weather forecasts, and by 1892 these had become so popular that they were expanded into the first newspaper comic strip in the country.

Later, when Hearst went to New York to start a Sunday supplement, Swinnerton joined him and launched the comic strips, "Little Jimmy" and "Little Tiger." His success, however, was shadowed by alcoholism and tuberculosis. In 1903, when a dry climate was prescribed as his only hope, he moved to Palm Springs, California, and from that base roamed the desert on his burro, sketching and sleeping in the open.

With the return of his health, he began to range over the entire Southwest. In 1907 he explored northern Arizona and here he found some of his favorite subjects — the Grand Canyon, the Navajos and the Hopis. He started "Canyon Kiddies" which ran in *Good Housekeeping* magazine and became the favorite of millions.

In 1938 Swinnerton married Gretchen Parshall and in that same year he was the only Western artist to have a painting selected for exhibit in the San Francisco World's Fair. Over the years his oil paintings took on a new subtlety — a soft blending of colors and delicate lighting. His desert scenes with smoke trees, boulders, canyon walls, the humble home of the Navajo or Hopi, and his scenes of the Grand Canyon and Monument Valley have become famous and are in major galleries and private collections. In 1969 he had two retrospective exhibitions — in Flagstaff, Arizona and Palm Springs, where he now lives. At the age of ninety-six, James Swinnerton is known to thousands as "the Dean of Desert Artists."

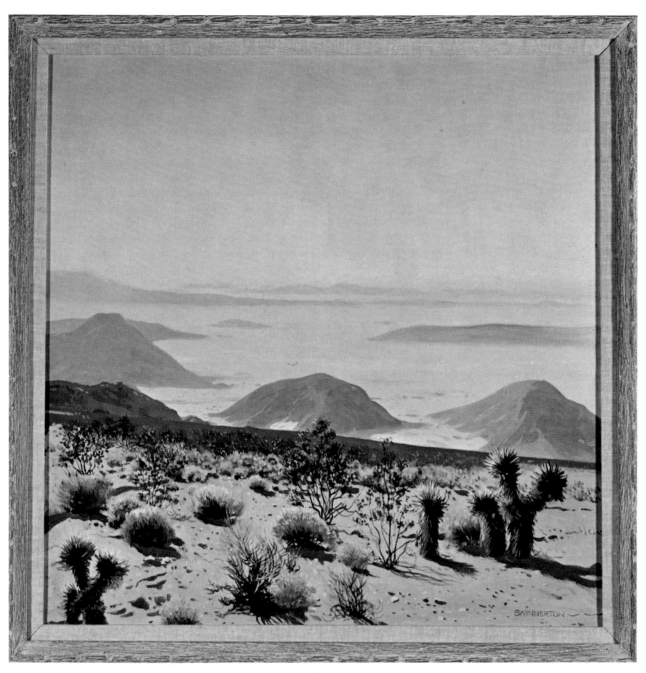

DEATH VALLEY SINK *Oil* 20 x 25 inches Dated 1938

Arthur Fitzwilliam Tait NA

1819–1905

KNOWN PRIMARILY for his wild game and barnyard animal pictures, which were reproduced extensively by Currier and Ives, Arthur Fitzwilliam Tait also did many paintings depicting the Western scene. In contrast to most Western artists, he made no particular attempt at authentic representation, but was more concerned with the purely pictorial beauty of his compositions. His paintings were popular, and from them many people in the East formed their ideas about life on the frontier.

Born near Liverpool, England, Tait was working for a company of art dealers while still in his mid-teens. His interest in art was so great that even after a twelve-hour workday, he studied at night at the Royal Institute in Manchester. When George Catlin arrived in England, Tait assisted him with his Indian Gallery and is said to have accompanied him to Paris for his exhibitions there. Fired by this contact with the Western frontier, Tait determined to make art a full-time career, and emigrated to the United States.

In 1850 he arrived in New York and established a studio on Broadway and another by Long Lake in the Adirondacks. It was at this lakeside camp that he did some of his best work. Here he had the chance to observe nature and study animals in their natural habitat. He spent long hours in the wilds hunting, fishing, examining forest life, and painting. So thoroughly did he pursue these activities that he became an expert woodsman and one of our greatest sporting artists.

He formed a close friendship with William Sonntag, the landscape painter. The two men achieved a practical working relationship — Tait sometimes painted animals into the foreground of Sonntag's landscapes, and Sonntag did the backgrounds for Tait's works, which is the case with the painting shown here. According to Tait's records of 1882, this painting originally belonged to Henry Fairbanks, onetime governor of Vermont.

Tait also collaborated with Louis Maurer on a series of Indian and Western life pictures. William Ranney had done a number of paintings portraying trappers and pioneers which were similar to those of Tait, and after Ranney's death, Tait helped finish some of the uncompleted canvases so they could be sold in an auction to benefit the Ranney family.

Tait's dead-game panels are now in great demand and his Currier and Ives prints are collectors items. He died at his home in Yonkers, New York.

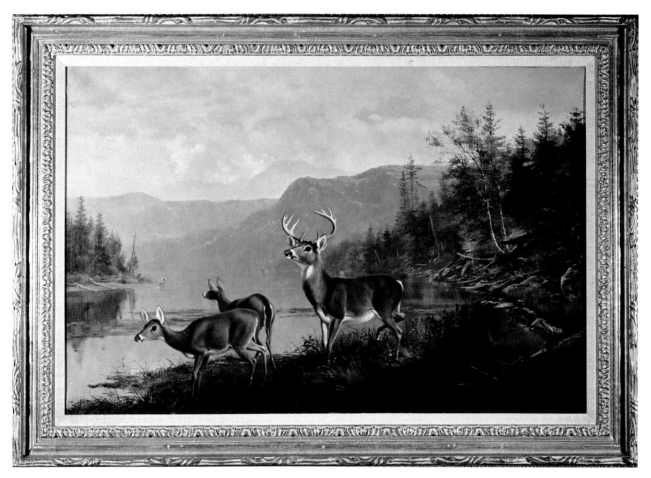

LANDSCAPE WITH DEER *Oil* 26 x 40 inches Dated 1882

Walter Ufer NA

1876–1936

LIKE MANY OTHER ARTISTS of the period, Walter Ufer began his career as a commercial lithographer's apprentice. Much of the expert draftsmanship reflected in his paintings is the result of this early training. The son of an immigrant German master engraver, he was born in Louisville, Kentucky, and as a child sold newspapers in the streets. This liberal, but rather harsh education was, perhaps, most influential in shaping his future personality. He was quick-witted, rough, and unrestrained.

Having decided to become a painter, he saved enough money to go to Dresden and Munich to study. There he developed the solid, realistic style which became his trademark. He also studied at the Art Institute and the F. Francis Smith Art School in Chicago and eventually taught at the latter school. He spent several years working in Chicago as a commercial artist and portrait painter. Later, he liked to tell his fellow artists in Taos that while they were gaining fame and acclaim at the major Chicago galleries, he was drawing tomato can labels for Armour and Company.

In 1914, at the suggestion of Carter Harrison, the former mayor of Chicago who became his patron, he set off for Taos. There his paintings took on lighter and more vivid colors. He portrayed his subjects in a narrative manner and employed rich lighting effects in his landscape backgrounds. Along with Victor Higgins, he joined the Taos Society of Artists, the first new members to be taken into the Society since its founding.

From 1916 to 1926, Ufer won many major awards, but in 1920 he won the award which caused the most rejoicing in the little Taos art colony — the third prize in the Carnegie International Exhibition, Pittsburgh. These prizes invariably went to Europeans and had never before been awarded to a New Mexican artist. It was one of Ufer's greatest triumphs and also the beginning of his downfall. An exclusive eastern dealer began to handle his work, resulting in sales of fifty thousand dollars a year. However four years later, sales dwindled and the fifth year was a failure. The 1929 crash followed and with it Ufer's personal decline — excessive drinking, a disastrous "cure," sudden rages, and an obsession for playing the slot machines. In 1936 when he suffered a heart attack, his Taos artist friends desperately gathered together enough money to speed him to Santa Fe and the nearest hospital, but he was beyond help. It was the tragic ending to a colorful and tumultuous life.

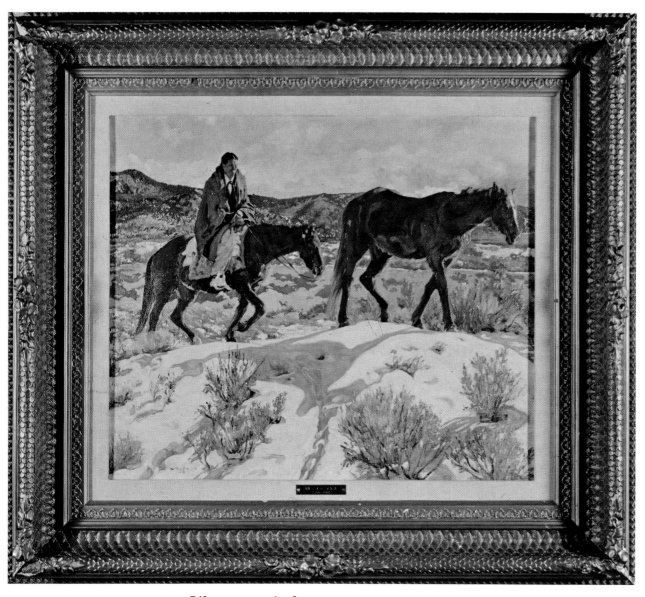

FROM WINTER PASTURE *Oil* 20 x 25 inches

Carlos Vierra

1876–1937

CONSIDERED THE FOUNDER of the art colony at Santa Fe, New Mexico, Carlos Vierra was also largely responsible for the preservation of the city's atmosphere of antiquity and unique charm. He was always vigilant to see that the Spanish-Pueblo style of architecture did not give way to modernistic forms, that historic landmarks were not removed, and that the natural beauties of the area were retained in the path of progress,

The son of a sailor of Portuguese descent, Vierra was born in Moslanding near Monterey, California. His father, knowing the hardships of life at sea, counseled his sons to earn their livelihood on land, but young Vierra felt drawn to the sea and was determined to be a marine painter.

After attending school at Monterey he studied art under Gittardo Piazzoni in San Francisco. Seeking further training in New York, Vierra set sail on an old wooden ship that took six months to reach its destination by way of rounding Cape Horn. In New York he studied and struggled for existence. Just at the time when his marine canvases began to meet with some success his health broke and a physician advised him to seek the dry climate of New Mexico.

For a while he roughed it in a little cabin on the Pecos, but finally, in 1904, went to St. Vincent's Sanitarium in Santa Fe to recuperate. Upon his release he opened a photographic studio on the plaza. His tasteful photographs soon earned him a large clientele. He continued to work at his painting, studied architecture, and practiced target shooting, at which he became so proficient that he later served as an instructor with the New Mexico National Guard for several years. During the border skirmishes with the Villistas in 1916 he served as a captain of the Guard.

Vierra was also a skillful muralist. Upon the death of Donald Beauregard he was selected along with Kenneth Chapman to complete the murals depicting the life of St. Francis which adorn the walls of the auditorium in the Art Museum of Santa Fe; his scenes of Mayan cities are in the California Building in Balboa Park, San Diego. These were commissioned for the California-Pacific International Exposition of 1935 and were seen and admired by people from all over the world.

His devotion and service in preserving the heritage and architectural purity of Santa Fe gained Vierra a permanent place in the hearts of New Mexicans.

194

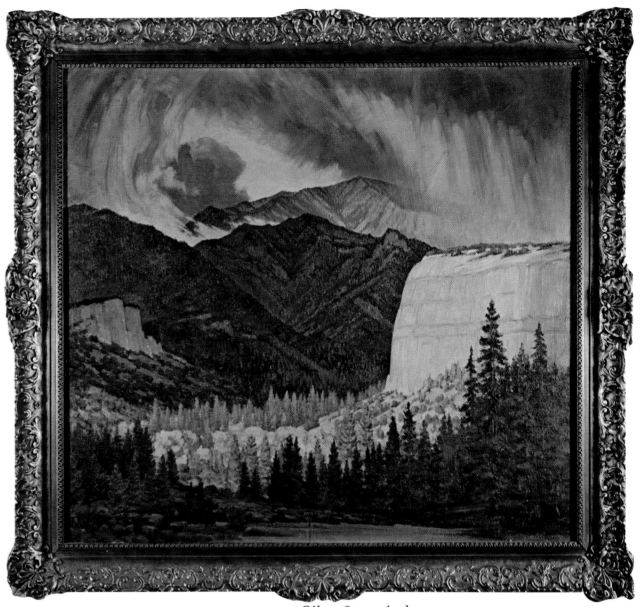

IN THE LAND OF THE CLIFF DWELLERS *Oil* 36 x 40 inches

Harold Von Schmidt

b. 1893

ANY REGULAR READER of the old *Saturday Evening Post* will be familiar with the work of Harold Von Schmidt. One of America's leading illustrators, his work was frequently featured in the *Post, American, Cosmopolitan, Collier's,* and *Sunset.* Among his book illustrations is the classic *Death Comes for the Archbishop* by Willa Cather.

Born in Alameda, California, Von Schmidt was orphaned at five. He and his brothers lived with their grandfather, Colonel Alexis Von Schmidt, who often entertained them with fascinating stories about his early days in the West. Upon his grandfather's death, Von Schmidt was cared for by an aunt who encouraged him to be an artist, and during summers spent as a cowboy, lumberjack, construction worker, and mule skinner he observed closely and practiced his art wherever he went.

He studied at the San Francisco Art Institute and the California College of Arts and Crafts. After serving an informal apprenticeship under Maynard Dixon, he went to New York where he studied under Harvey Dunn at the Grand Central Art School. Dunn taught him "to paint the epic rather than the incident," and had a great influence on his career.

He took a job in 1915 with the Foster and Kleiser advertising agency and became head art director. Some of his co-workers were Roi Partridge, Maynard Dixon, Fred Ludekens, and Judson Starr. In 1920 a group of them, along with Von Schmidt, opened their own advertising art studio in California and it was a great success. During World War I, Von Schmidt did posters for the Navy, and in World War II, served as an artist-correspondent for the Air Force and King Features Syndicate.

Five of his Civil War paintings are in the U. S. Military Academy at West Point, and twelve paintings depicting the Westward trek and the Gold Rush of 1849 are in the Governor's office in Sacramento, California.

Harold Von Schmidt has been an active participant in civic affairs and in numerous art societies. He is a life trustee of the Artists' Guild, New York; honorary president of the Society of Illustrators; and member and officer of the American Indian Defense Association. He was a founding member of the Famous Artists Schools International, Westport, Connecticut, where he now lives with his wife, "Reb." In 1968 he received the Trustee's Gold Medal Award from the National Cowboy Hall of Fame for outstanding contribution to the field of Western art.

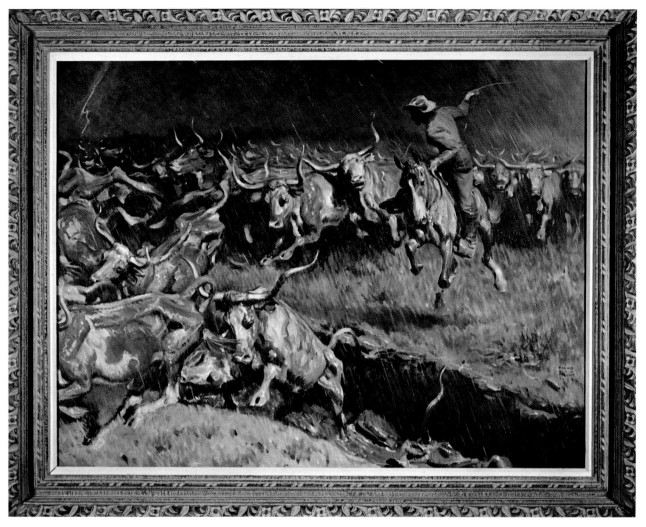

THE STAMPEDE *Oil* 30 x 40 inches

Olaf Wieghorst

b. 1899

FROM BOY ACROBAT in Denmark to one of the foremost painters in the American West is a broad jump, but Olaf Wieghorst made it.

Trained as a child to perform tumbling and balancing acts Wieghorst was known as "Little Olaf — the Miniature Acrobat," and was an immediate success when he made his professional debut at age nine. At the outbreak of World War I, a Paris contract was cancelled and Wieghorst accepted a job on a stock farm. Having always loved horses he took particular delight in his new position, and it was here that he learned to be an expert rider. Later he worked as a stunt man for a film company in Copenhagen and as a trick rider for a circus.

Stories of the adventure to be found in the great American West had excited his imagination, and in 1918 he boarded a steamer bound for New York. After working at various jobs in the city he enlisted in the U. S. Cavalry and spent three years patrolling the Mexican-American border on horseback. This was followed by a period of working as a cowboy on ranches in the New Mexico area. Returning to New York, he joined the Mounted Police, and as soon as he had passed the required examinations, married Mabel, the girl he had met during his first week in this country.

Since boyhood he had sketched and painted, but now he spent as much time as possible visiting museums and galleries in an effort to improve his technique. He attended all rodeo events, not only for sketching, but to keep in touch with the Western life. Eventually his thorough knowledge of horses made him an expert delineator of this subject, and his paintings were reproduced for calendars and magazines. Retiring after twenty years on the Force he headed back west. He is represented in major private collections including the Eisenhower Library in Abilene.

The book, *Olaf Wieghorst*, by William Reed was chosen by the Western Heritage Center in Oklahoma City as the Best Western Art Book of 1969. In the foreword of the book, Senator Barry Goldwater says of him, "After we had talked, I knew that here was a man deeply in love with the West and its people and its way of life. Here was a man possessed with the talent to create on canvas this love. I consider Olaf Wieghorst the outstanding contemporary Western artist." Wieghorst and his wife now live in El Cajon, California, where he continues to ride and paint.

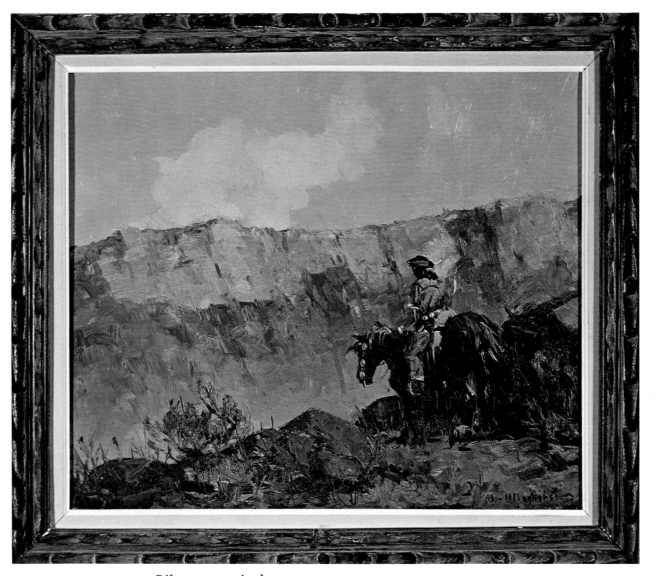

NAVAJO COUNTRY *Oil* 20 x 24 inches

Charles Wimar

1828–1862

CHARLES WIMAR was the youngest of the first generation of Indian painters and died at the early age of thirty-four. Yet the authenticity, craftsmanship, and dramatic power of his work establish him as one of the most accomplished painters of the Indian in the nineteenth century.

Born in Siegburg, Germany, Wimar was christened Karl Ferdinand, but was often referred to by his family nickname, Carl. Later in his professional life he was known as "Charles" Wimar and signed his pictures with that name. At fifteen he came to this country with his mother and stepfather and settled in St. Louis, then still a frontier town and a center of fur trade. Young Wimar made friends with the Indians who came to barter and gained a keen insight into their character and culture.

At seventeen he apprenticed himself to Leon de Pomarede, an enterprising decorative painter. In 1849, when Pomarede decided to do a giant panorama of the Mississippi, he took his young assistant with him on a long steamboat trip up the river to the Falls of St. Anthony. It was Wimar's first extensive view of the vast, unpopulated country with its roving bands of Indians which would later become his favorite theme.

In 1852 Wimar went to Düsseldorf where he studied under Josef Fay and Emanuel Leutze. He continued to dwell on the Indian and sent a number of paintings back to St. Louis to be sold. Only twelve of his Düsseldorf paintings have been located; the painting shown here is one of them and is his only known watercolor. Returning to St. Louis in 1856, Wimar found that the Indians were trading at outposts further west and he embarked on several lengthy journeys up the Missouri River. He did countless sketches and his photographs of the Indians, taken with a primitive box camera, are among the earliest in existence. His paintings were exhibited in the annual St. Louis Fairs, and in 1859 he became a founder of the Western Academy of Art, the first art institution west of the Mississippi. For its opening, he completed "The Buffalo Hunt" which was an overwhelming success and marked the apex of his career.

In 1861 he married Anna von Senden, and in that same year received a commission to decorate the new dome of the old St. Louis Court House. His younger half-brother, artist August Becker, assisted him. After months of arduous labor, Wimar, always in frail health, became hopelessly afflicted with tuberculosis. He died in St. Louis less than a year later.

200

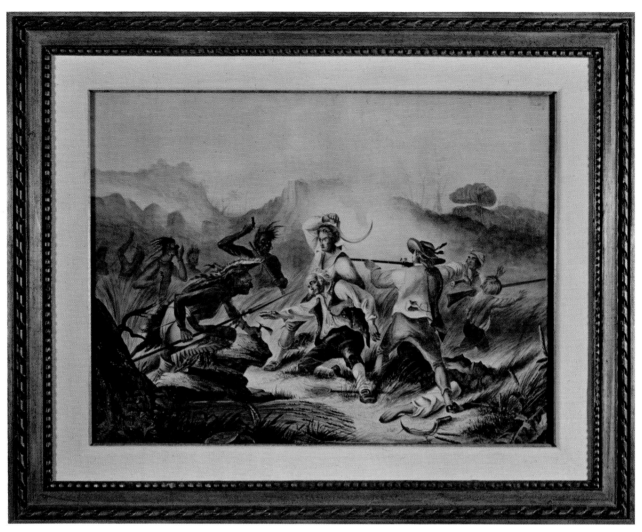

MASSACRE OF WYOMING VALLEY *Watercolor* 18 x 24 inches

Byron B. Wolfe CA

b. 1904

IN SCHOOL the margins of his books were filled with drawings of horses, cowboys, and Indians, disclosing an interest which remains with Byron Wolfe to this day. His studio-home in Leawood, Kansas, on the outskirts of Kansas City, is filled with Indian artifacts and cowboy gear which he studies to gain authenticity in his paintings. He also possesses many valuable Western books for researching historical data and Indian culture.

Born in Parsons, Kansas, Wolfe's interest in Western outdoor life gained momentum when he was employed on a cattle ranch. Determined to be an artist, he studied at the University of Kansas. Upon completion of his training there he became a free-lance commercial artist in Kansas City.

One of his first commissions was a series of Western illustrations for the Goetz Brewing Company of St. Joseph, Missouri. Another soon followed to do cattle scenes which were used in the *Kansas City Star*; this gave his work wide local exposure. After gaining valuable experience in free-lance work, he accepted a job as art director for an advertising agency. He remained in this position for many years, until 1964 when he realized his life ambition and established his studio in Leawood, giving all his time to Western painting. He says of his present situation, "It's just like retiring and doing exactly what you've always wanted to do."

A member of the Cowboy Artists of America, he won the Silver Medal Award for his watercolor, "Way Station, Morning Stop," at their fifth annual exhibit at the National Cowboy Hall of Fame in Oklahoma City. His paintings are in the permanent collections of the Eisenhower Library in Abilene, Kansas; the Whitney Gallery in Cody, Wyoming; the Montana Historical Society in Helena; and others. His work has been featured in many publications, most recently: on the covers of *Western Horseman*, the *Kansas Historical Society* magazine, and the new *Western* magazine.

The degree of historical accuracy for which Wolfe strives is apparent in the painting shown here. It was done to commemorate the centennial of the Chisholm Trail, which stretched from the Mexican border to Abilene, Kansas. Indians sometimes demanded beeves or money from the cowboys on the trail as a price for crossing their land. The cattle were called "WoHaws" by the Indians because they heard the white men yelling at their oxen teams, "Whoa!" and "Haw!"

202

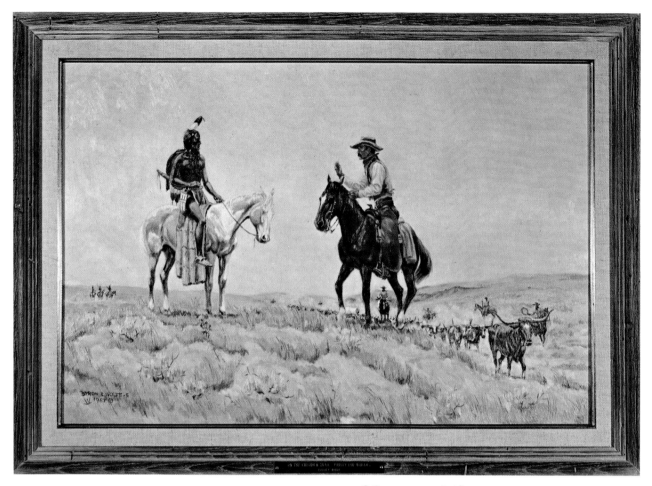

ON THE CHISHOLM TRAIL — PARLEY FOR WOHAWS *Oil* 20 x 30 inches
Dated 1967

N. C. Wyeth NA

1882–1945

ANYONE WHO REMEMBERS the pleasure of curling up on a cold winter's day in his youth with a copy of *Treasure Island* or *Robin Hood* or *The Last of the Mohicans* and being thrilled by the marvelous action-packed pictures in those books, knows the work of Newell Convers Wyeth. For Wyeth has undoubtedly reached his greatest public through his illustrations, which contain much of his best work. Dramatic, filled with movement, and always of arresting composition they more than bring to life the texts which they accompany. So popular was his work in this field that many of these old editions are still in print.

He studied under Howard Pyle in Wilmington, Delaware. Wyeth worshiped the old master illustrator, and was the one to fill the void left by his death in 1911. Like Pyle, Wyeth portrayed moments of great drama and action with technical brilliance.

Although he was born in Needham, Massachusetts, and spent most of his early life there, he soon showed a fascination with the Far West, Indians, trappers, and cowboys. Most of what he learned of the West was from studying the work of Remington, Russell, and others, but he had a period in his youth when he was able to make an extended visit to the Southwest, and he returned with a great many sketches from which he later made Western illustrations and paintings.

Having achieved success as an illustrator and painter, Wyeth later in life felt the longing for larger surfaces on which to paint. The result was many industrial commissions for murals, some of which are to be seen in the Missouri State Capitol, the First National Bank of Boston, the National Geographic Society building in Washington, and many others.

Easel painting became more interesting to Wyeth later in life, and between his other commissions for murals and illustrations he turned out many fine canvases which are now of great value.

A tragic accident ended his life at a railroad crossing in 1945.

He was the father of five children. Nathaniel is a noted creative engineer; Ann, a pianist and composer, is married to a former student of Wyeth's, John McCoy; and three became artists — Carolyn, Henriette (now Mrs. Peter Hurd), and Andrew Wyeth, one of America's best known artists.

GUNFIGHT *Oil* 34 x 25 inches
From the book *Nan of Music Mountain* by Frank H. Spearman

John Young-Hunter

1874–1955

BORN IN GLASGOW, SCOTLAND, John Young-Hunter was the son of Colin Hunter, a well-known marine painter and member of the Royal Academy of London. In his youth, Young-Hunter grew up in an atmosphere which encouraged his artistic inclinations. The circle of artists who were his parents' friends included Lawrence Alma–Tadema and the celebrated John Singer Sargent, under whom the boy later studied.

This was a period in which art flourished on the continent, and the Young-Hunter family lived extravagantly and with much elegance. In his book, *Reviewing the Years*, which he wrote many years later, Young-Hunter provides illuminating anecdotes and insights into the society of the period and the many famous personalities who were a part of it. He himself was often described as "the perfect Edwardian."

In 1912, when in his mid-thirties, Young-Hunter severed his connections with the European art world and came to the United States. He had already achieved a substantial reputation as a painter; his works hung in the National Tate Gallery in London and the *Musée du Luxembourg*, Paris, but he had a persistent desire to investigate the American West. Taos, New Mexico seemed to fulfill something in his nature and he established a studio there, becoming a member of the well-known art colony already in residence. Mabel Dodge Luhan described his studio as being ". . . an elegant Spanish studio with a British accent."

Alternating between Taos and New York, where he spent the winters, he was constantly visited by prominent friends and admirers, many of whom commissioned him to do portraits. Of his work in this field Gilbert Highet has said, ". . . a worthy successor of that remarkable portraitist, John Singer Sargent."

Young-Hunter was not only a society portrait painter, but a versatile and extremely knowledgeable artist. When he died in 1955 he left a large and varied body of work consisting of portraits, paintings of flowers, Indians, the New Mexico landscape, and scenes depicting life on the frontier of the Old West.

Contrary to the way of most artists, who prefer to keep their professional secrets, Young-Hunter reveals his formulas and methods in his book, *Reviewing the Years*.

TRAIL ABLAZE *Tempera* 26 x 36 inches

CHRONOLOGICAL LIST OF THE ARTISTS

1785–1862	Charles Bird King	1861–1962	Warren E. Rollins
1810–1874	Alfred Jacob Miller	1864–1926	Charles M. Russell
1814–1872	John Mix Stanley	1864–1939	DeCost Smith
1819–1905	Arthur Fitzwilliam Tait, NA	1865–1929	Robert Henri, NA
1828–1862	Charles Wimar	1865–1937	Grace Carpenter Hudson
1829–1908	Thomas Hill	1866–1936	E. Irving Couse, NA
1830–1902	Albert Bierstadt, NA	1866–1955	William R. Leigh, NA
1837–1918	Henry H. Cross	1868–1956	Bert Phillips
1837–1926	Thomas Moran, NA	1869–1959	Carl Rungius, NA
1839–1911	William Keith	1870–1953	John Marin
1840–1922	William de la Montagne Cary	1871–1970	Robert Lindneux
1842–1914	John D. Howland	1873–1945	Edward Borein
1843–1942	William Henry Jackson	1874–1939	Frank Tenney Johnson, NA
1846–1931	Charles Craig	1874–1952	Oscar E. Berninghaus, ANA
1847–1919	Ralph A. Blakelock, NA	1874–1955	John Young-Hunter
1852–1919	Edgar Samuel Paxson	1874–1960	Ernest L. Blumenschein, NA
1854–1924	H. W. Hansen	1874–1962	R. Farrington Elwell
1854–1937	Henry Raschen	1875–1921	John N. Marchand
1855–1941	George de Forest Brush, NA	1875–1946	Maynard Dixon
1856–1924	A. D. M. Cooper	b. 1875	James Swinnerton
1858–1915	Richard Lorenz	1876–1936	Walter Ufer, NA
1858–1942	Charles Partridge Adams	1876–1937	Carlos Vierra
1858–1949	Elbridge Ayer Burbank	1877–1957	Olaf Seltzer
1859–1913	John Hauser	1878–1932	E. William Gollings
1859–1939	George Elbert Burr	1878–1936	W. Herbert Dunton
1859–1953	Joseph H. Sharp	1879–1934	Gerald Cassidy

1879–1947	Carl Oscar Borg, ANA	1897–1966	Kenneth M. Adams, NA
1881–1947	Edgar Alwin Payne	b. 1897	Nick Eggenhofer, CA
1881–1955	Nicolai Fechin	b. 1899	Olaf Wieghorst
1882–1945	N. C. Wyeth, NA	b. 1901	Howard Cook, NA
1882–1964	Leon Gaspard	b. 1904	Peter Hurd, NA
1882–1970	Lone Wolf	b. 1904	Byron B. Wolfe, CA
1884–1949	Victor Higgins, NA	b. 1905	J. Charles Berninghaus
1884–1952	Harvey Dunn, NA	b. 1906	Charlie Dye, CA
1885–1962	Clyde Forsythe	b. 1907	Thomas L. Lewis
1886–1956	E. Martin Hennings	b. 1910	Robert Lougheed, CA
1887–1938	LaVerne Nelson Black	b. 1911	H. Ray Baker
1887–1964	Randall Davey, NA	b. 1916	R. Brownell McGrew, CA
b. 1887	Andrew Dasburg	b. 1916	William Moyers, CA
b. 1887	Georgia O'Keeffe	b. 1917	Nicholas S. Firfires, CA
1888–1958	Frank B. Hoffman	b. 1918	John Hampton, CA
1888–1964	Frederic Mizen	b. 1921	Manuel Acosta
b. 1889	Arthur Mitchell	b. 1921	James Boren, CA
b. 1890	Gerard Curtis Delano	b. 1922	Tom Ryan, CA
1891–1958	Raphael Lillywhite	b. 1924	Robert D. Ray
1893–1969	Will Shuster	b. 1929	Joe Grandee
b. 1893	Harold Von Schmidt	b. 1931	Joe Beeler, CA
b. 1894	Doel Reed, NA	b. 1934	Ross Stefan
1895–1964	Benton Clark	b. 1938	Ned Jacob, CA
b. 1896	J. K. Ralston	b. 1939	Ramon Kelley

SELECTED BIBLIOGRAPHY

Adams, Ramon, and Britzman, Homer. *Charles M. Russell, The Cowboy Arist: A Biography*. Pasadena: Trail's End Publishing Co., 1948.

Ainsworth, Ed. *The Cowboy in Art*. New York and Cleveland: World Publishing Co., 1968.

_____. *Painters of the Desert*. Palm Desert, Calif., Desert Magazine Publishers, 1960.

Barker, Virgil. *American Painting: History and Interpretation*. New York: Macmillan Co., 1951.

Bickerstaff, Laura. *Pioneer Artists of Taos*. Denver: Alan Swallow, Sage Books, 1955.

Bowditch, Nancy Douglas. *George de Forest Brush: Recollections of a Joyous Painter*. Peterborough, N.H.: William L. Bauhan, Noone House, 1970.

Burbank, E. A. and Royce, Ernest. *Burbank Among the Indians*. Caldwell, Idaho: Caxton Printers, 1946.

Canaday, John. *Mainstreams of Modern Art*. New York: Simon and Schuster, 1959.

Cheney, Sheldon. *The Story of Modern Art*. New York: Viking Press, 1941.

_____. *A Primer of Modern Art*. New York: Liveright, 1958.

Clark, Edna Maria. *Ohio Art and Artists*. Richmond, Va.: Garrett and Massie, 1932.

Coke, Van Deren. *Taos and Santa Fe: The Artist's Environment, 1882–1942*. Albuquerque: University of New Mexico Press, 1963.

Craven, Thomas. *Treasury of American Prints*. New York: Simon and Schuster, 1939.

Eddy, Arthur Jerome. *Cubists and Post-Impressionism*. Chicago: A. C. McClurg and Co., 1914.

Eggenhofer, Nick. *Wagons, Mules and Men: How the Frontier Moved West*. New York: Hastings House Publishers, 1961.

Eliot, Alexander. *Three Hundred Years of American Painting*. New York: Time Inc., 1957.

Ewers, John C. *Artists of the Old West*. Garden City, N.Y.: Doubleday and Co., 1965.

Fielding, Mantle. *Dictionary of American Painters, Sculptors and Engravers.* Lancaster, Pa.: Lancaster Press, 1926.

Flexner, James Thomas. *The Pocket History of American Painting.* New York: Washington Square Press, 1966.

Fryxell, Fritiof Melvin. *Thomas Moran, Explorer in Search of Beauty.* Long Island: East Hampton Library, 1958.

Hamilton, Sinclair. *Early American Book Illustrators and Wood Engravers, 1670–1870,* 2 vols. Princeton, N.J.: Princeton University Press, 1968.

Horgan, Paul. *Peter Hurd: A Portrait Sketch from Life.* Austin: University of Texas Press, 1964.

Karolevitz, Robert F. *Where Your Heart Is: The Story of Harvey Dunn, Artist.* Aberdeen, S.Dak.: North Plains Press, 1970.

Krakel, Dean. *James Boren: A Study in Discipline.* Flagstaff, Ariz.: Northland Press, 1968.

_____. *Tom Ryan: A Painter in Four Sixes Country.* Flagstaff. Northland Press, 1971.

Luhan, Mabel Dodge. *Taos and Its Artists.* New York: Duell, Sloan and Pearce, 1947.

McCracken, Harold. *The Charles M. Russell Book: The Life and Work of the Cowboy Artist.* Garden City, N.Y.: Doubleday and Co., 1957.

_____. *Portrait of the Old West.* New York: McGraw-Hill Book Co., 1952.

Perceval, Don. *Maynard Dixon Sketch Book.* Flagstaff: Northland Press, 1967.

Reed, Walt. *The Illustrator in America: 1900–1960's.* New York: Reinhold Publishing Corp., 1966.

_____. *Harold Von Schmidt Draws and Paints the Old West.* Flagstaff: Northland Press, forthcoming.

Reed, William. *Olaf Wieghorst.* Flagstaff: Northland Press, 1969.

Reich, Sheldon. *John Marin: A Stylistic Analysis and Catalogue Raisonné.* Tucson: University of Arizona Press, 1970.

Russell, Austin. *Charles M. Russell, Cowboy Artist.* New York: Twayne Publishers, 1957.

Schultz, Joy. *The West Still Lives: A Book Based on the Paintings and Sculpture of Joe Ruiz Grandee.* Dallas: Heritage Press, 1970.

Seeber, Louise Combes. *George Elbert Burr, 1859–1939: Catalogue Raisonné and Guide to the Etched Works.* Flagstaff: Northland Press, 1971.

Shelton, Lola. *Charles Marion Russell: Cowboy, Artist, Friend.* New York: Dodd, Mead, 1962.

Smith, DeCost. *Indian Experiences*. Caldwell, Idaho: Caxton Press, 1943.

Taft, Robert. *Artists and Illustrators of the Old West, 1850–1900*. New York: Charles Scribner's Sons, 1953.

Taylor, Francis Henry. *Fifty Centuries of Art*. New York: Harper and Bros., 1954.

Waters, Frank. *Leon Gaspard*. Flagstaff: Northland Press, 1964.

Wilkins, Thurman. *Thomas Moran, Artist of the Mountains*. Norman: University of Oklahoma Press, 1966.

Woloshuk, Nicholas, Jr. *Edward Borein: Drawings and Paintings of the Old West*. Flagstaff: Northland Press, 1968.

Young-Hunter, John. *Reviewing the Years*. New York: Crown Publishers, 1963.